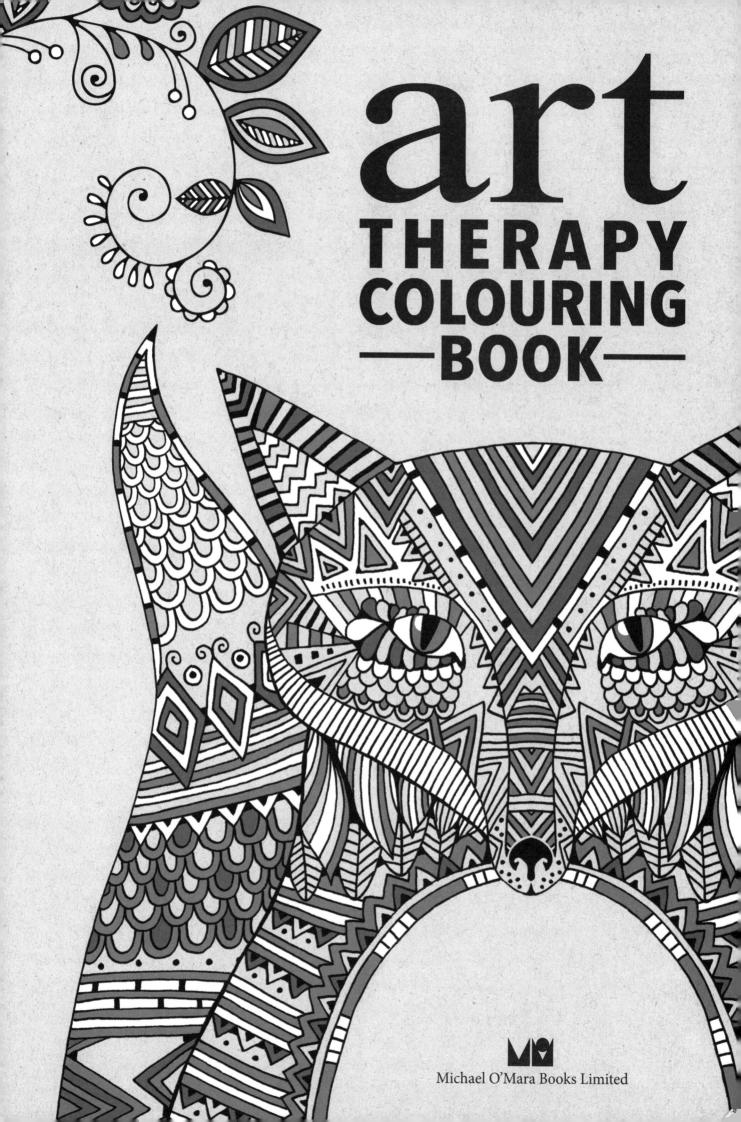

Illustrated by Hannah Davies, Richard Merritt and Cindy Wilde

Edited by Jonny Marx

Cover design by John Bigwood & Angie Allison

Designed by John Bigwood & Jack Clucas

With additional material adapted from www.shutterstock.com

First published in Great Britain in 2014 by Michael O'Mara Books Limited, 9 Lion Yard, Tremadoc Road, London SW4 7NQ

www.mombooks.com Michael O'Mara Books @OMaraBooks

Copyright © Michael O'Mara Books Limited 2014 . All rights reserved. No part of this book may be reproduced, stored in a retrieval system, or transmitted in any form or by any means, without the prior permission in writing of the publisher, nor be otherwise circulated in any form of binding or cover other than that in which it is published and without a similar condition including this condition being imposed on the subsequent purchase.

A CIP catalogue record for this book is available from the British Library.

ISBN: 978-1-78243-222-7 2 4 6 8 10 9 7 5 3 1

This book was printed in March 2014 by Leo Paper Products Ltd, Heshan Astros Printing Limited, Xuantan Temple Industrial Zone, Gulao Town, Heshan City, Guangdong Province, China.

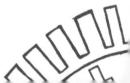

C

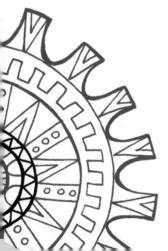

ō

2

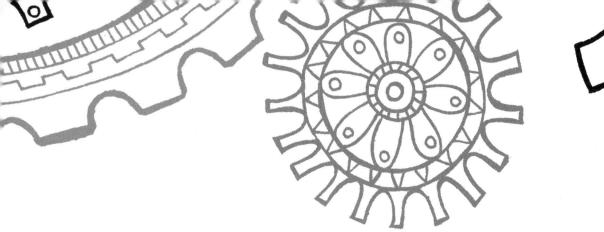

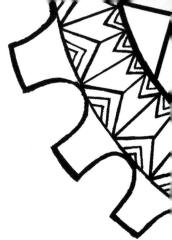

From doodling with loose lines and loops to colouring in complex designs, every activity in this book has been carefully crafted so you can enjoy the satisfaction of creating something beautiful.

With colouring and doodling, you need have no fear of making mistakes or failing. There is no right or wrong technique, only the opportunity to create stunning art. That's why this book contains no rules or complicated step-by-step instructions — you don't even have to stay within the lines if you don't want to.

From magical mandalas and rhythmical repeating patterns to gorgeous geometric designs and free-flowing doodles, the pictures in this book will help unlock your creativity and confidence. They will distract you from the stresses and strains of everyday life, and help you experience the calm that comes from focusing on simple tasks.

Pages for you to colour are at the beginning of the book, and there are doodles to do at the back. So pick up a pen, choose a page you like the look of, and start drawing.

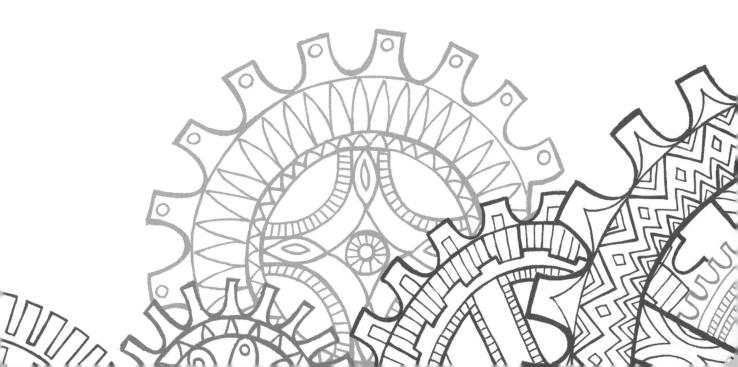

Colouring

Grab some pens or pencils and start colouring. These drawings contain intricate sections that can be filled in with a steady hand or scribbled over to create an area of solid colour.

ann

YYV

Canal and a second

0

000

0000

80000

00000

0000

°000

0000

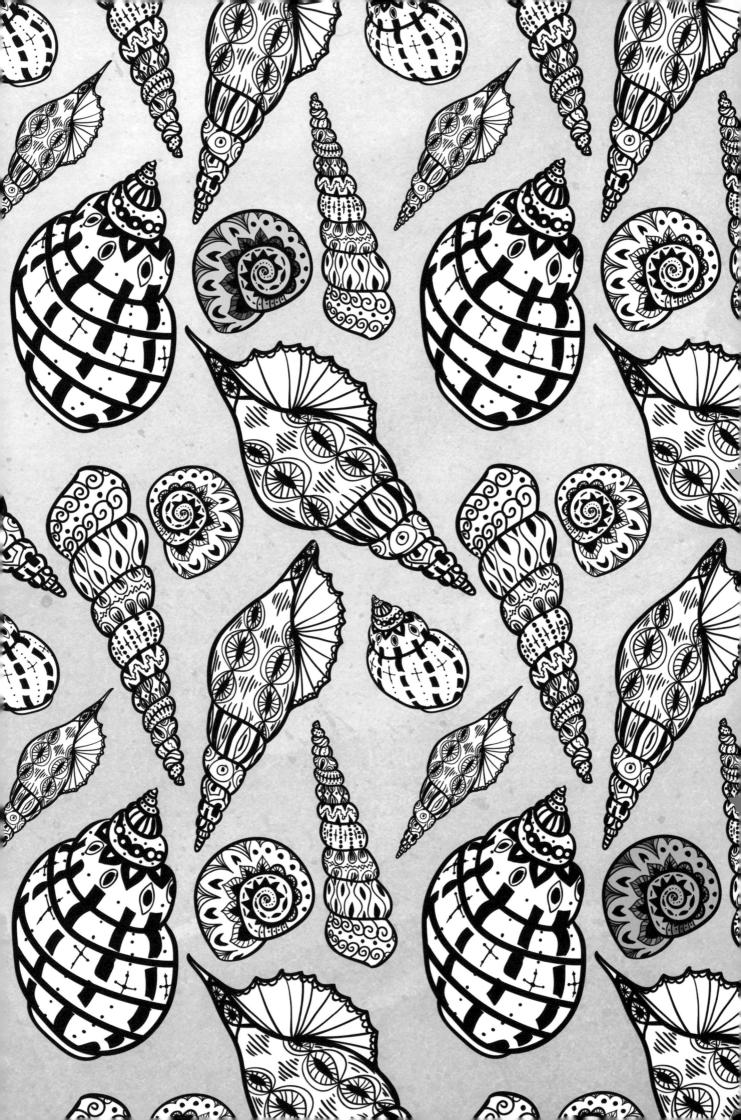

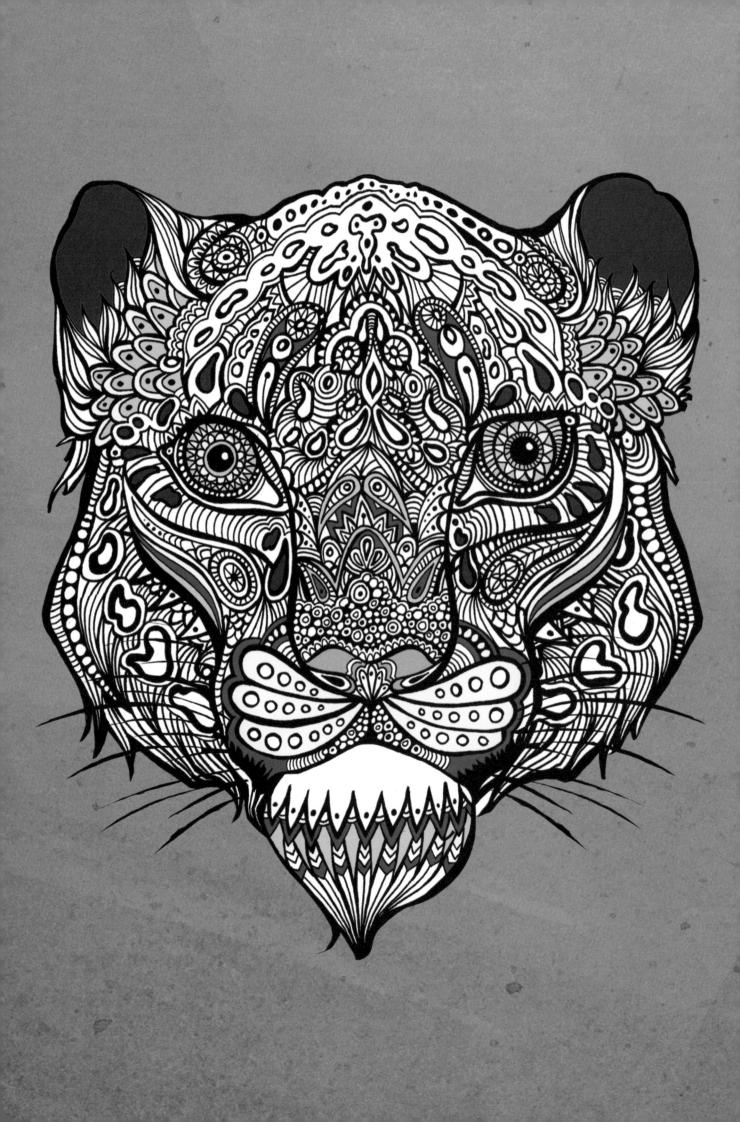

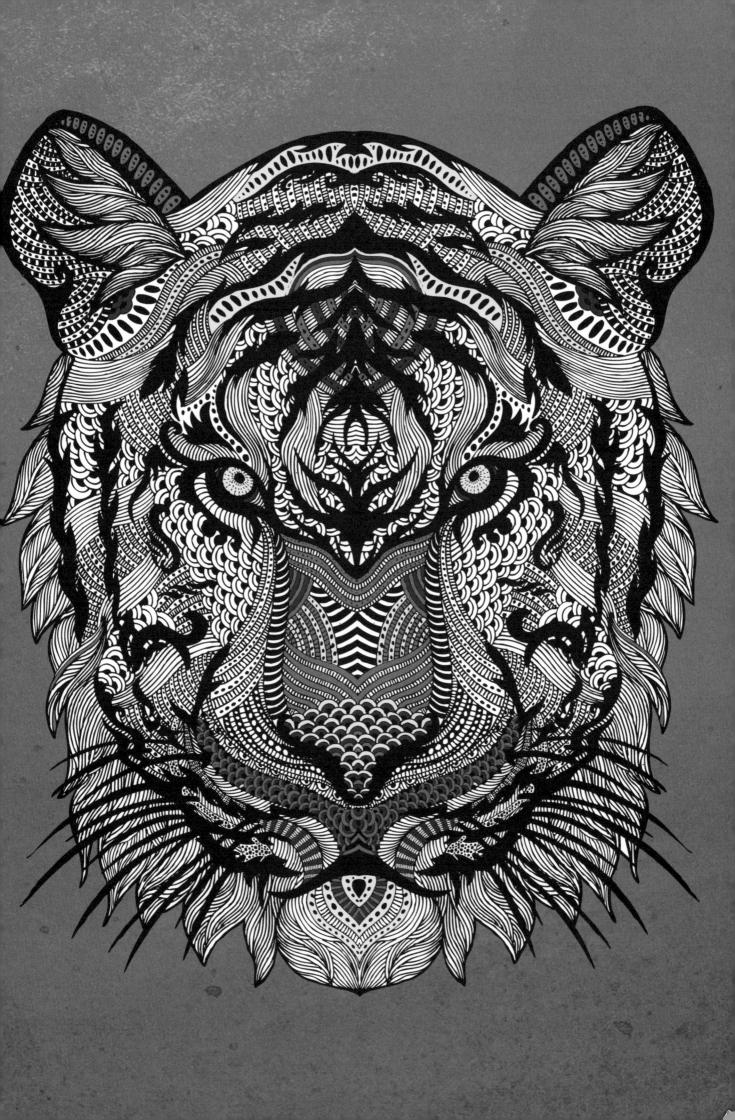

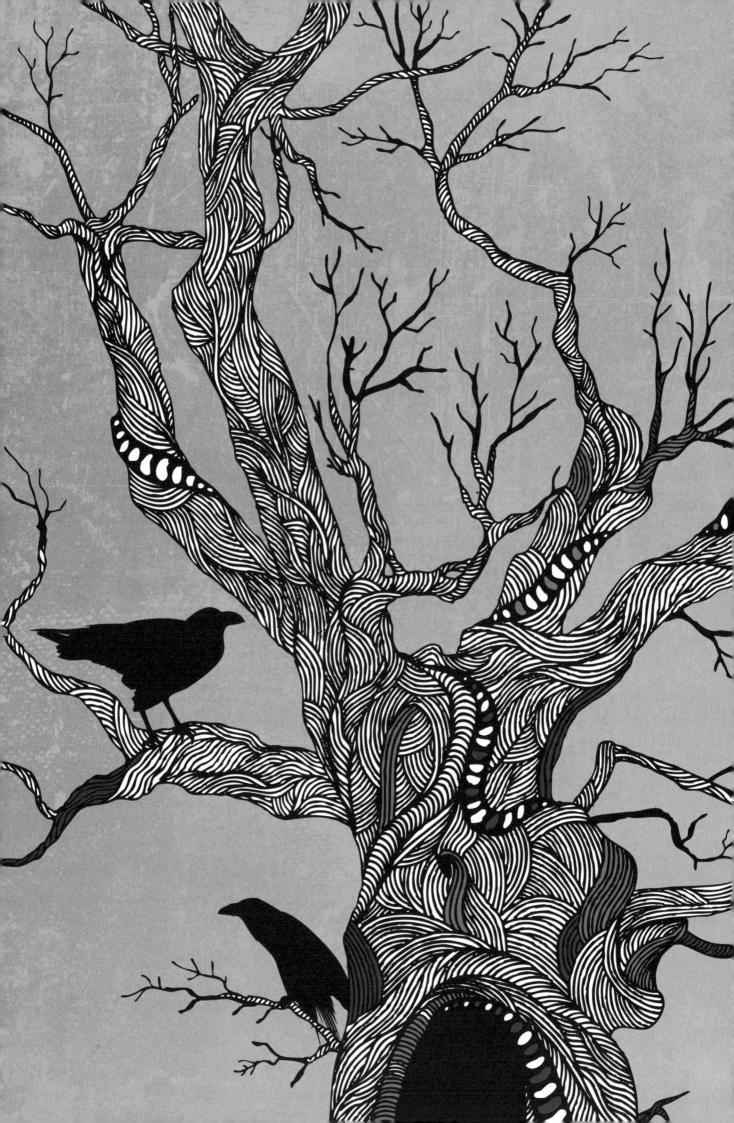

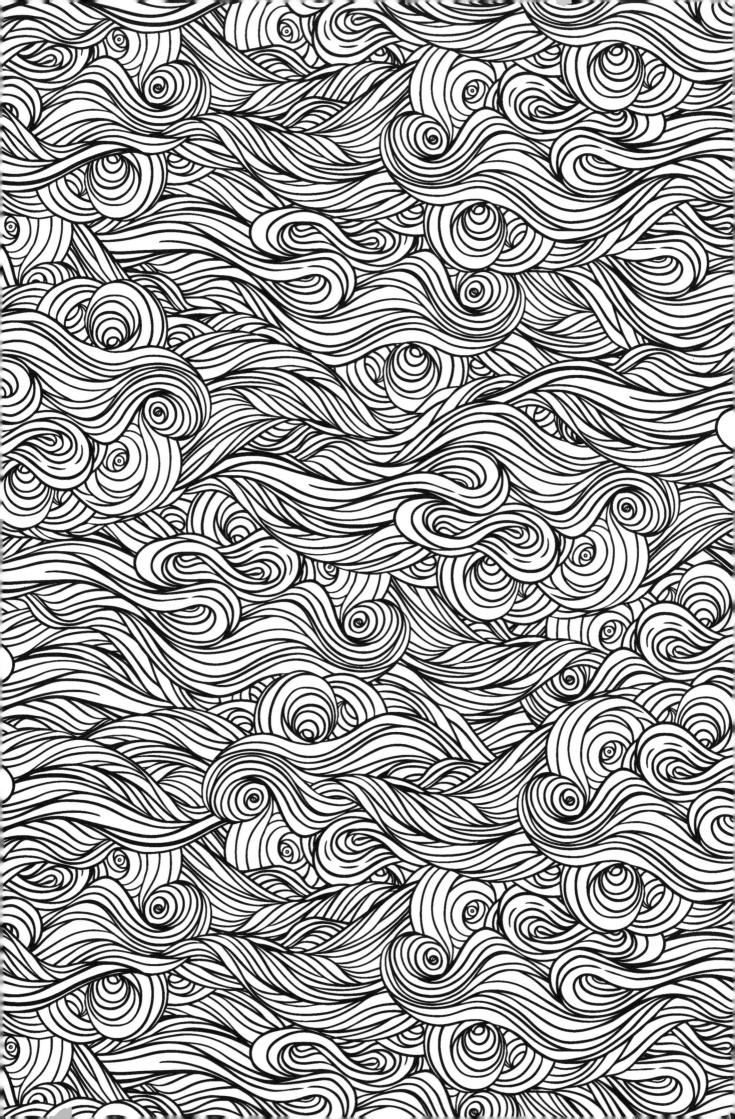

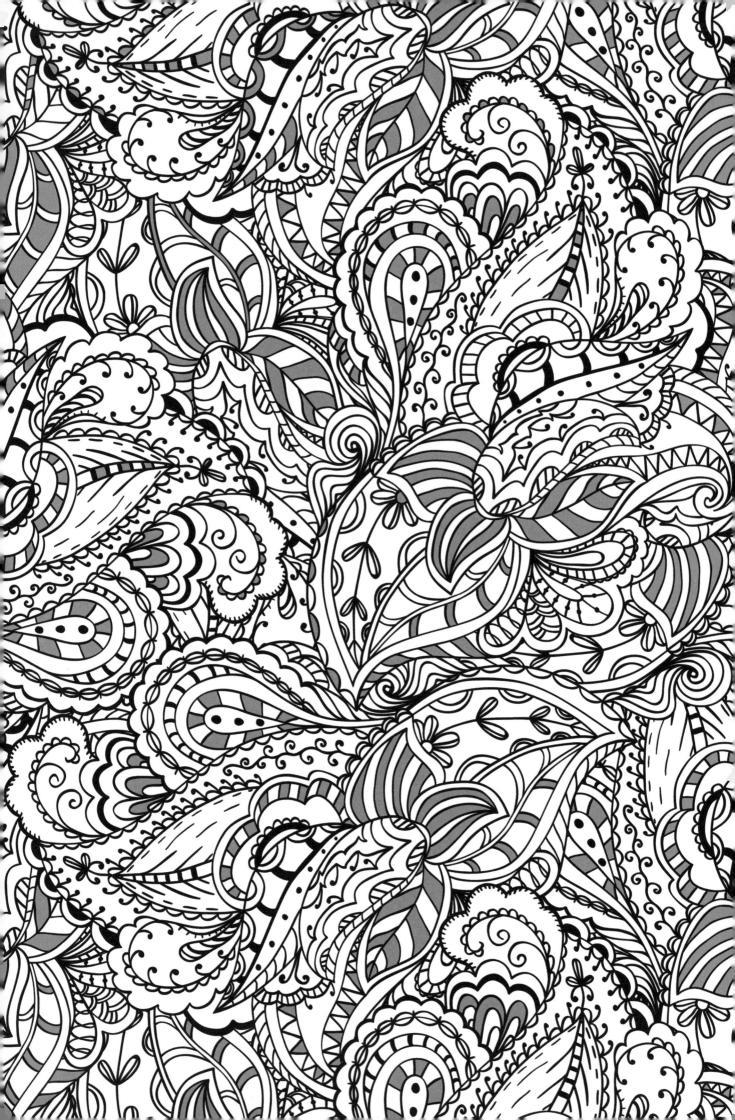

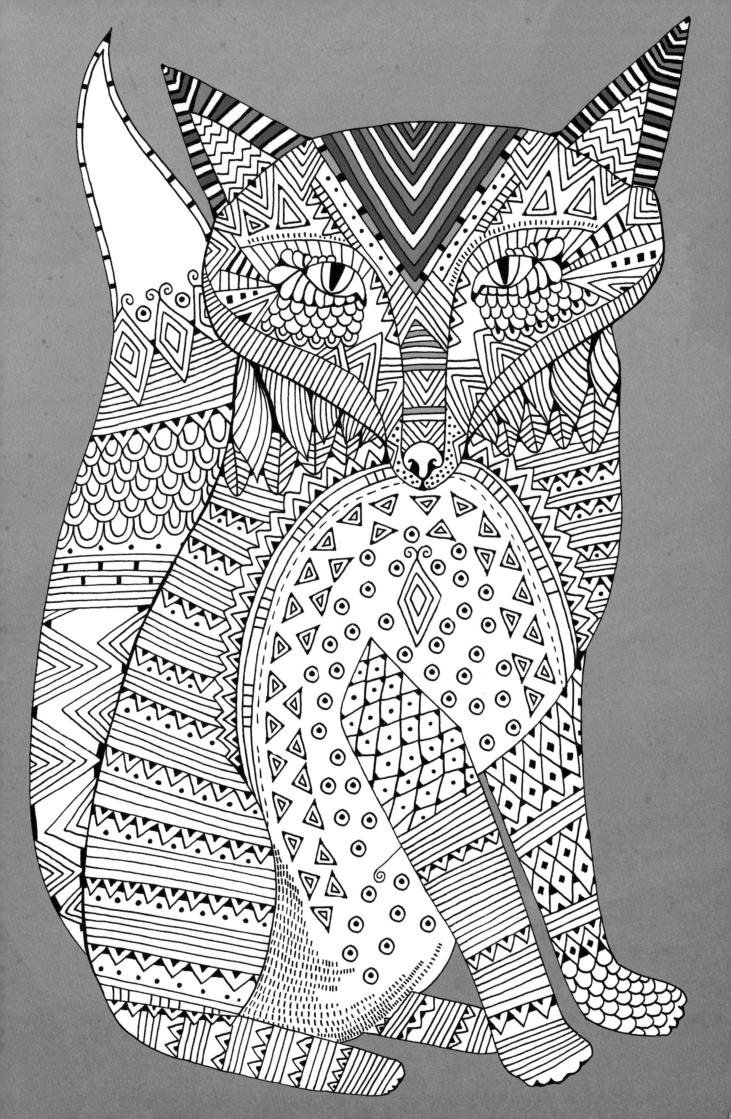

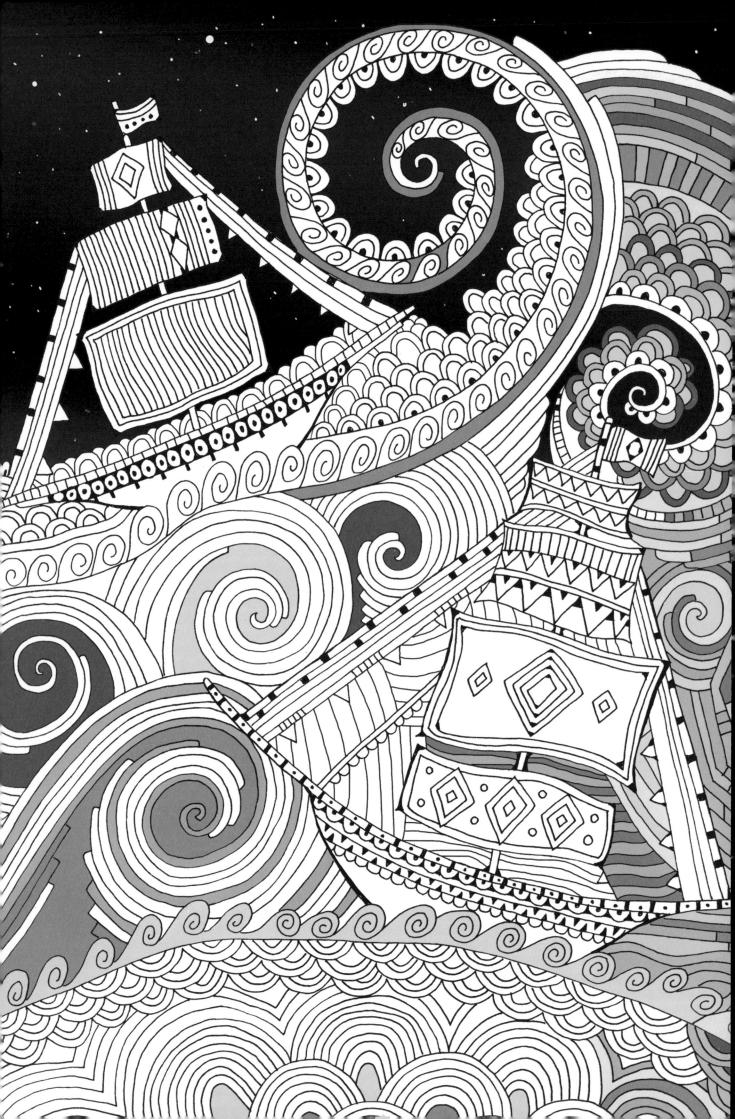

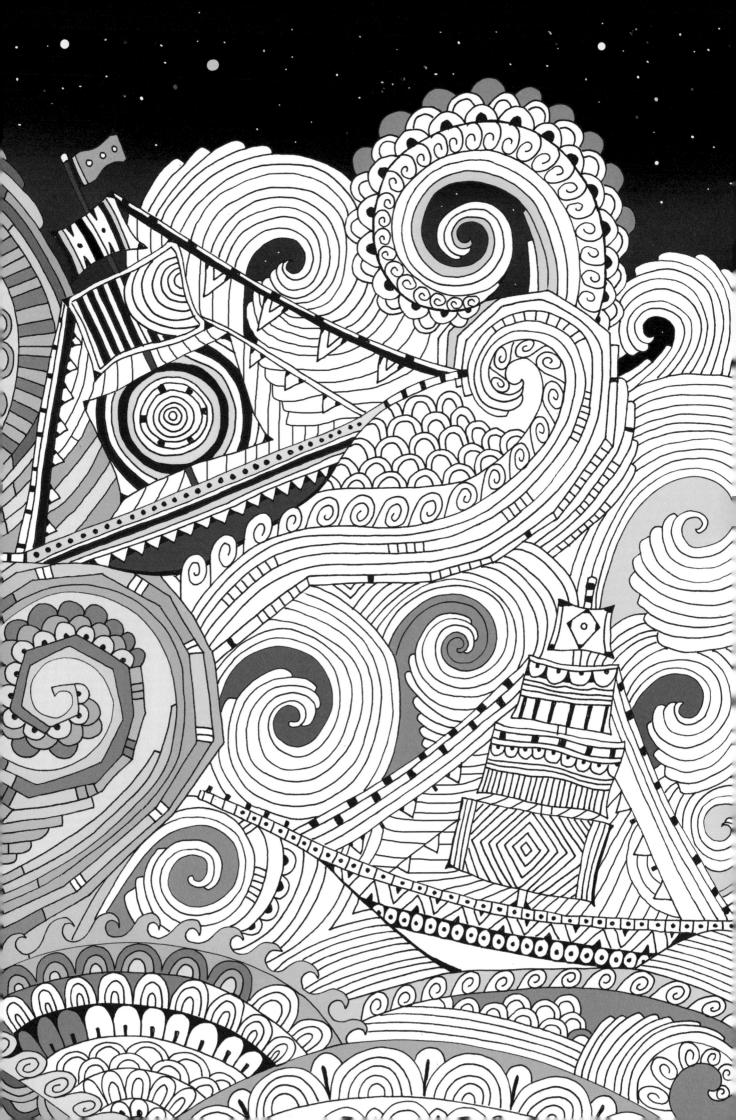

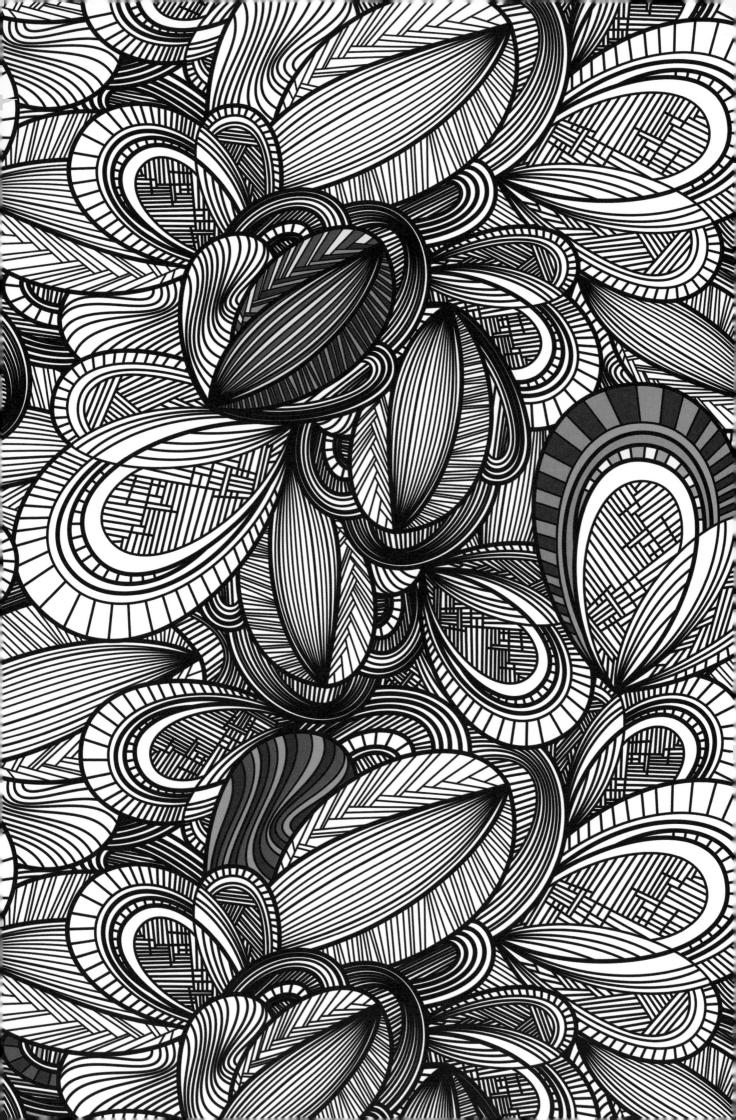

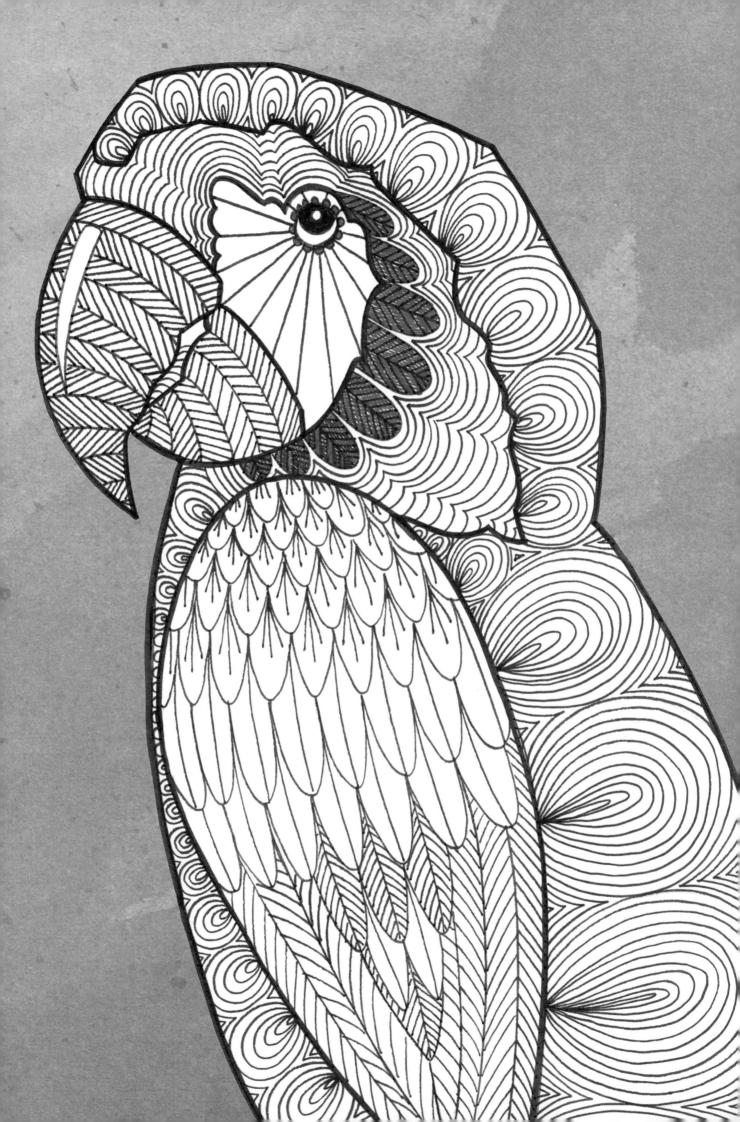

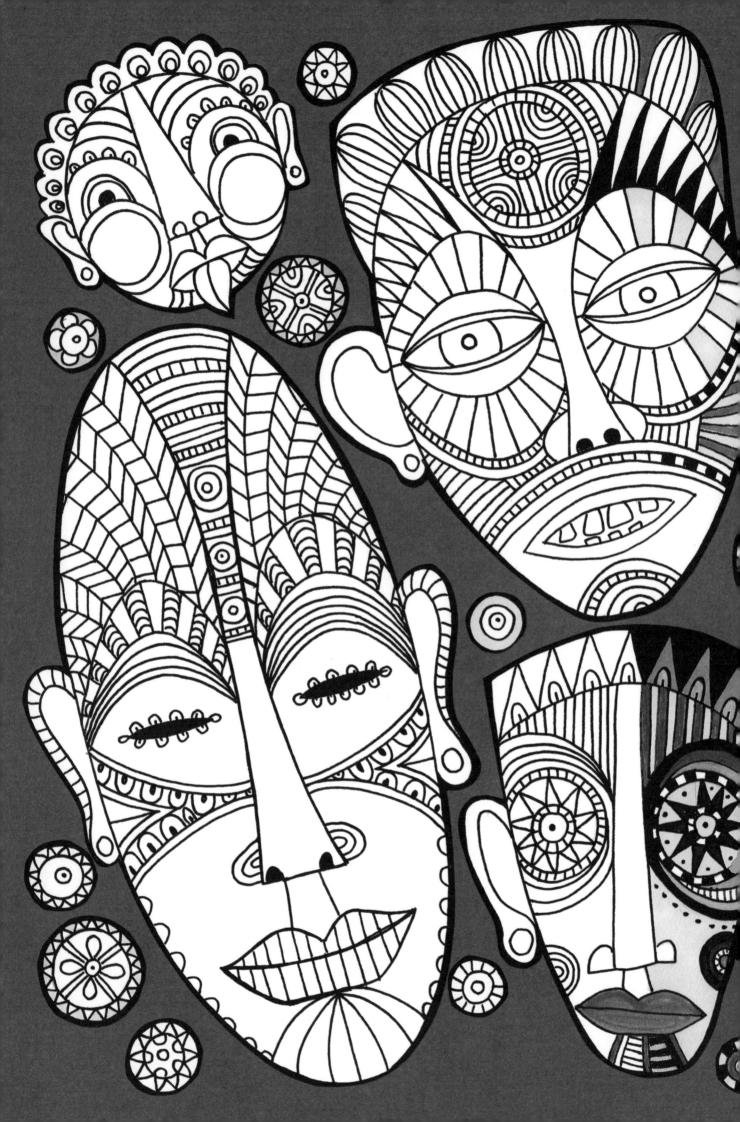

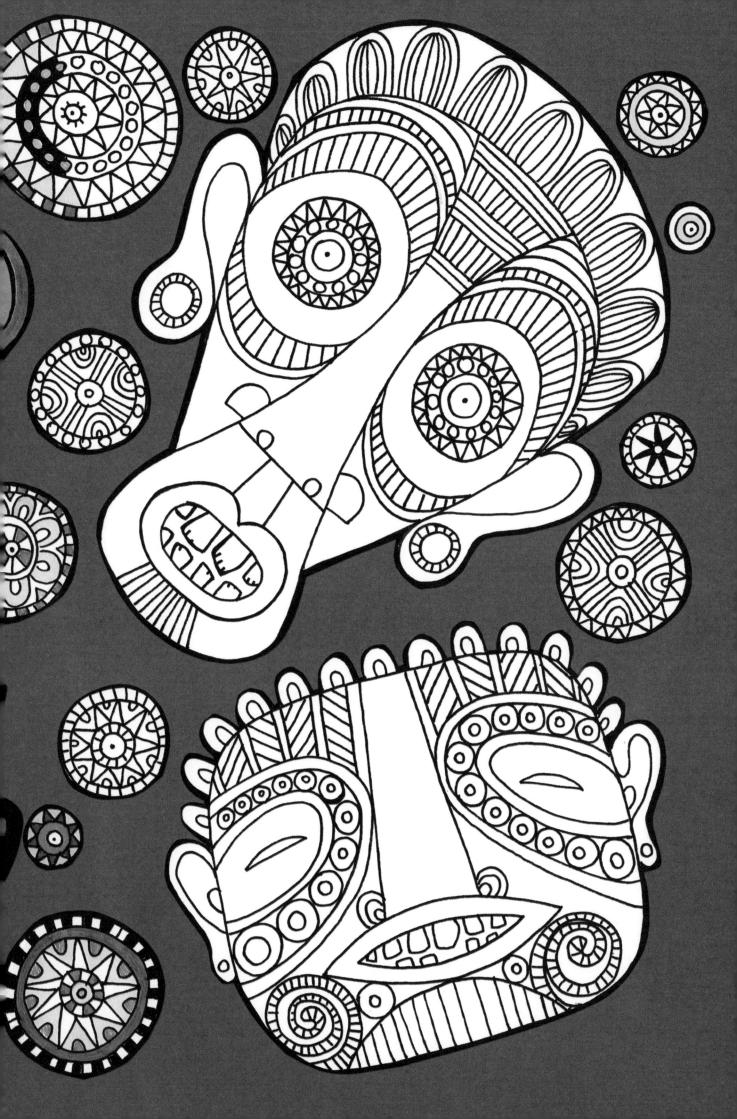

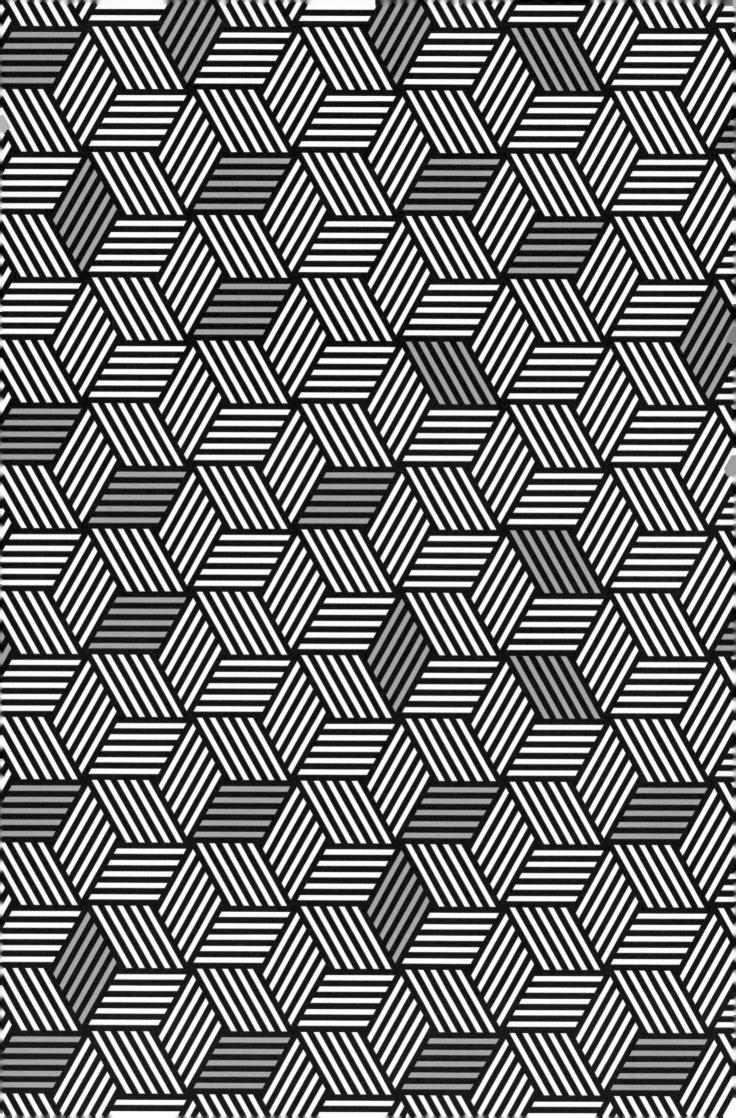

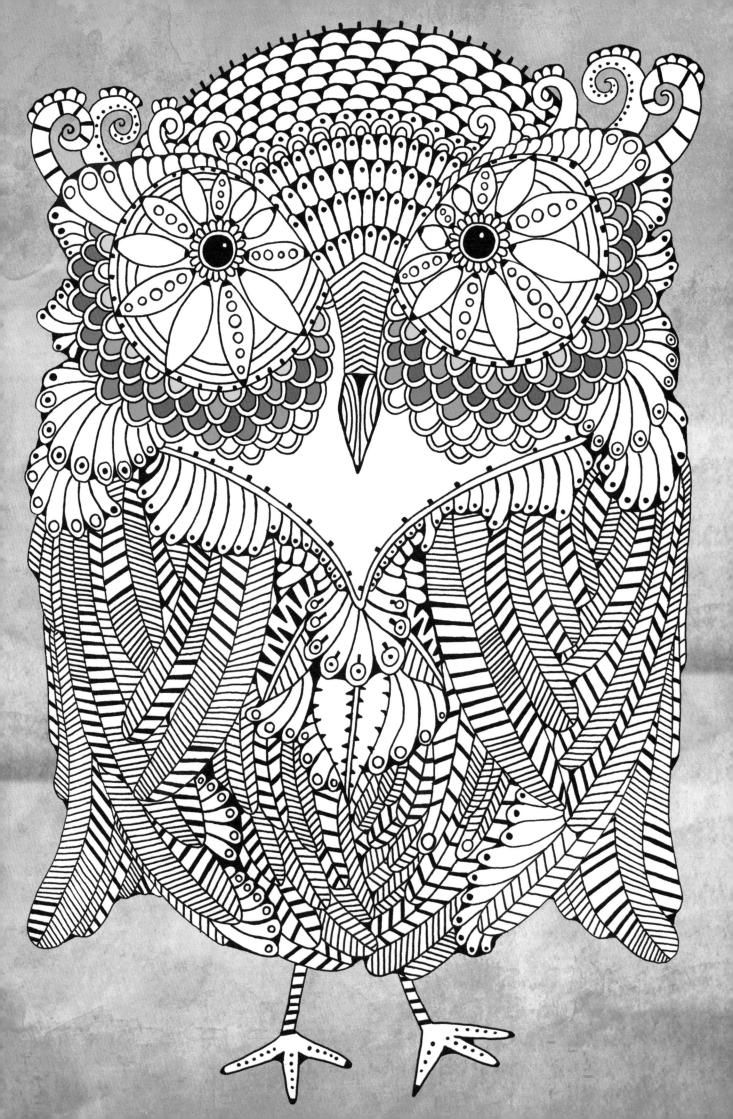

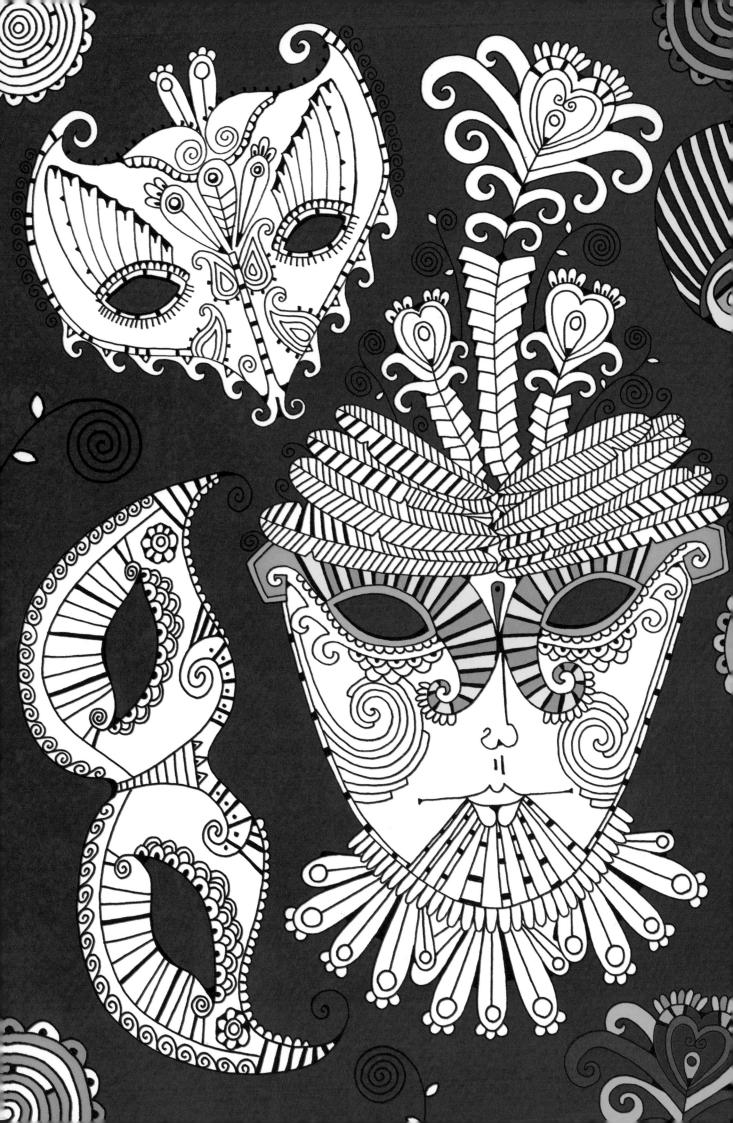

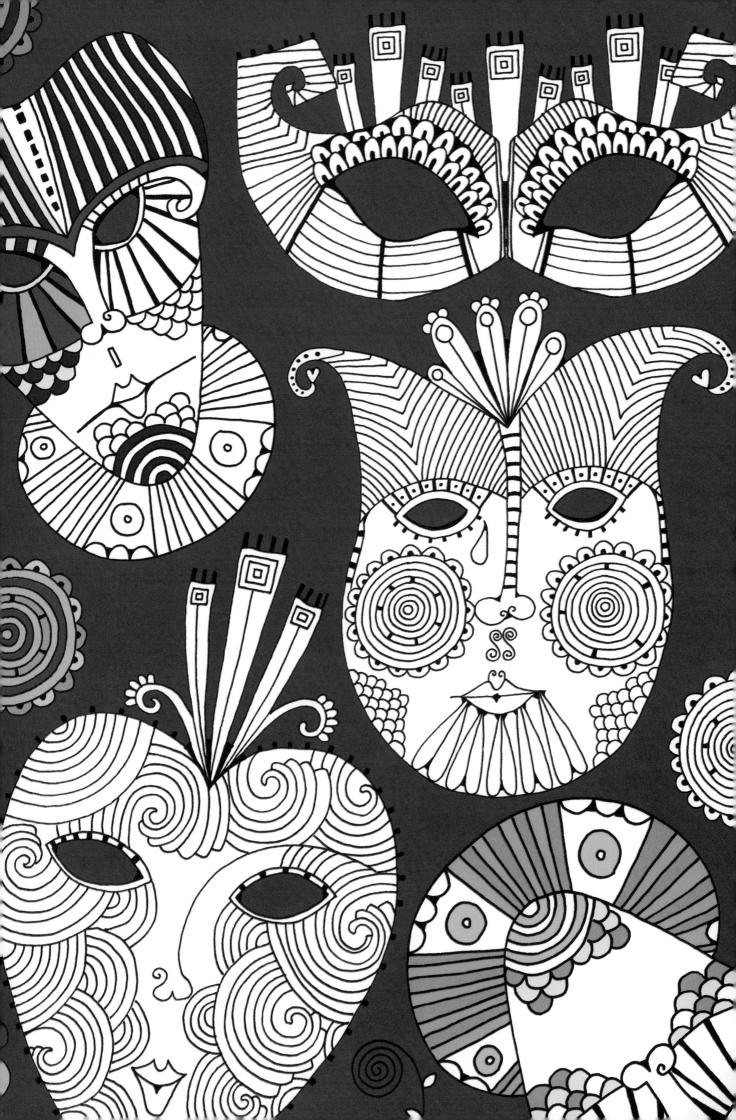

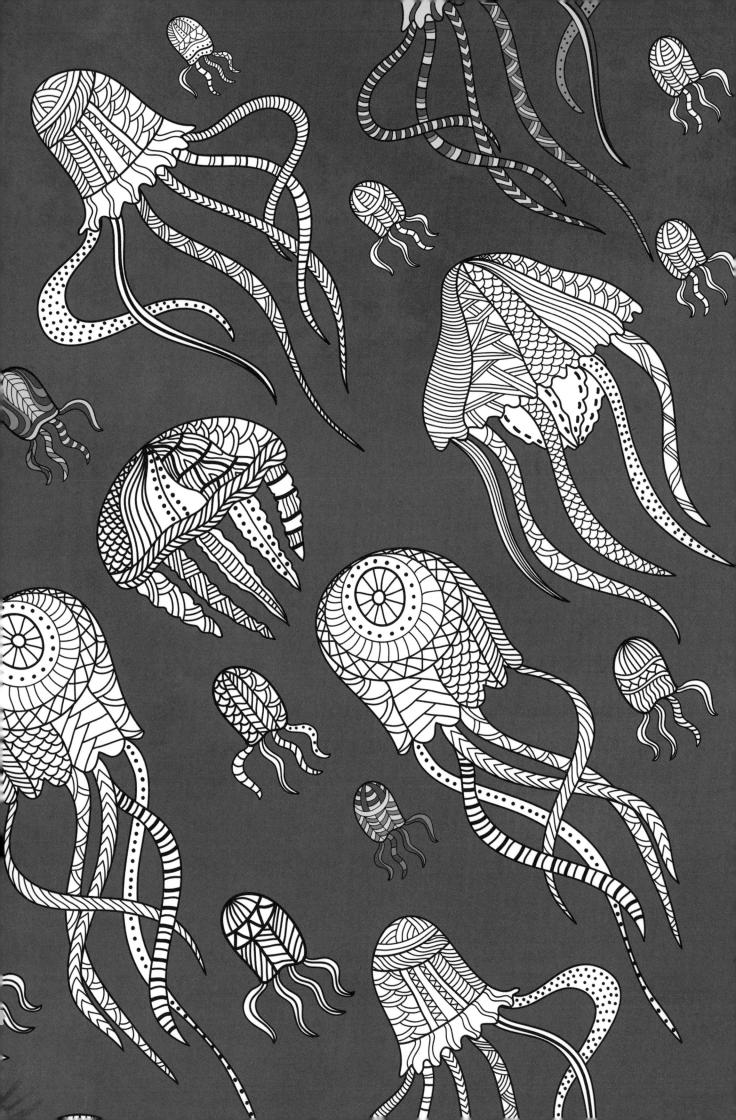

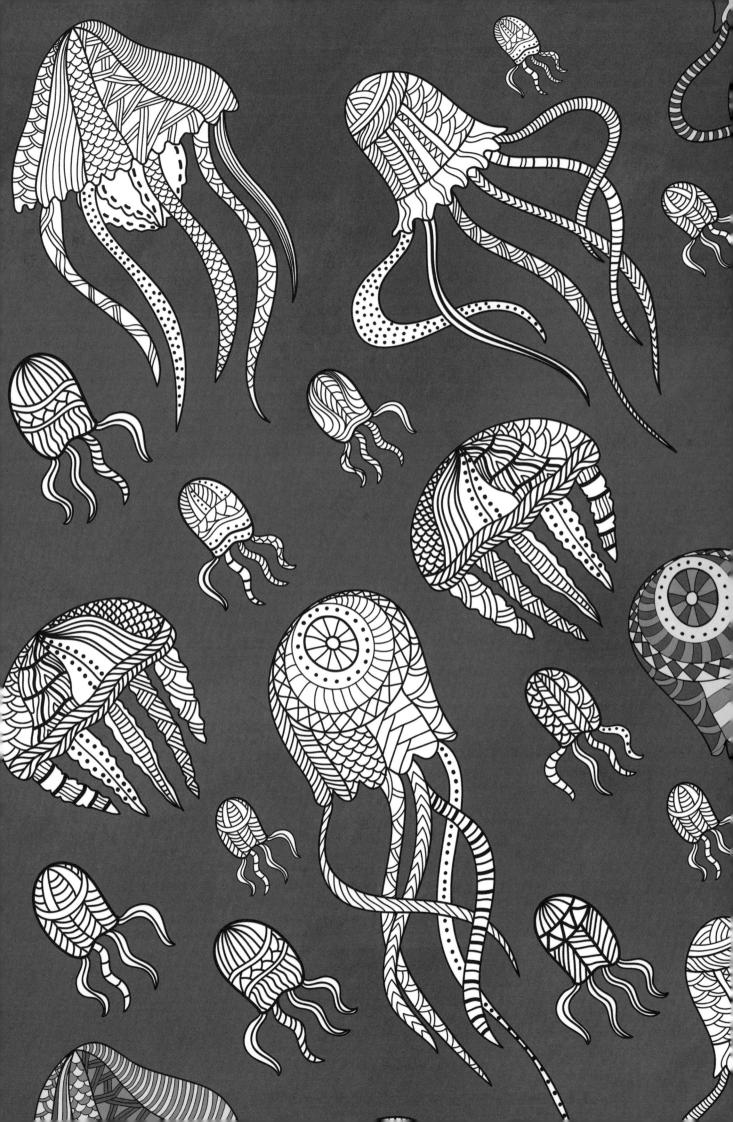

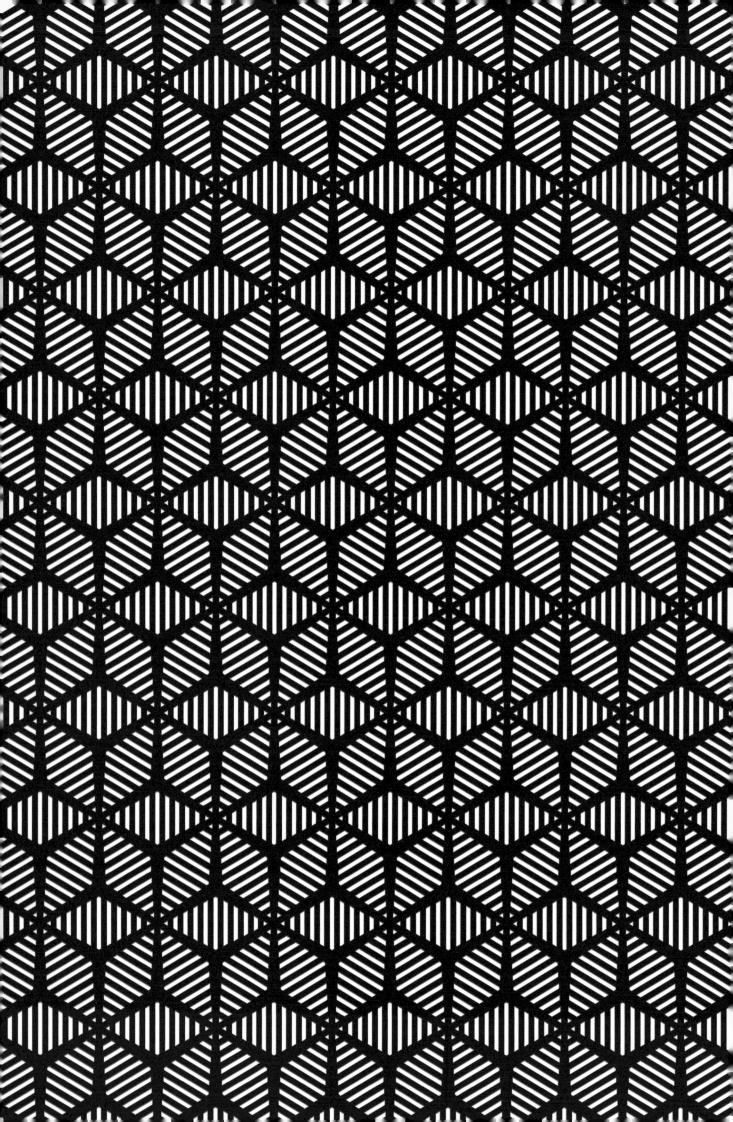

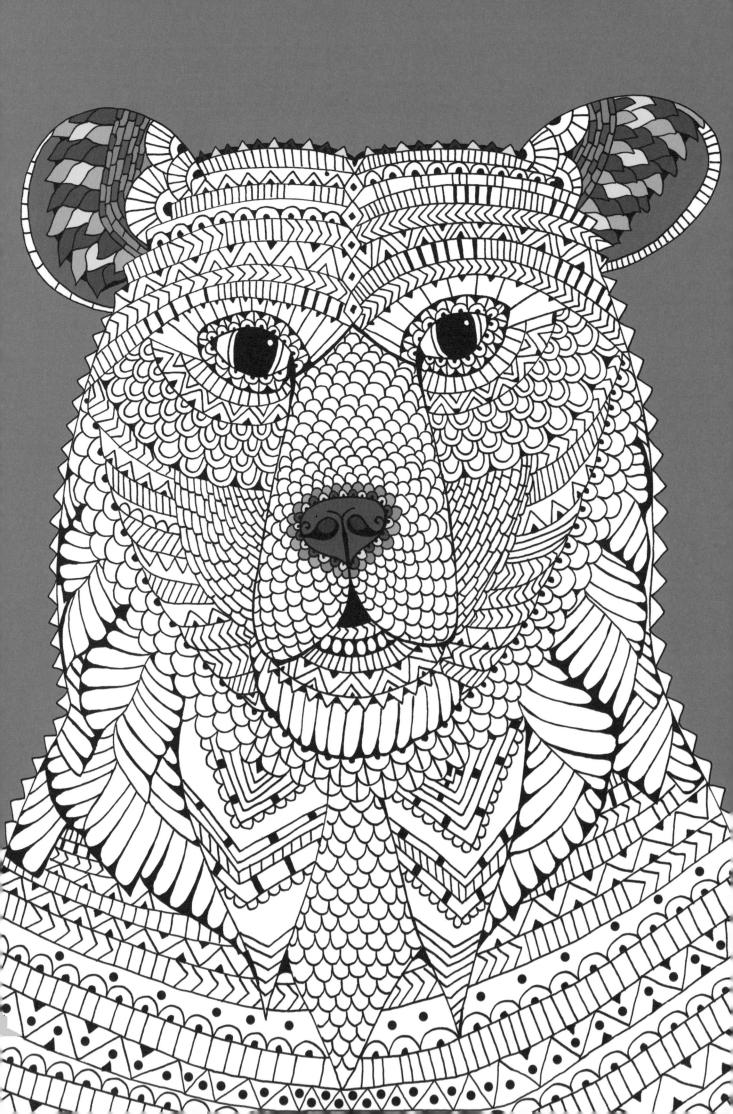

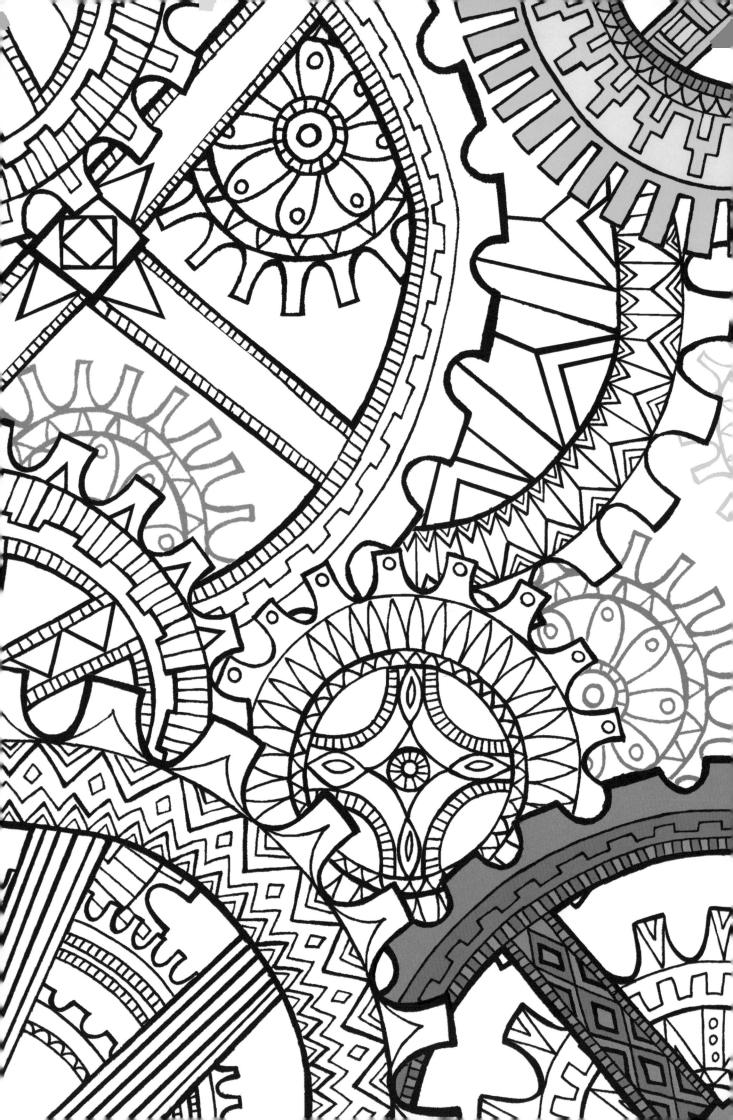

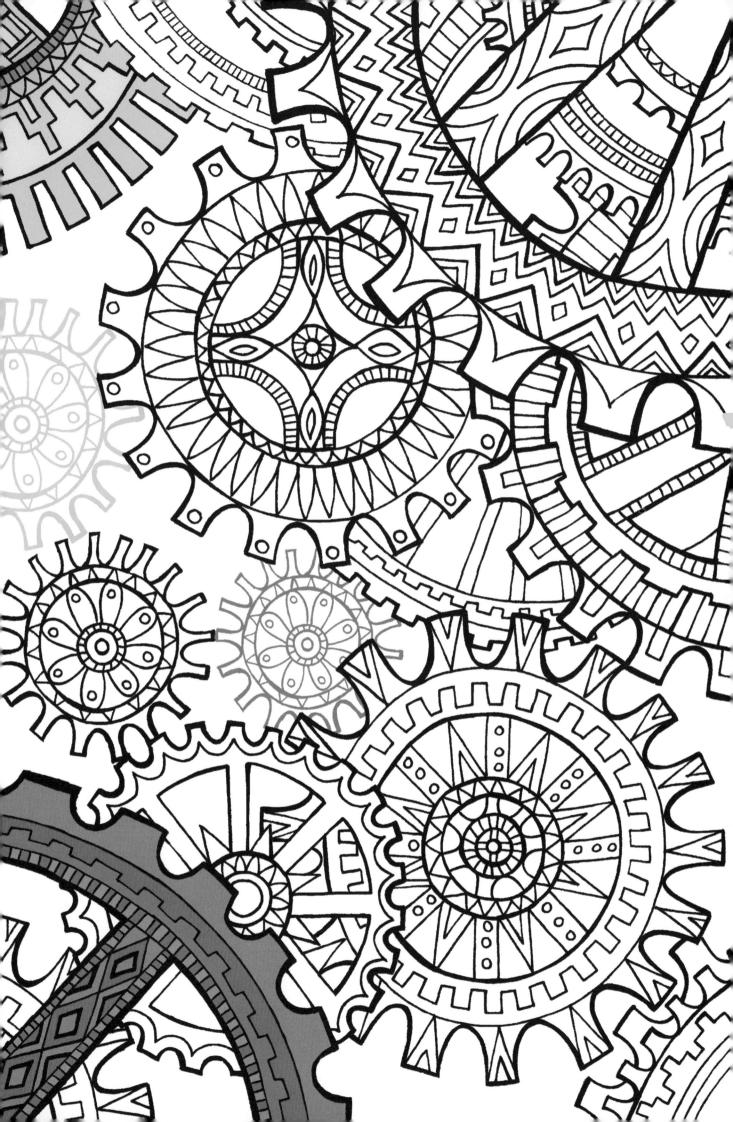

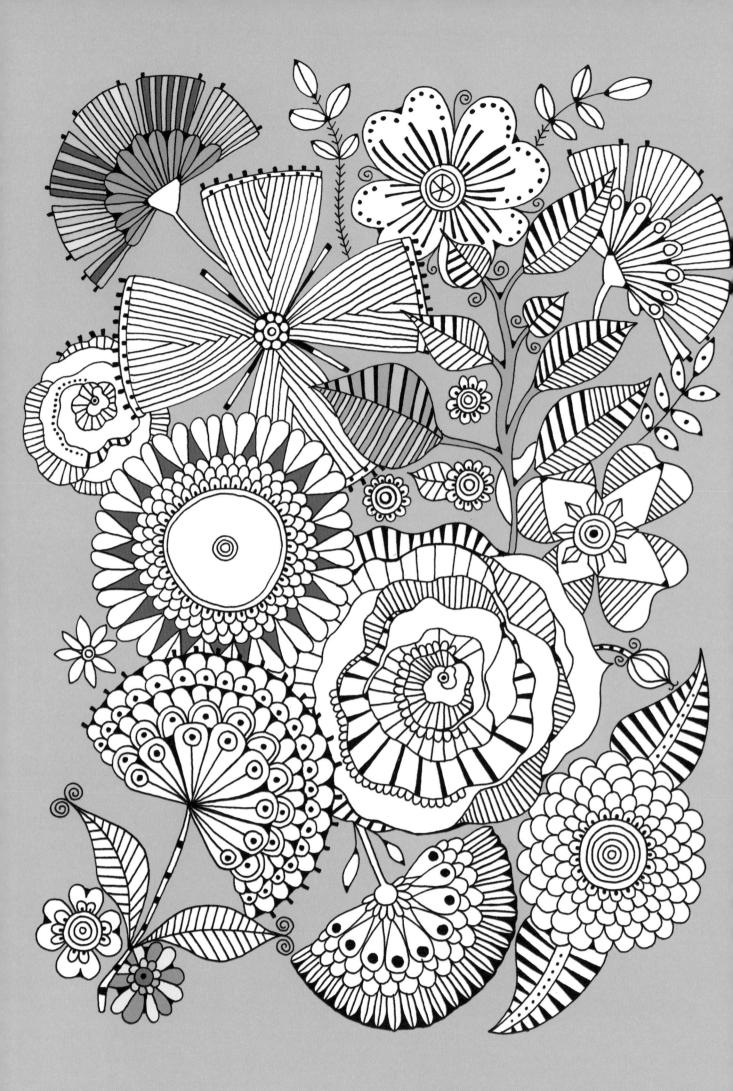

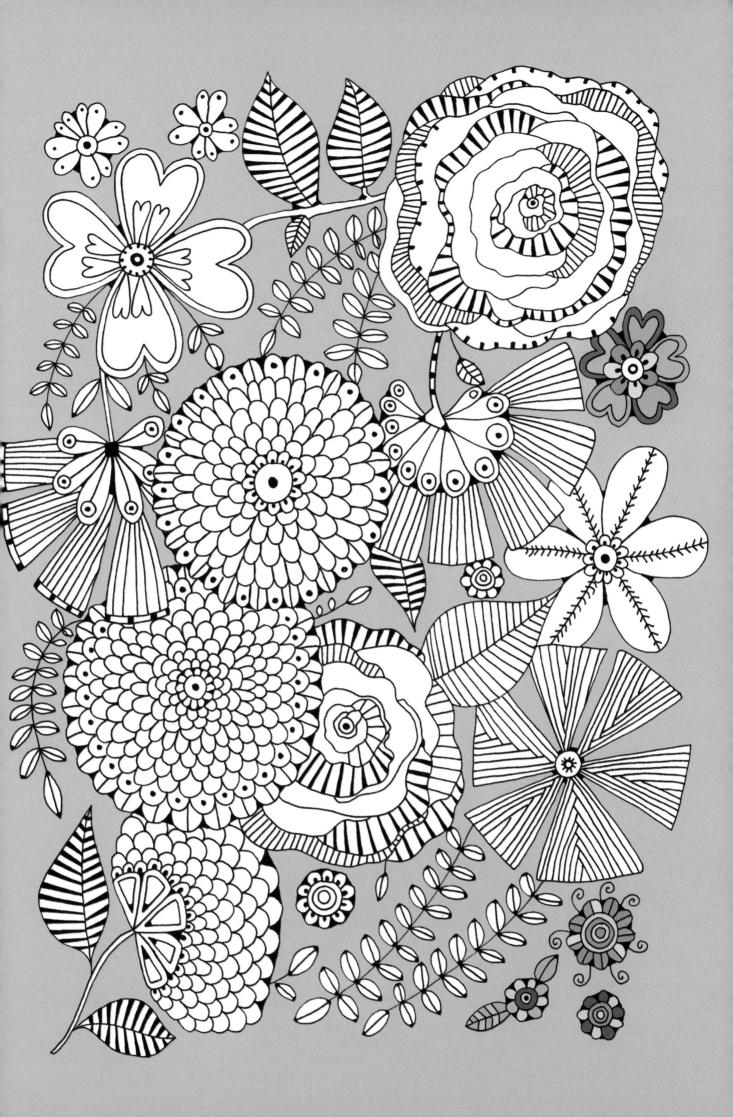

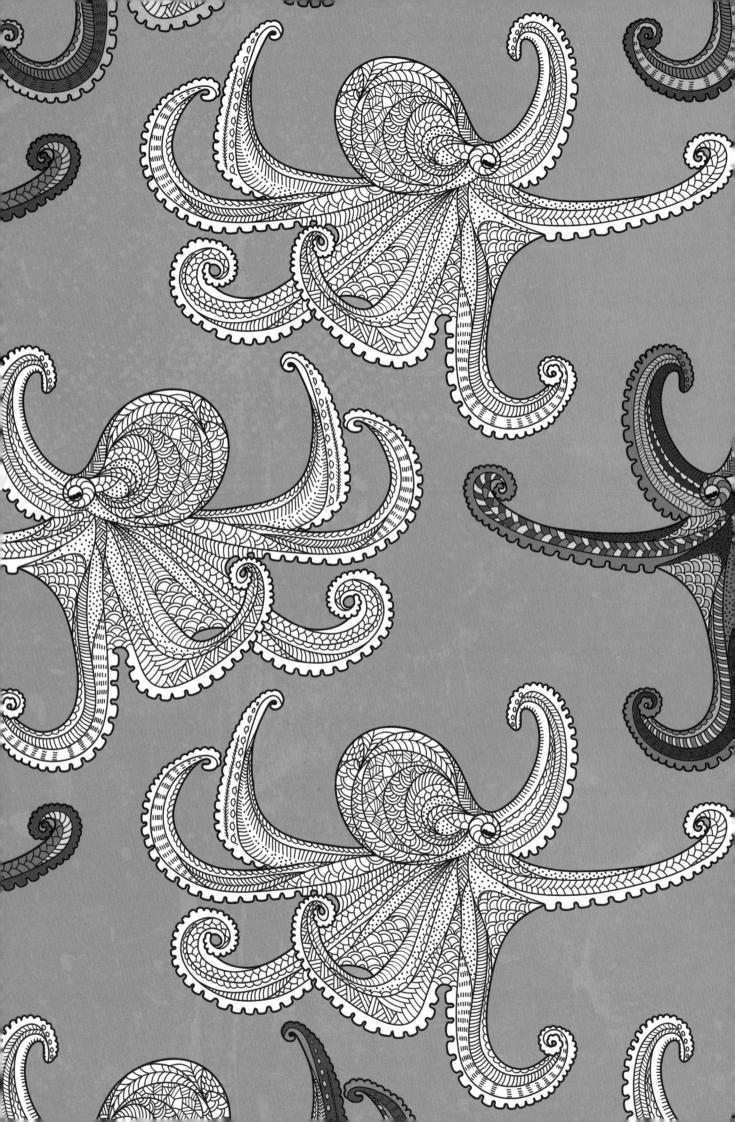

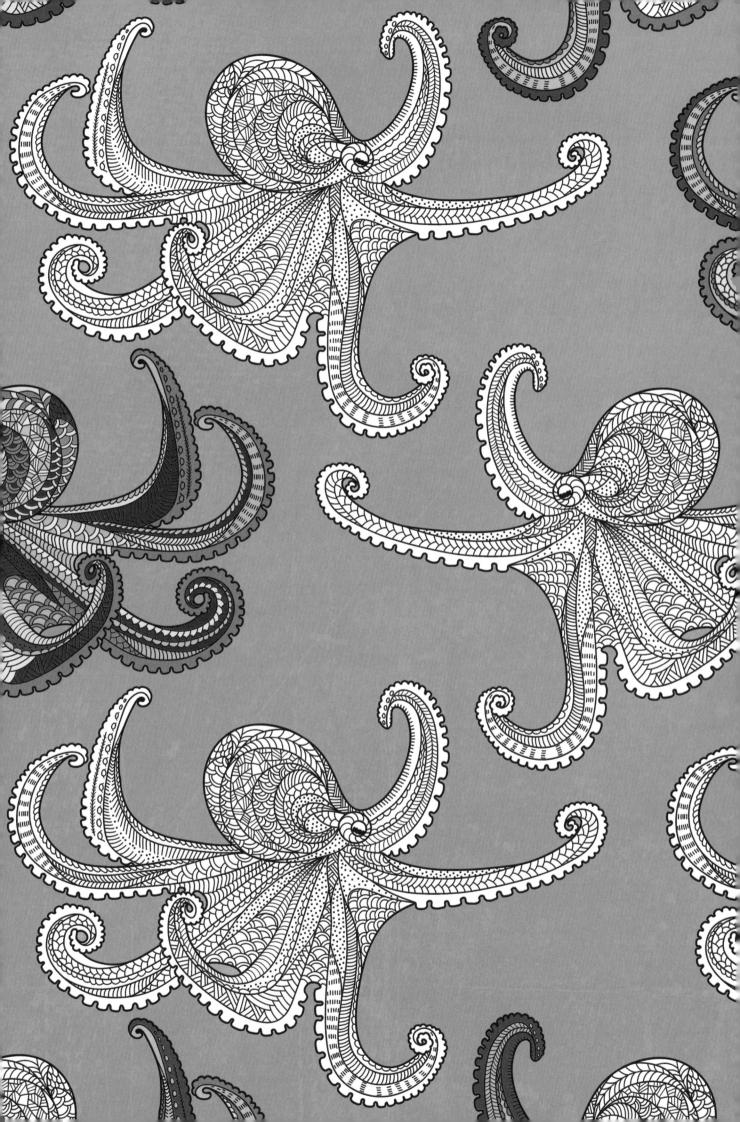

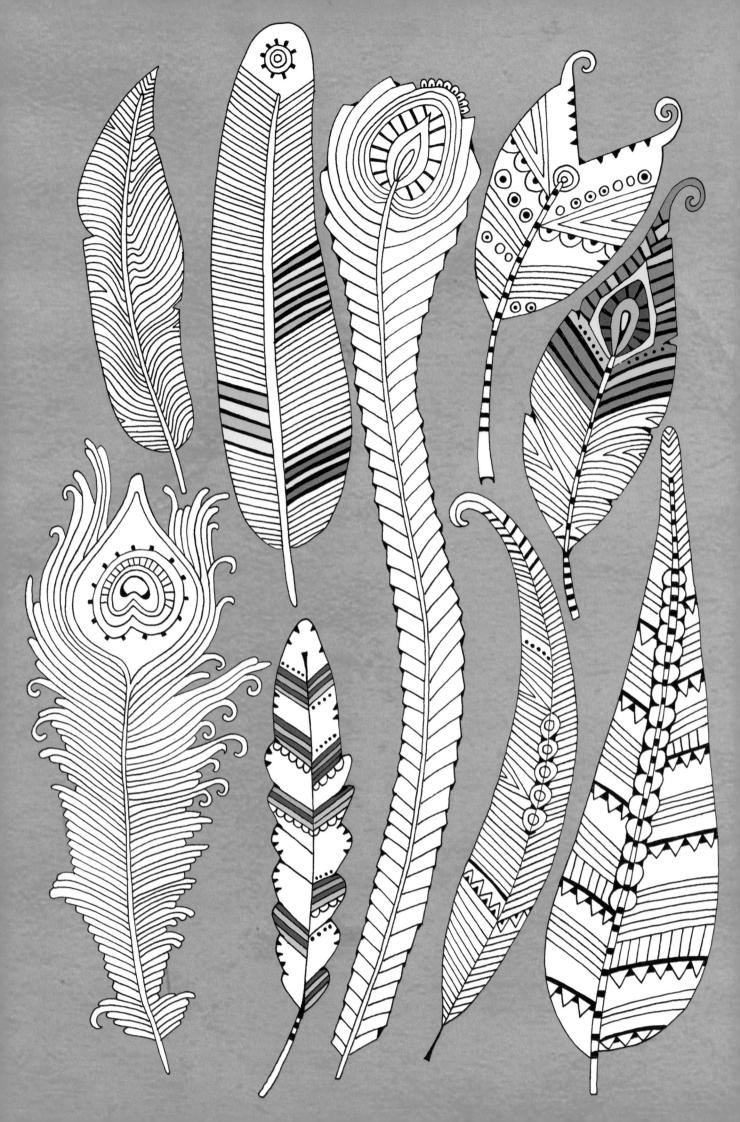

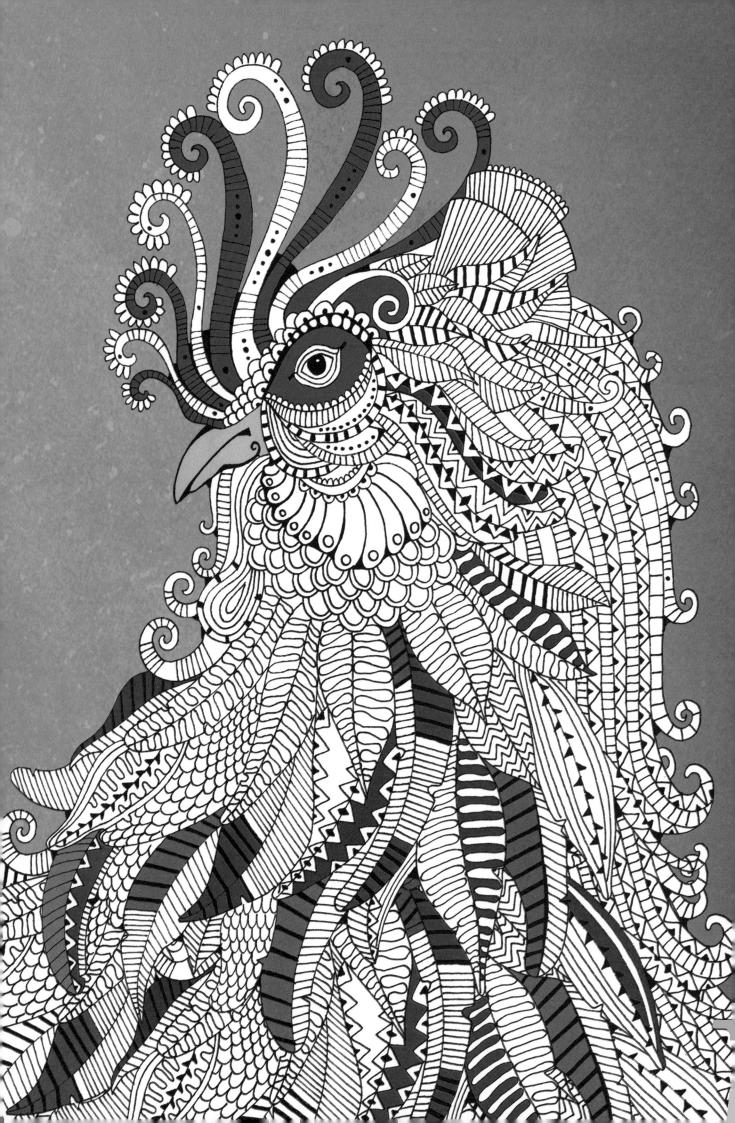

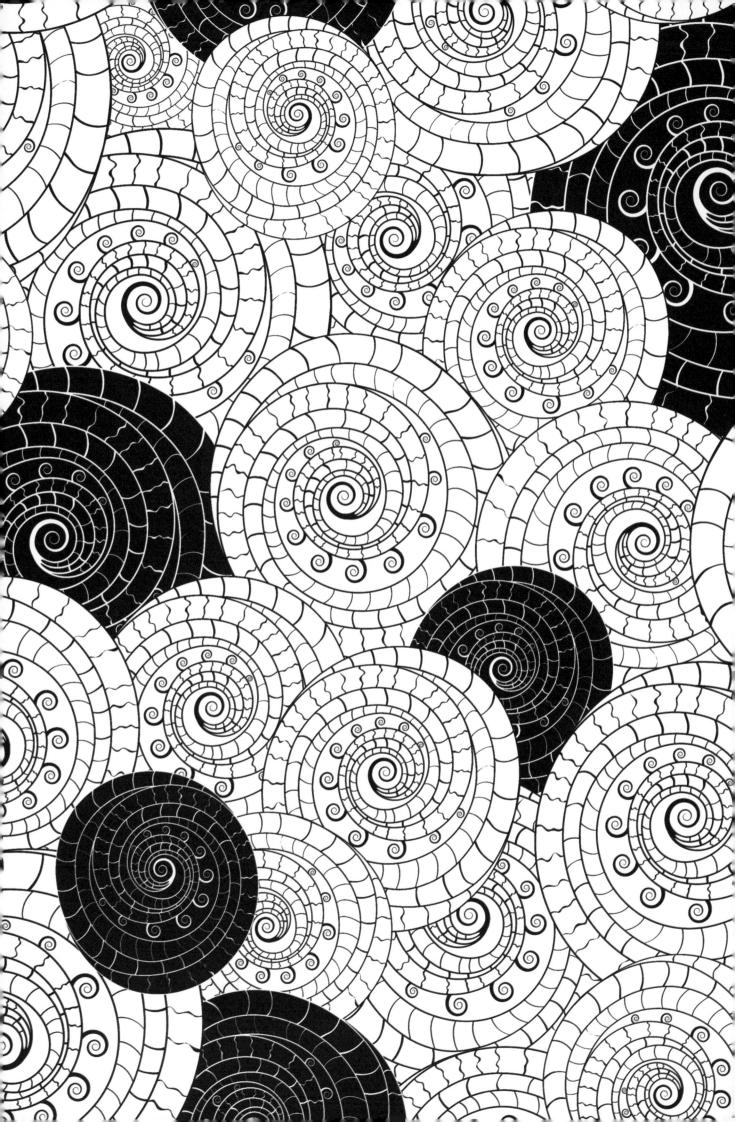

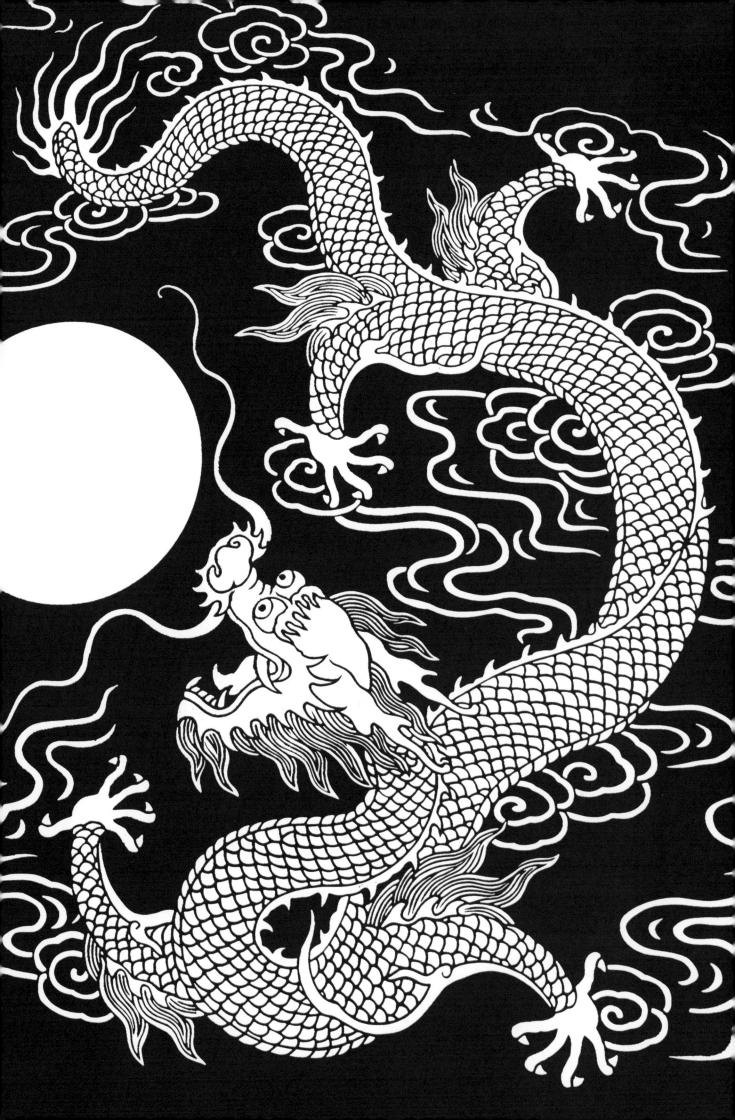

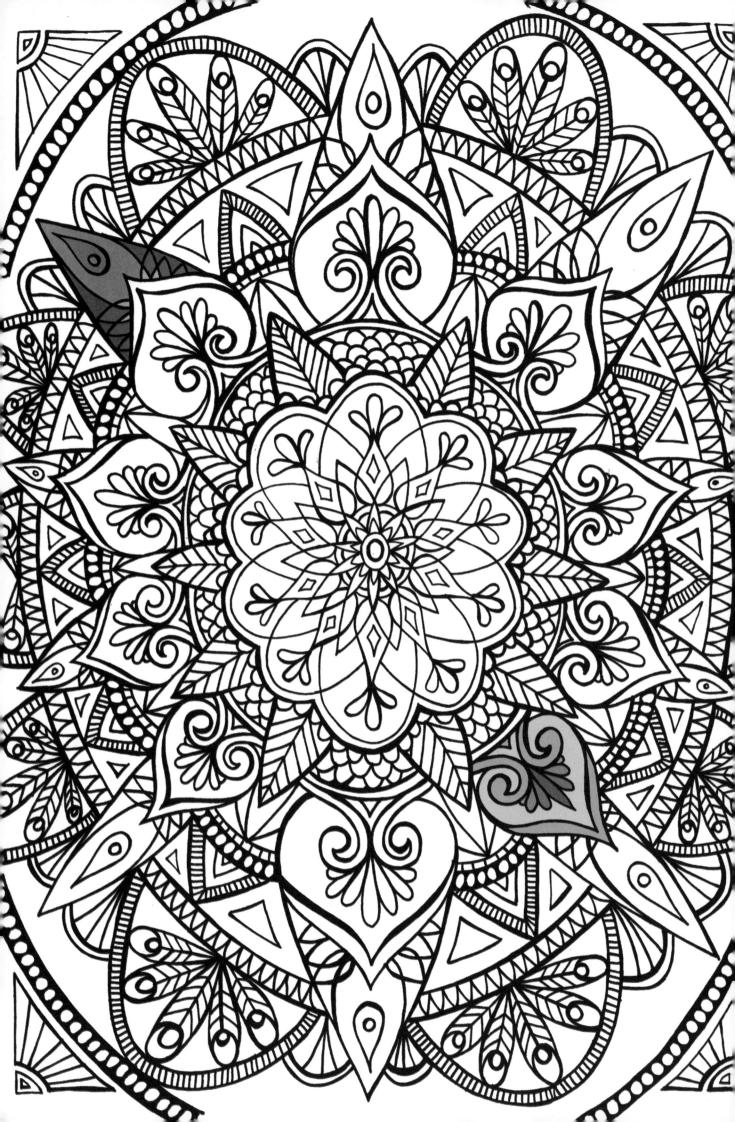

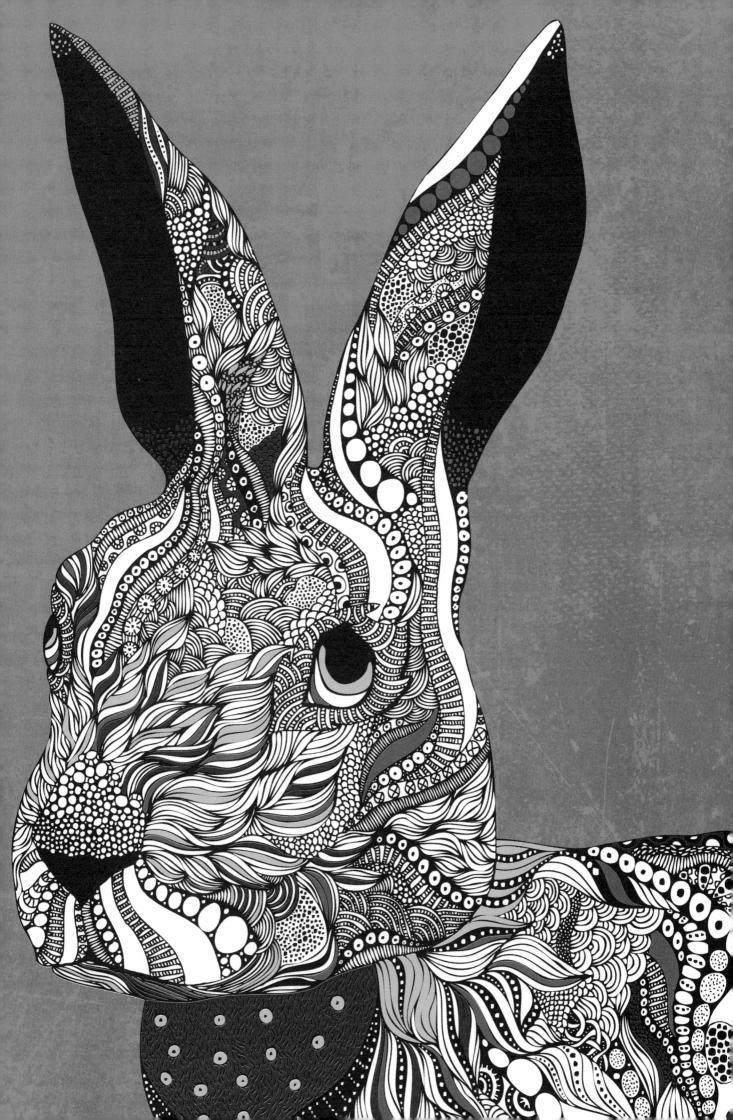

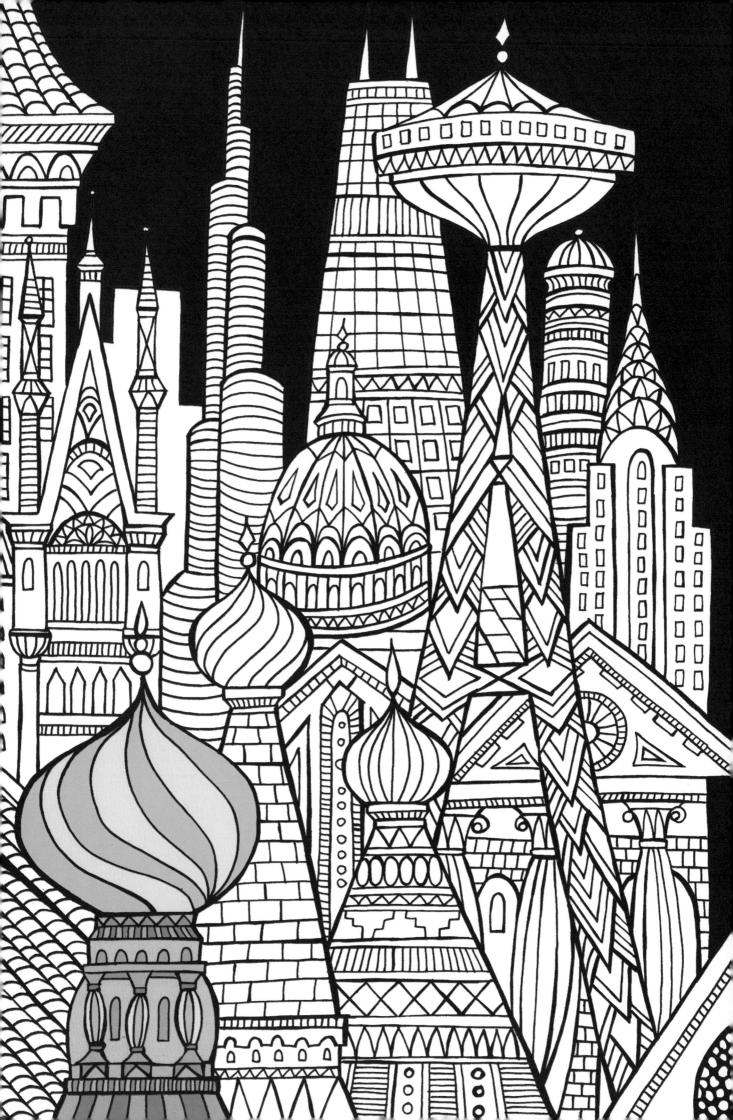

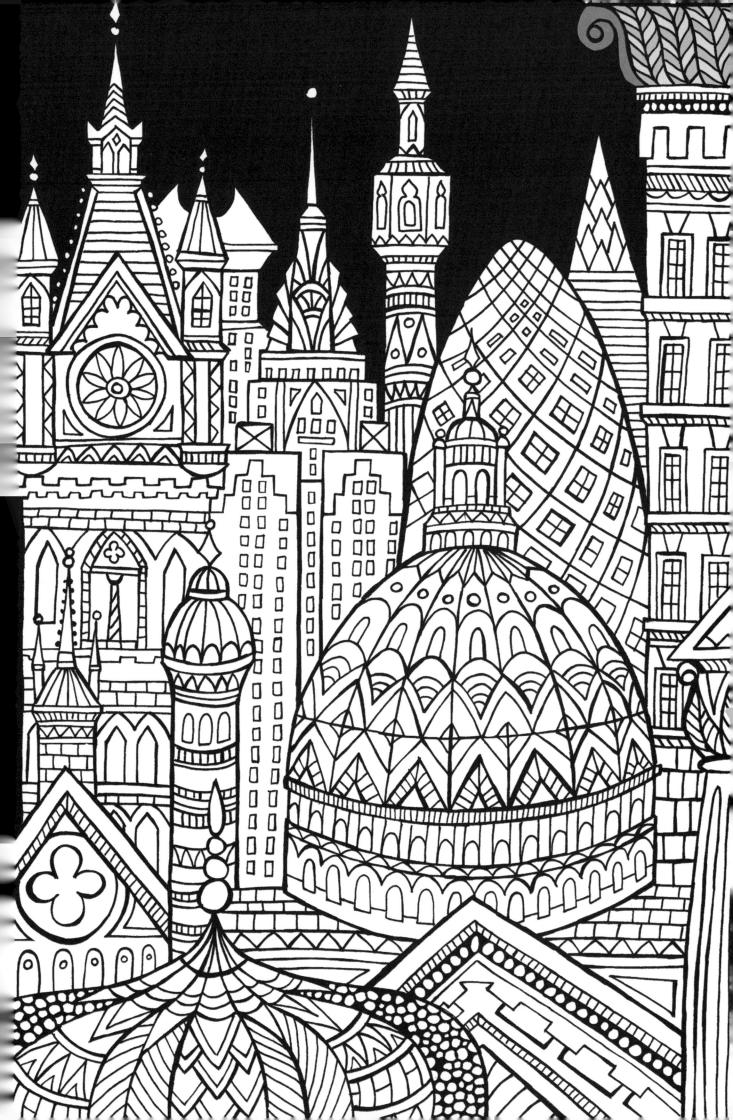

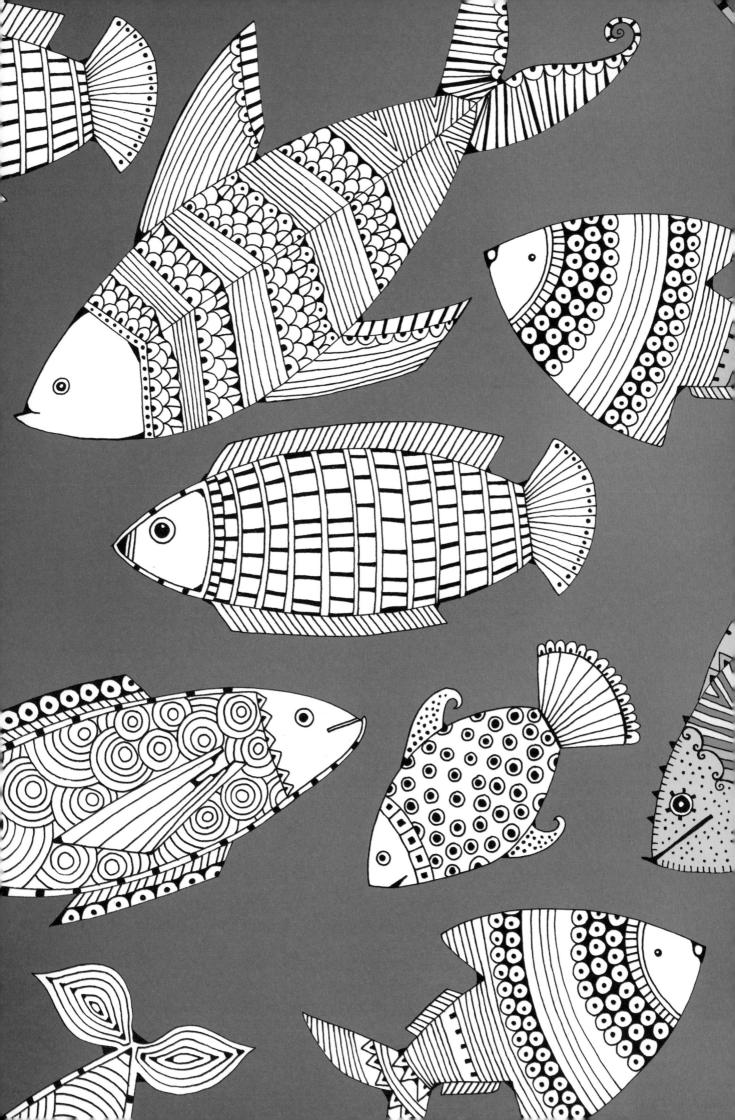

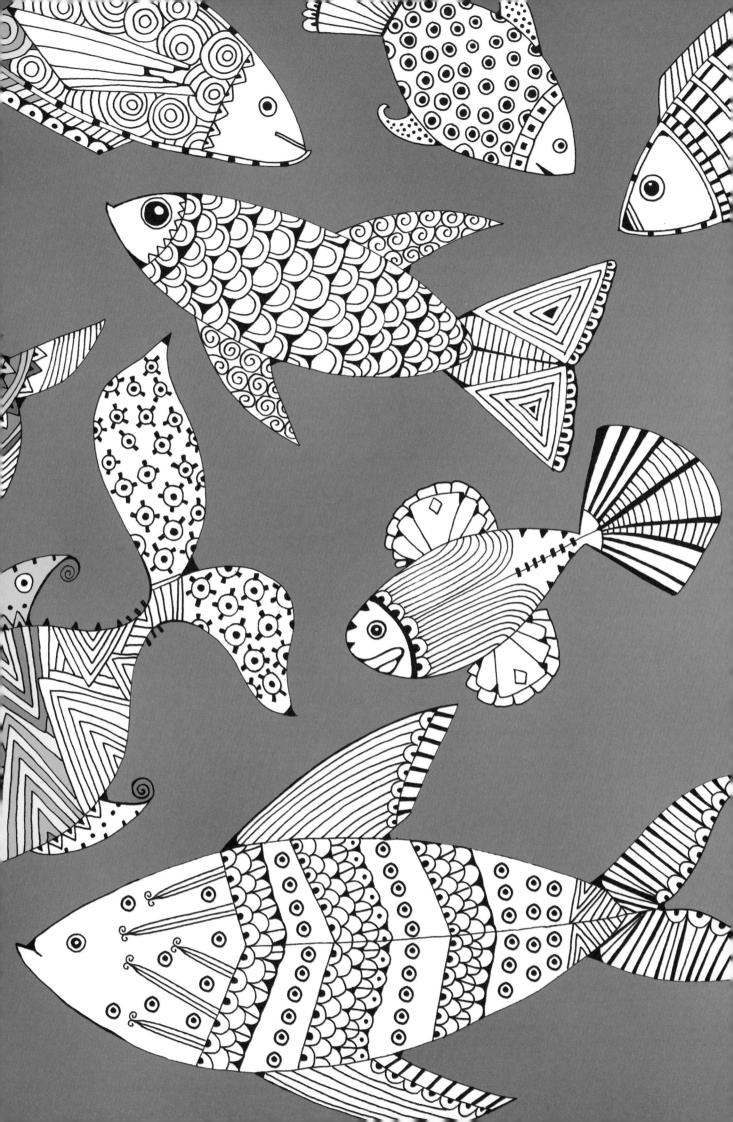

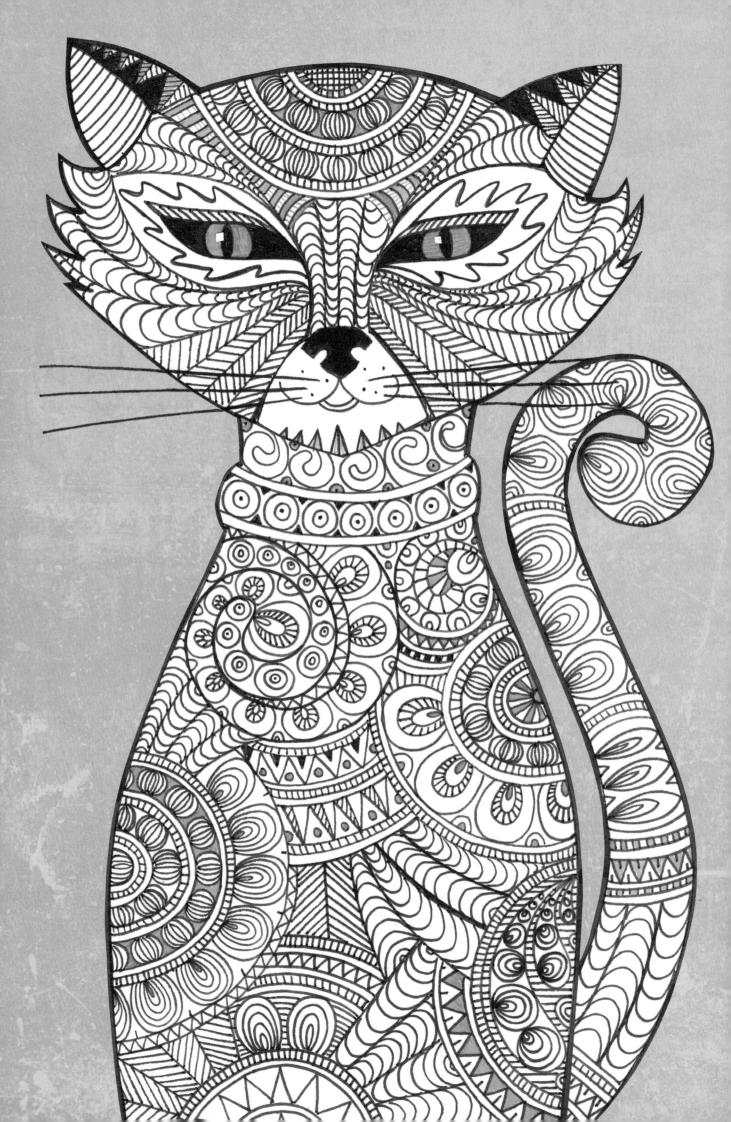

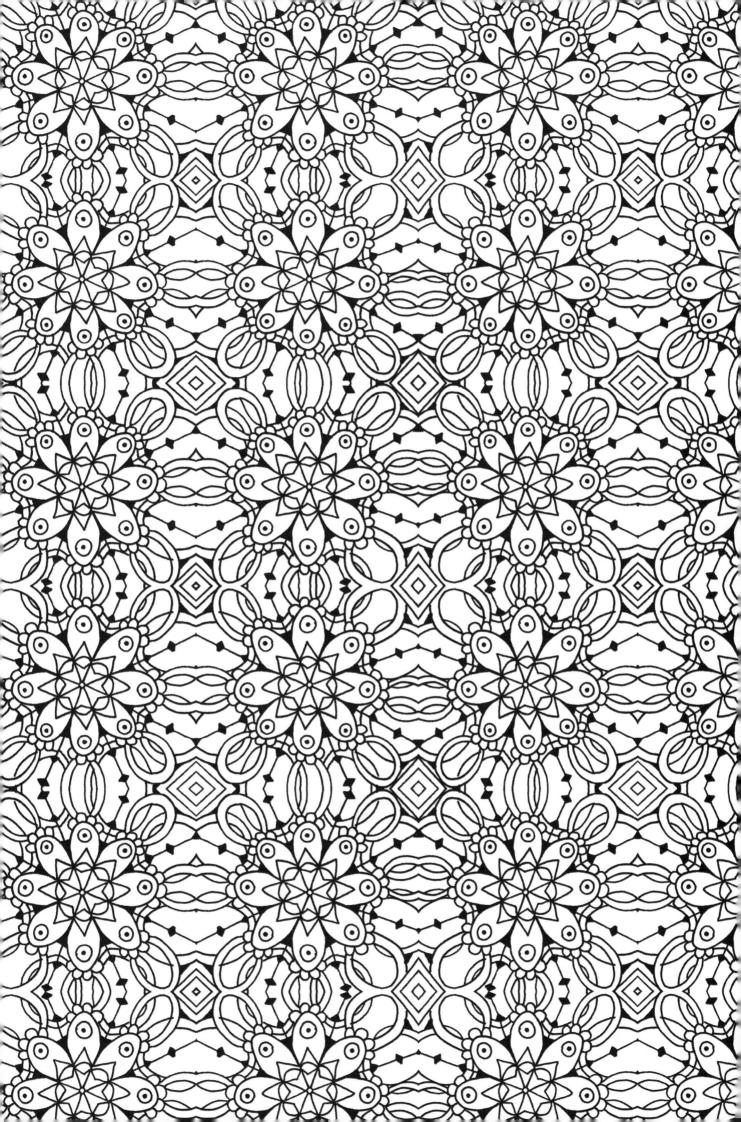

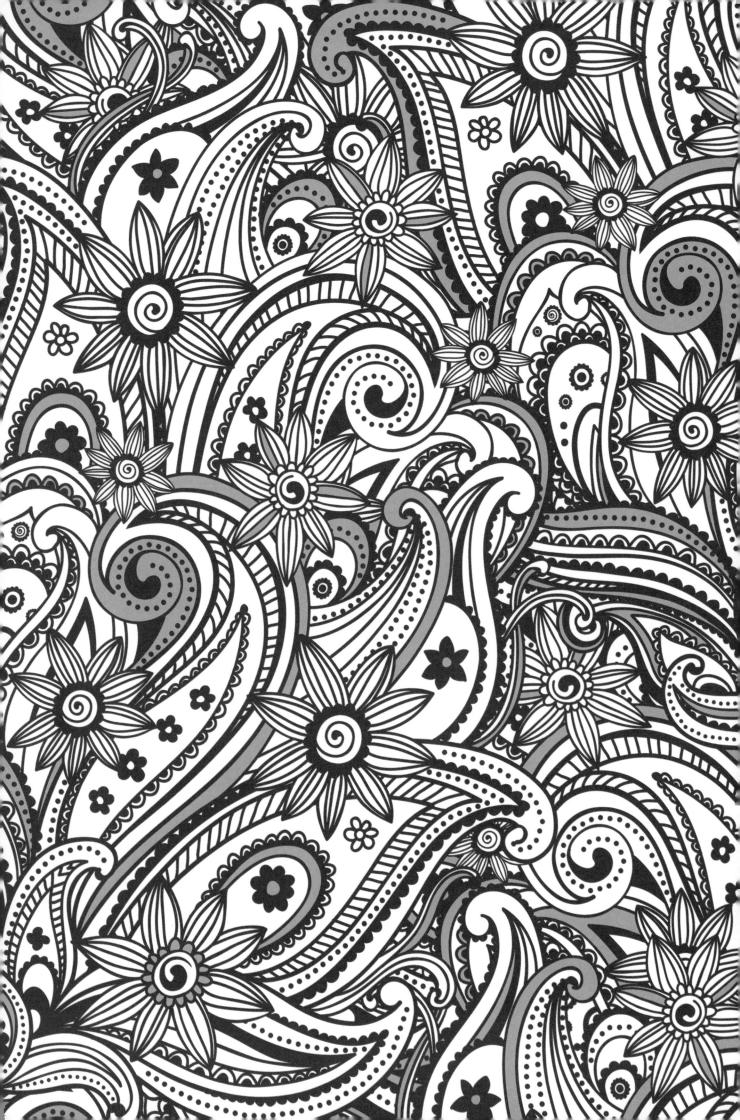

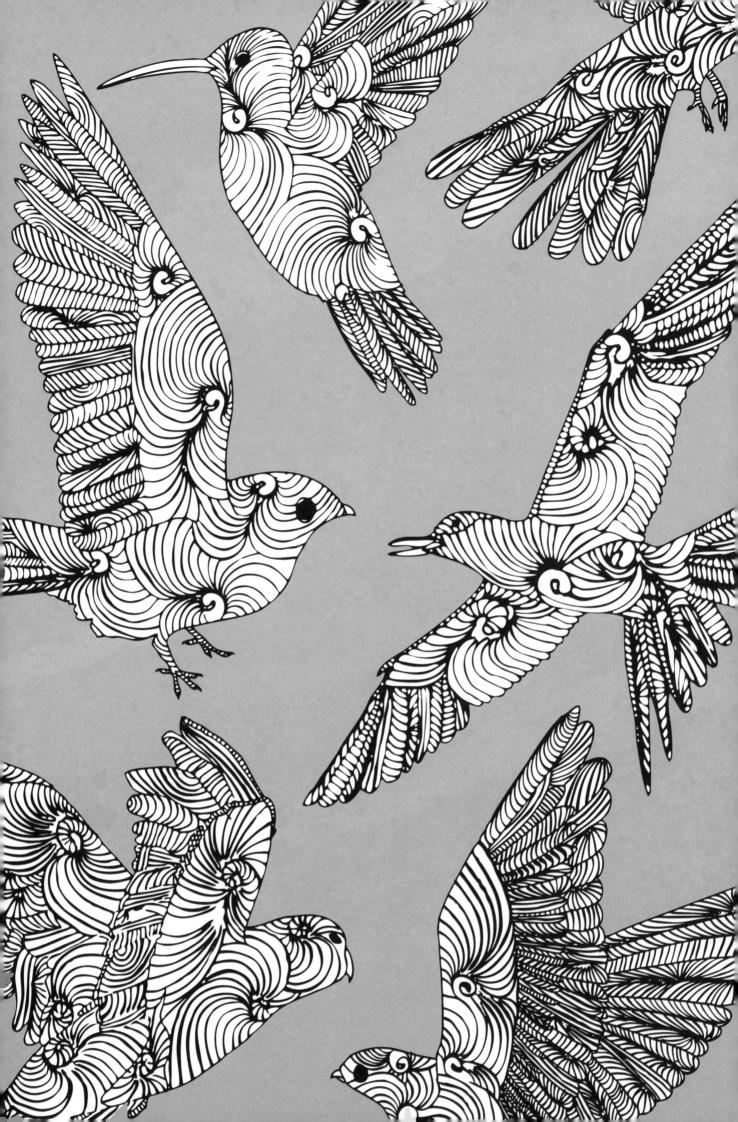

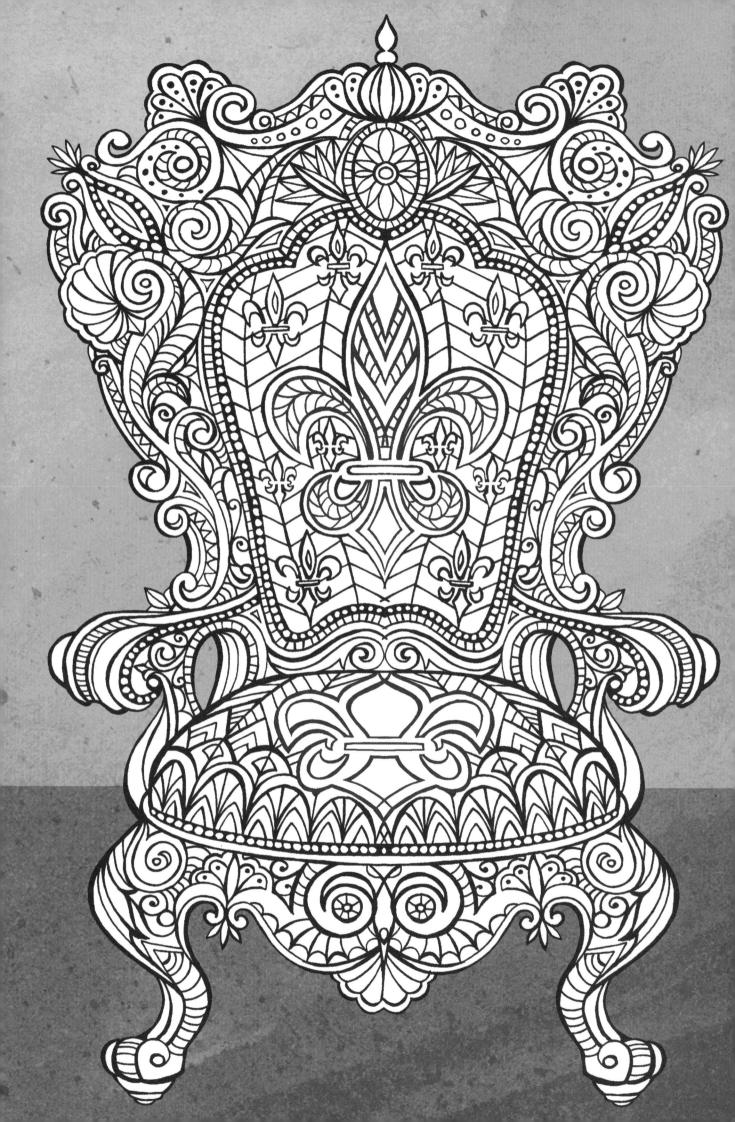

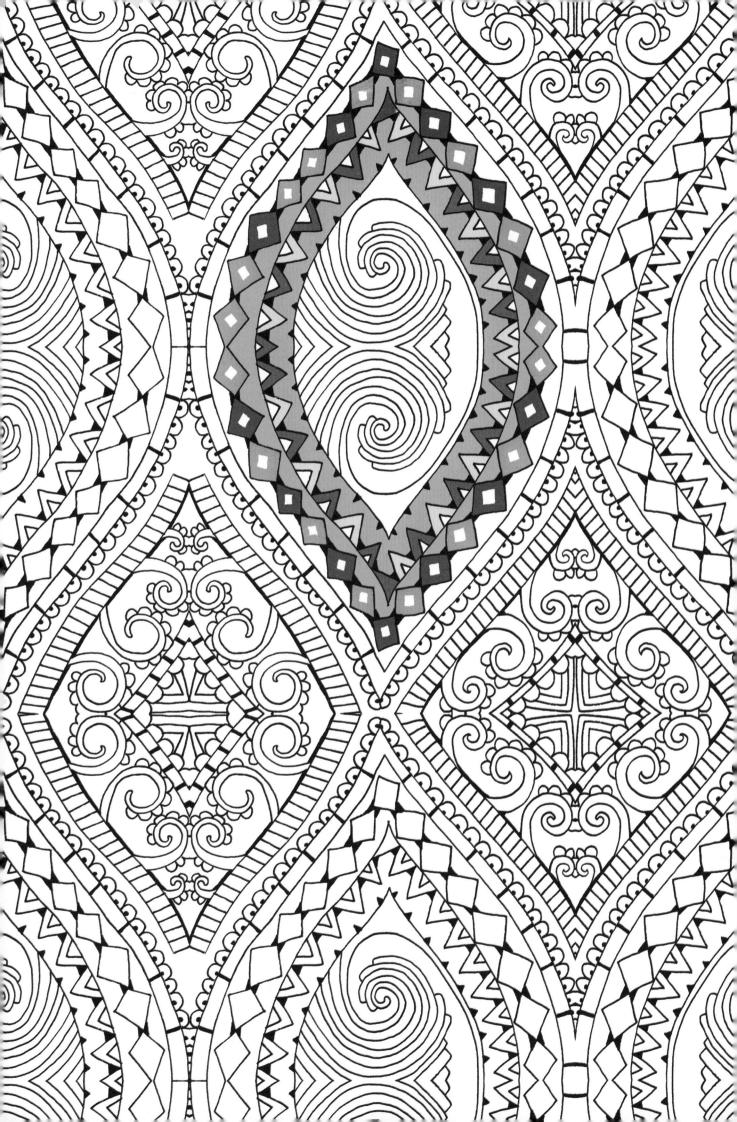

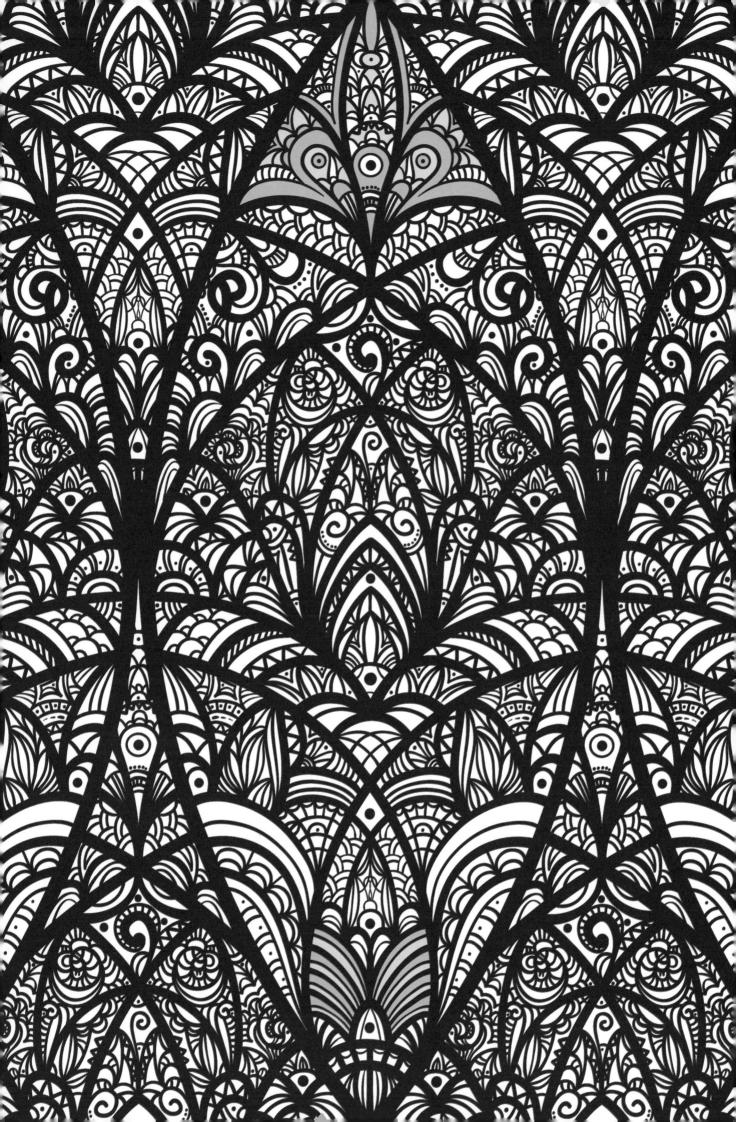

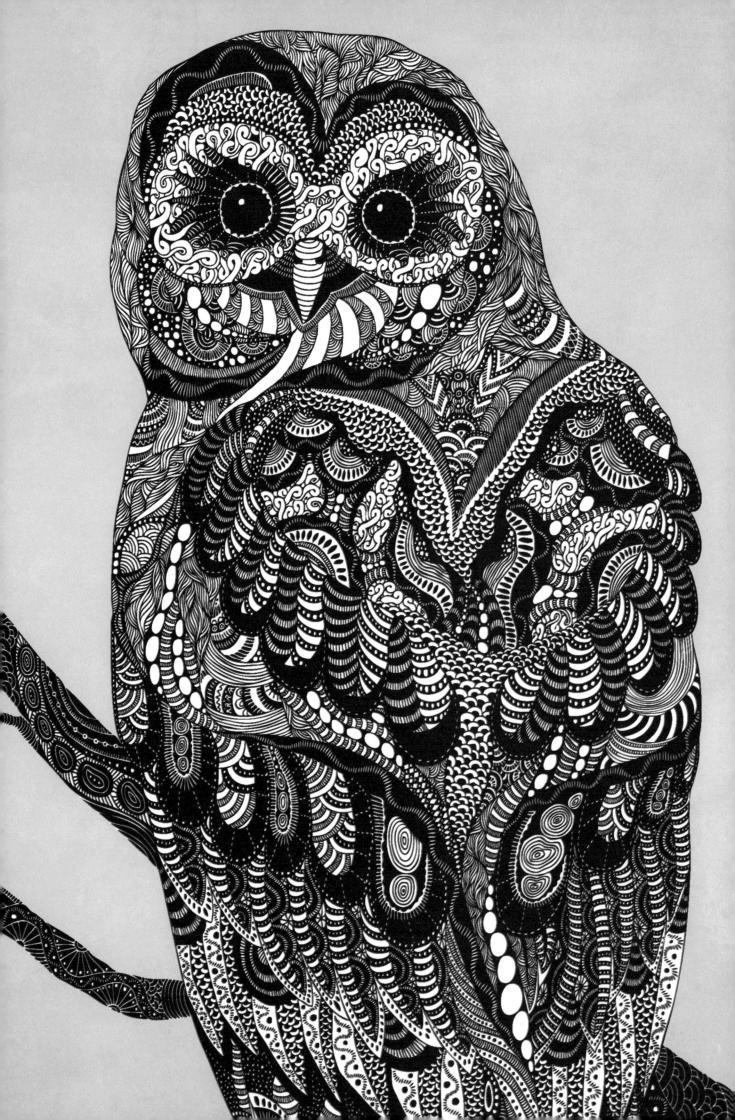

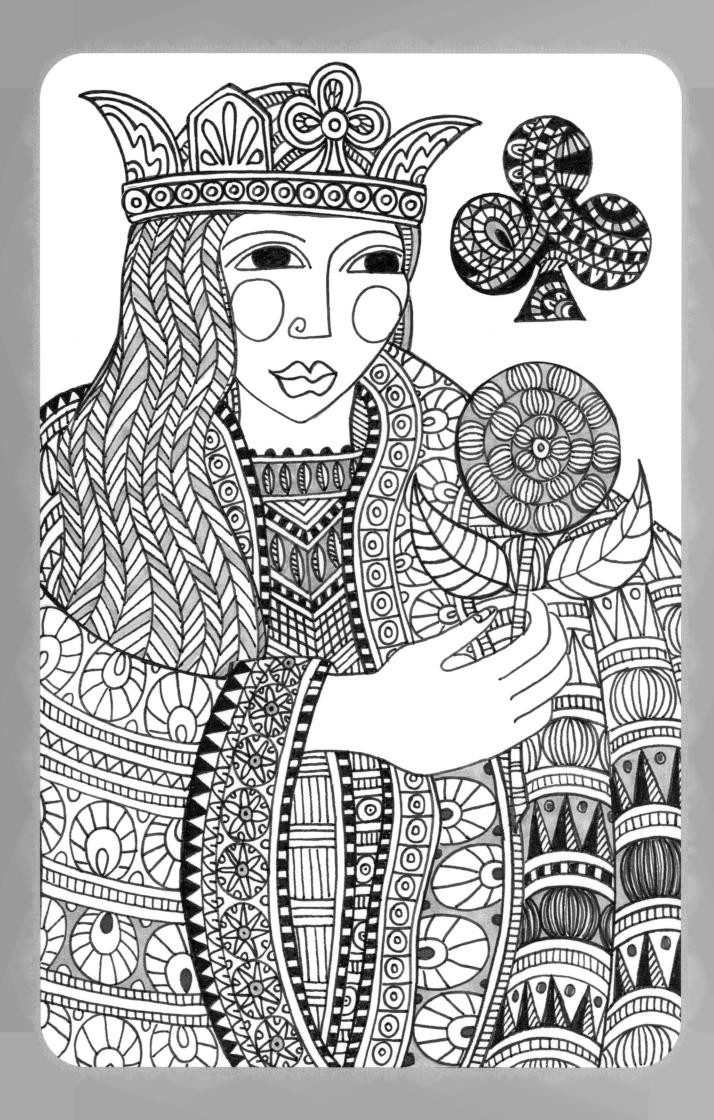

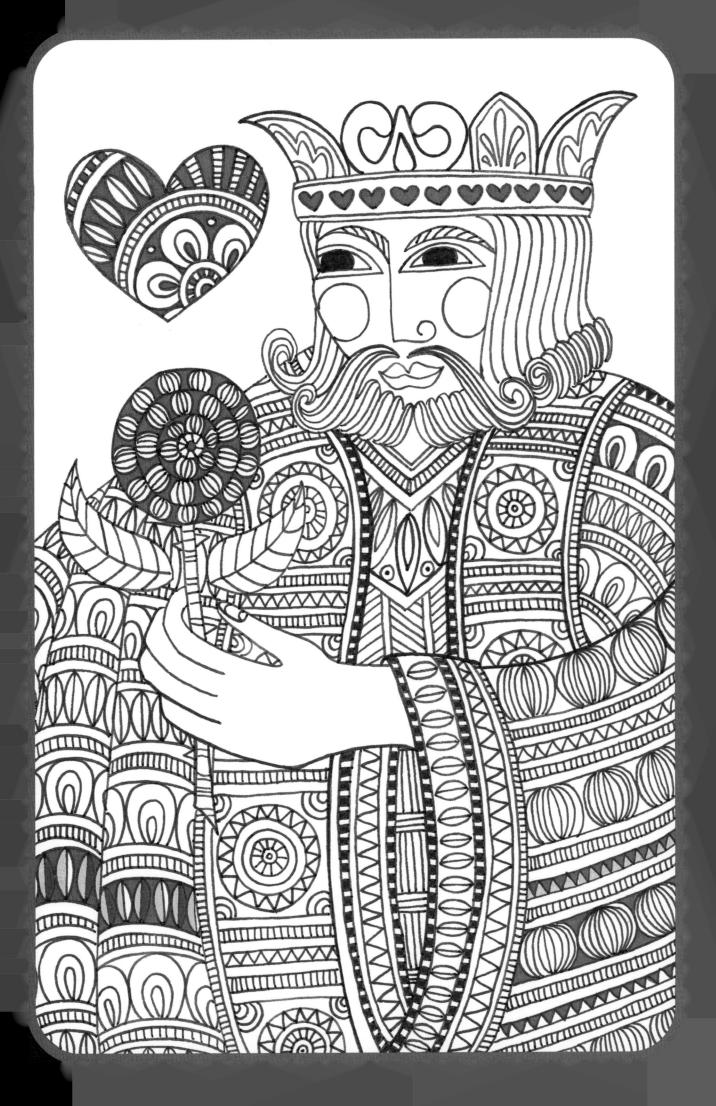

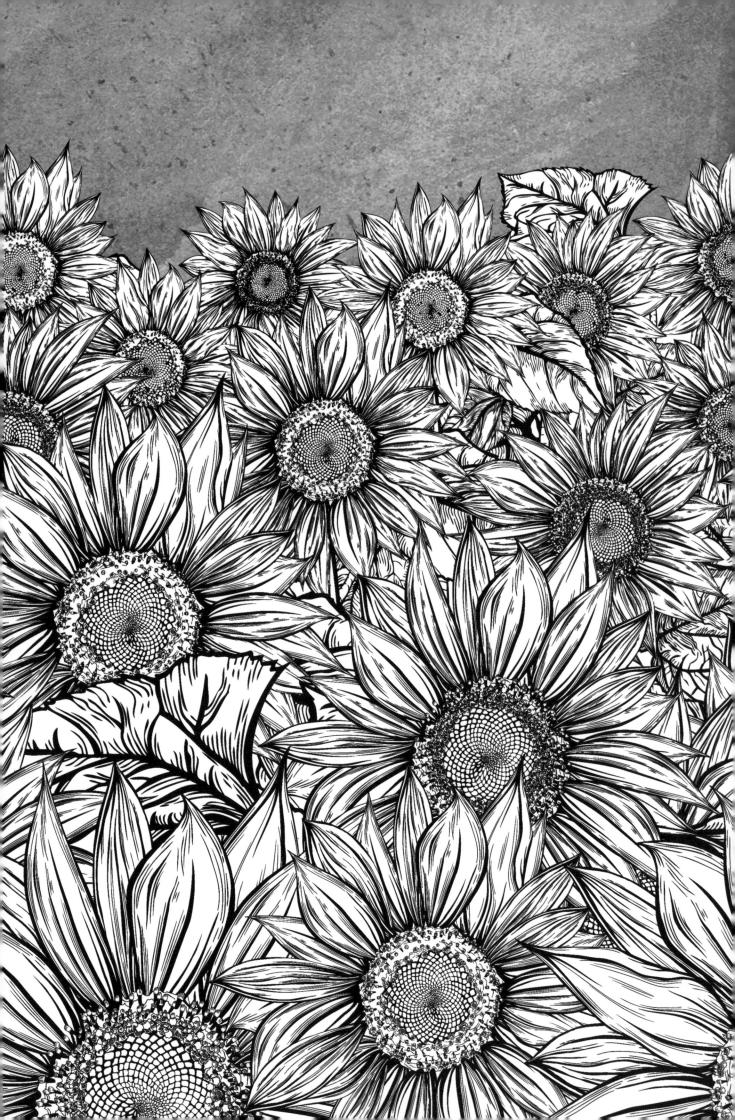

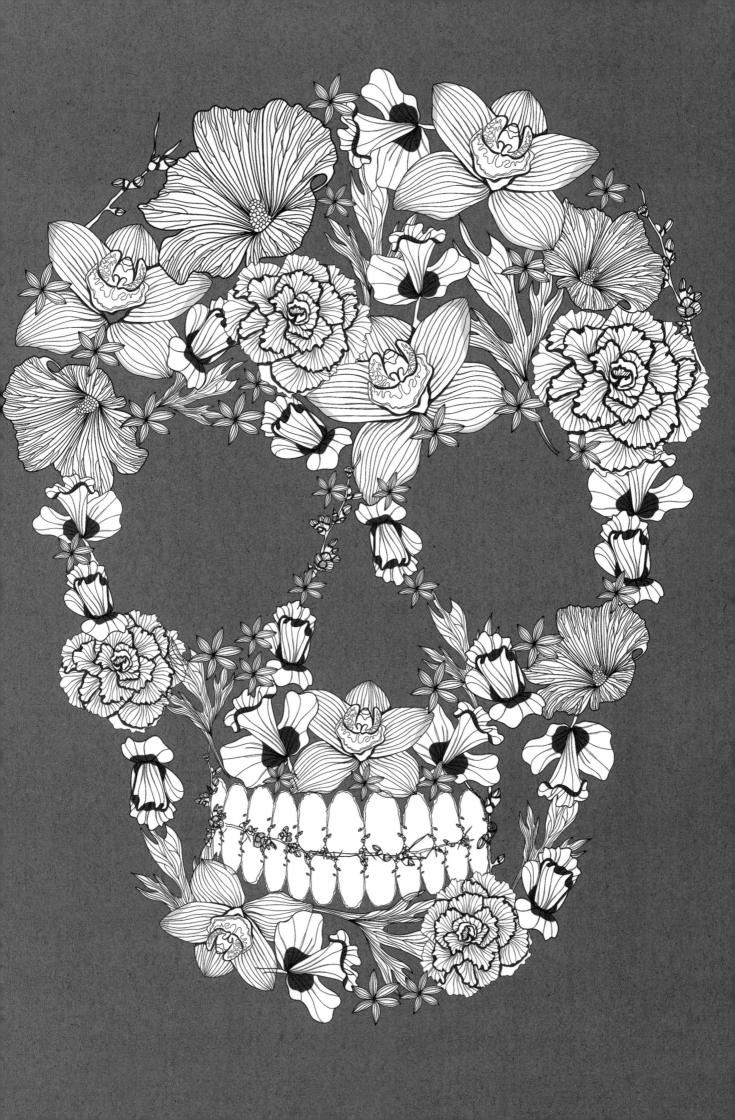

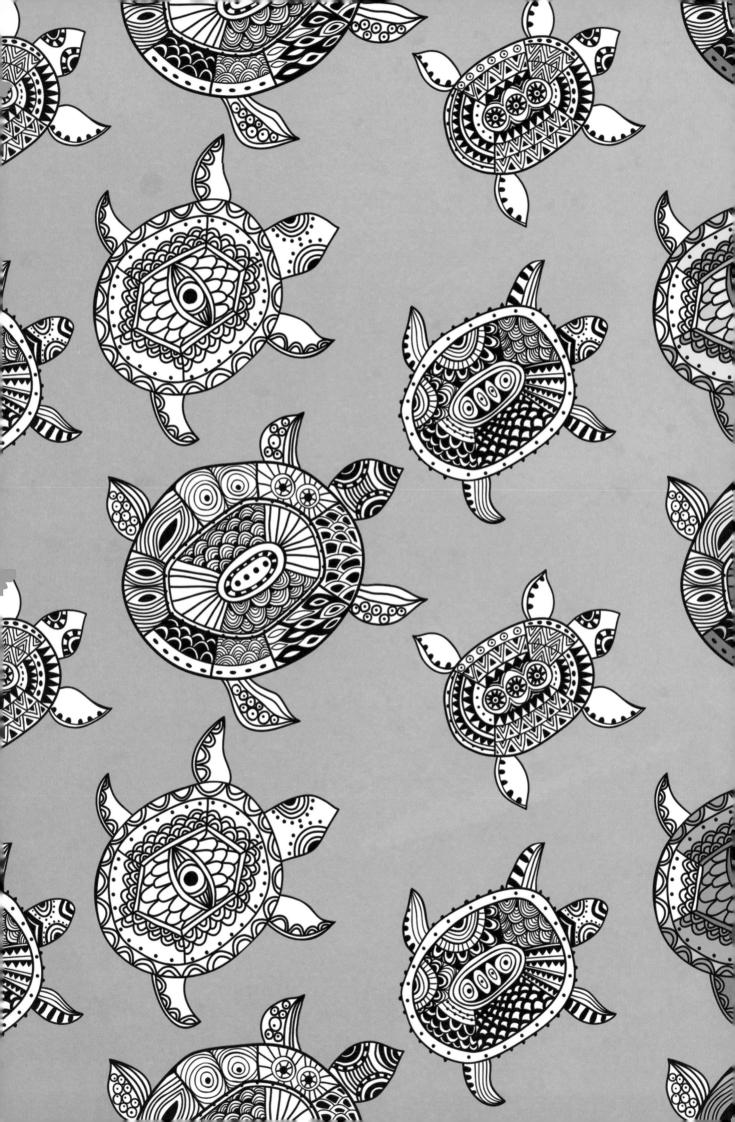

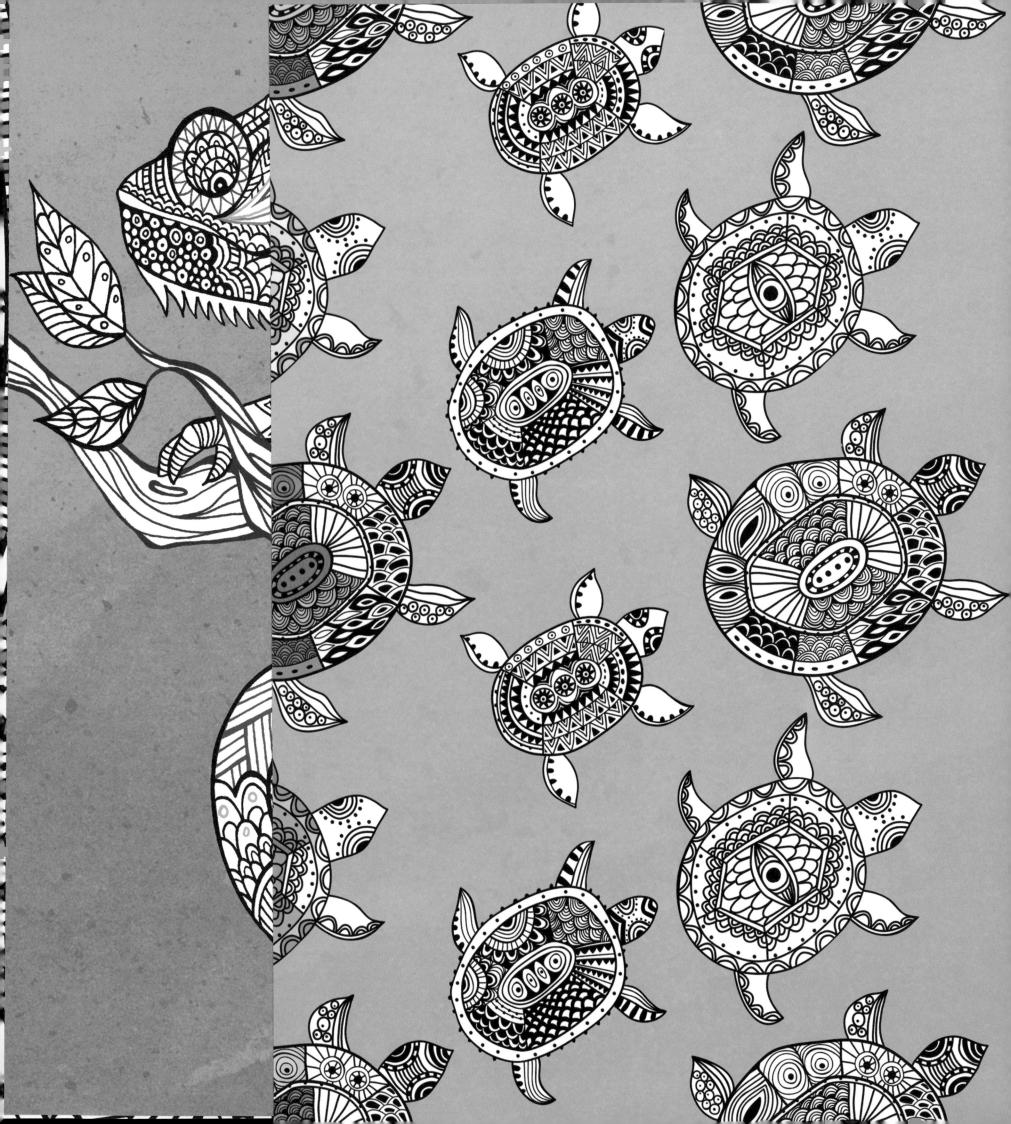

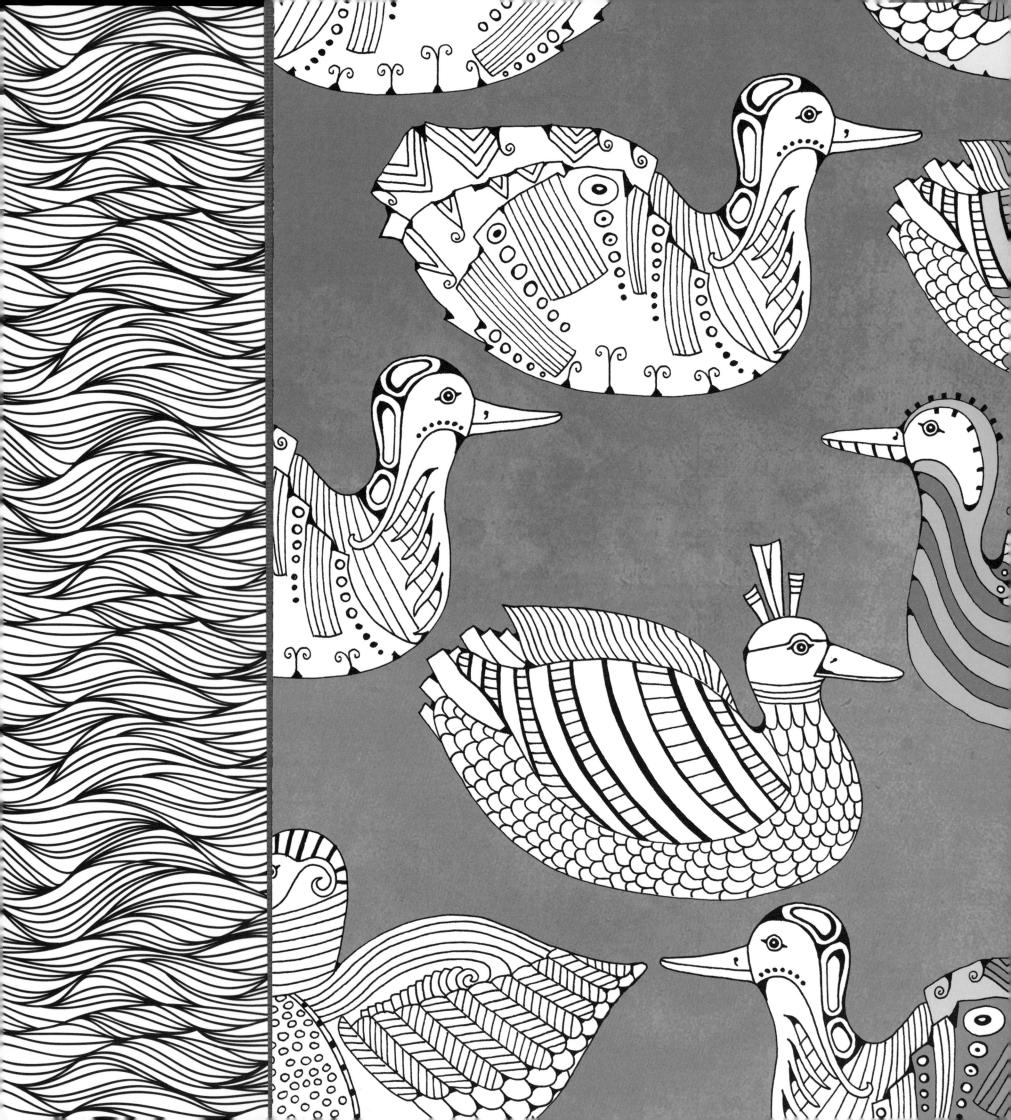

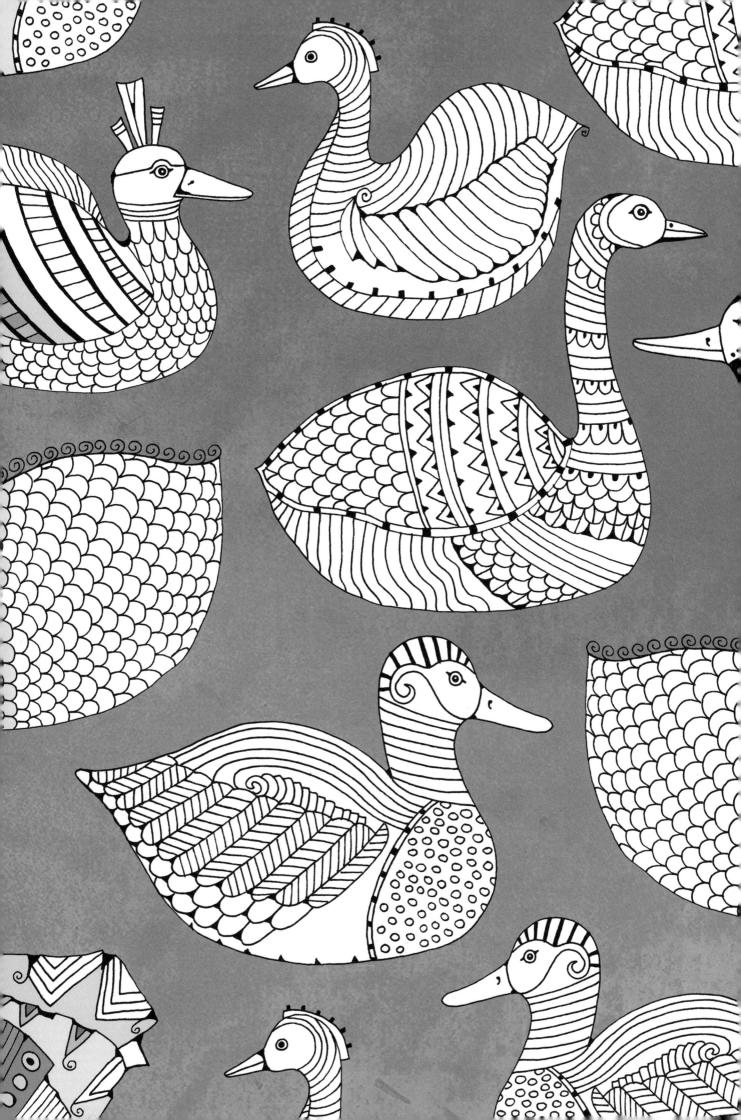

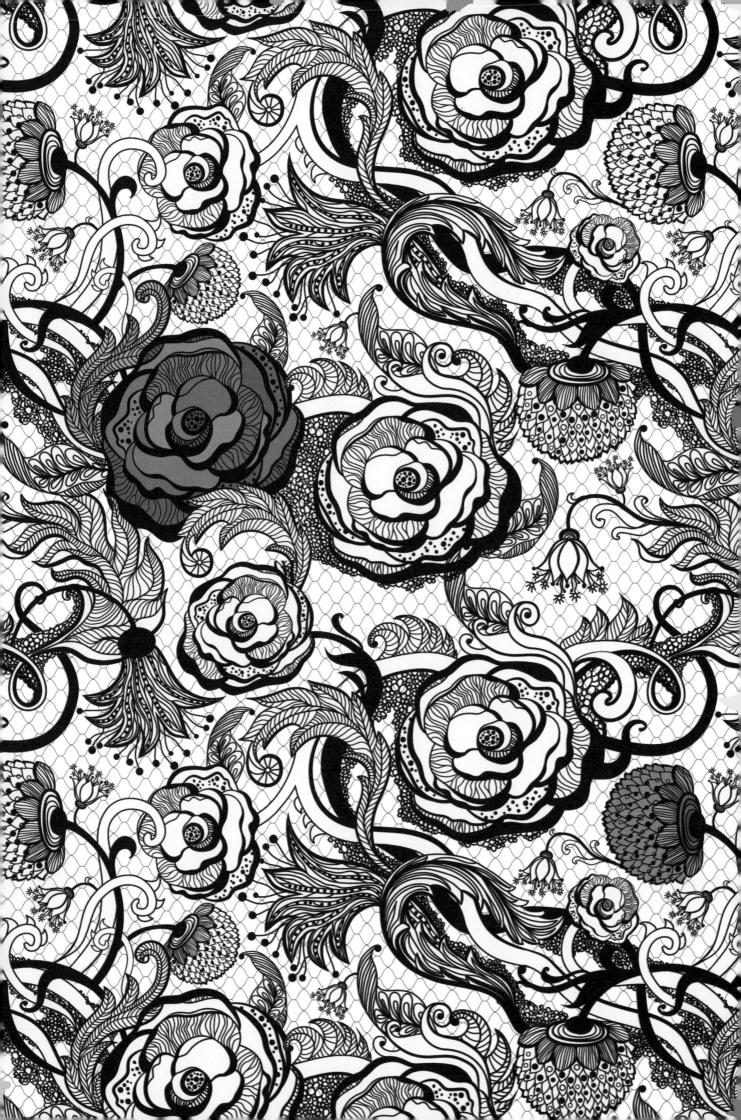

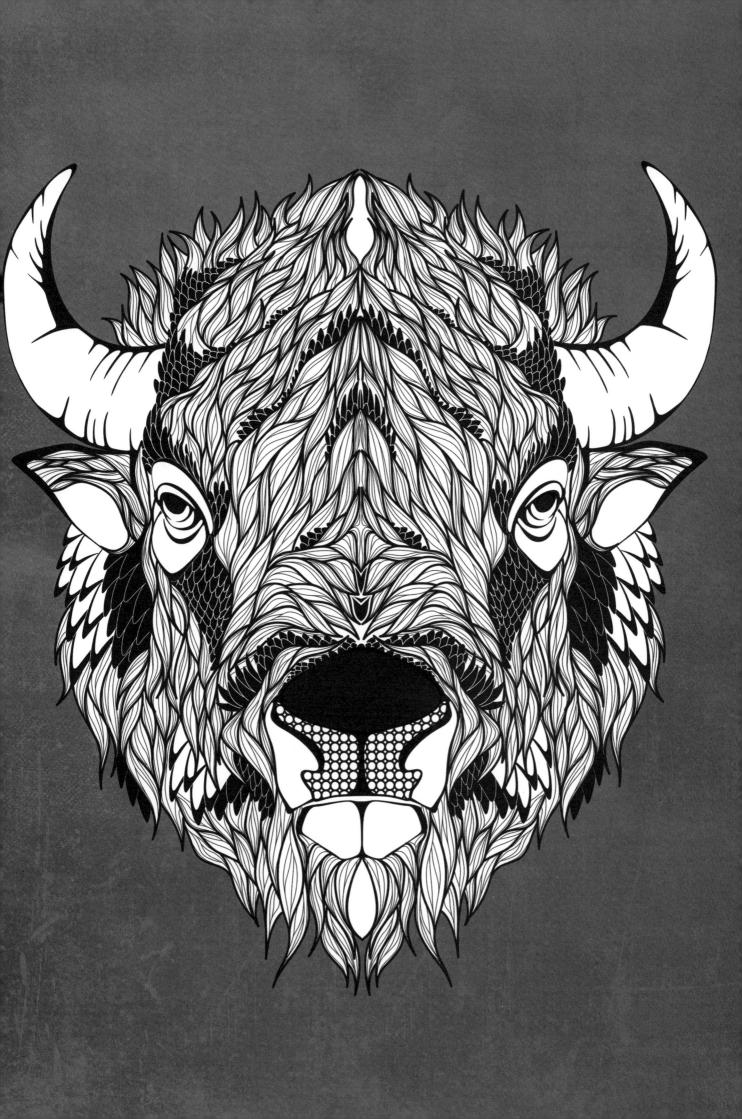

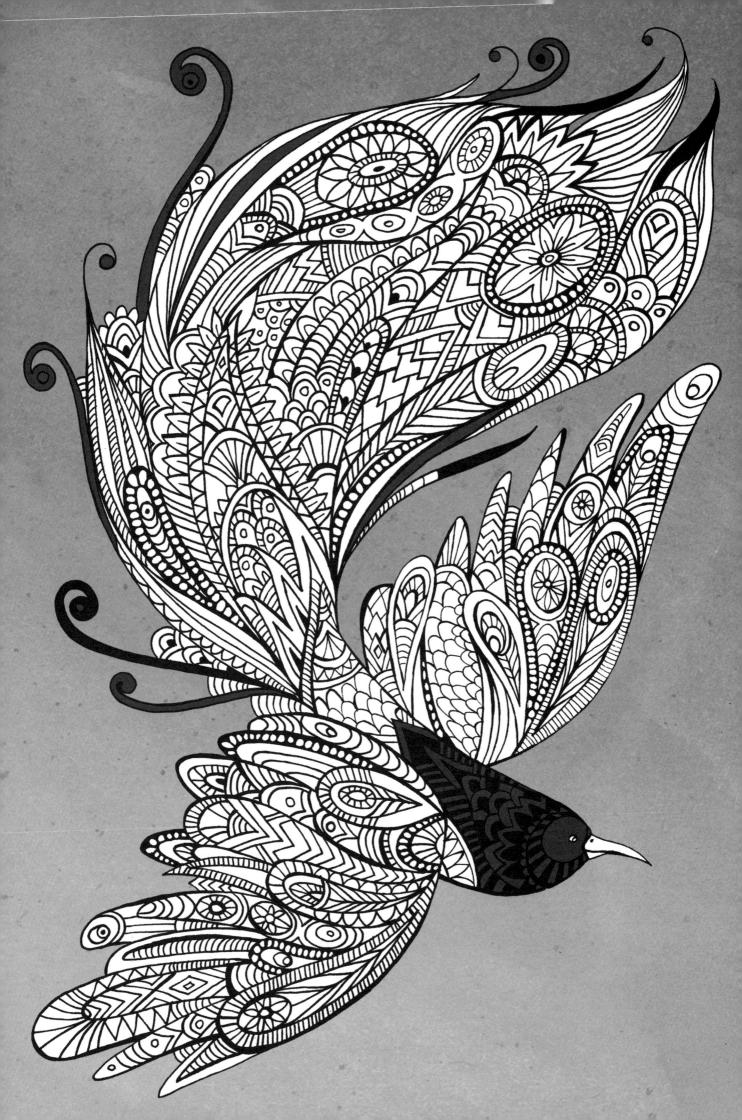

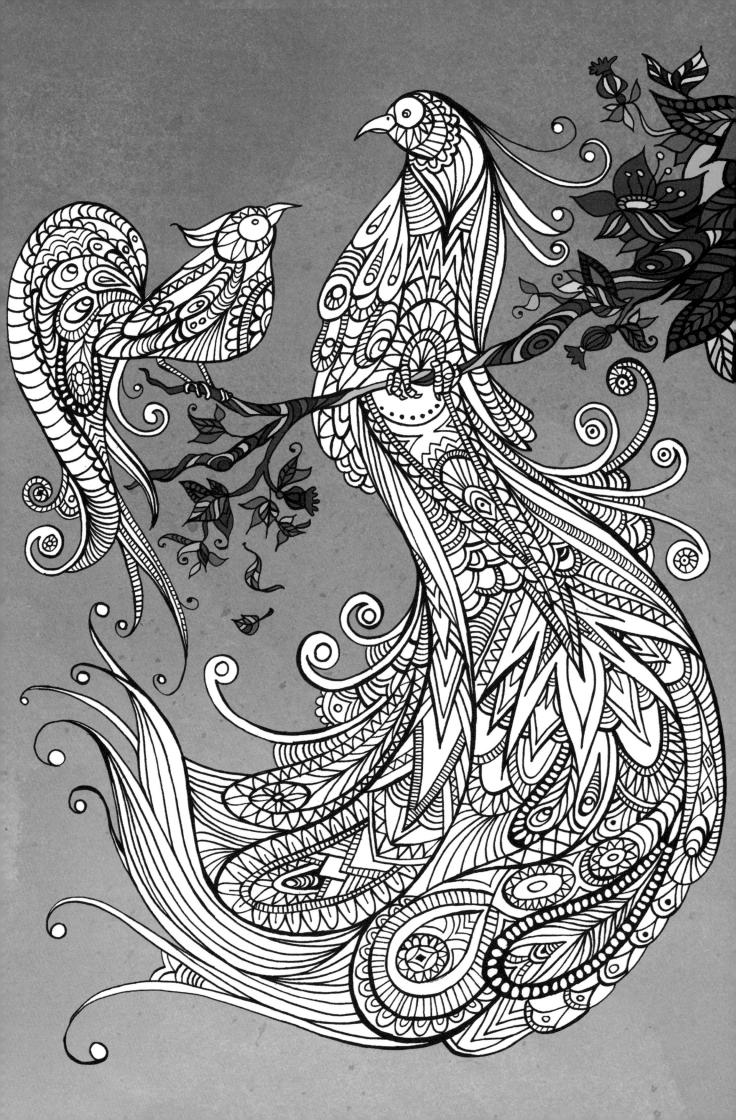

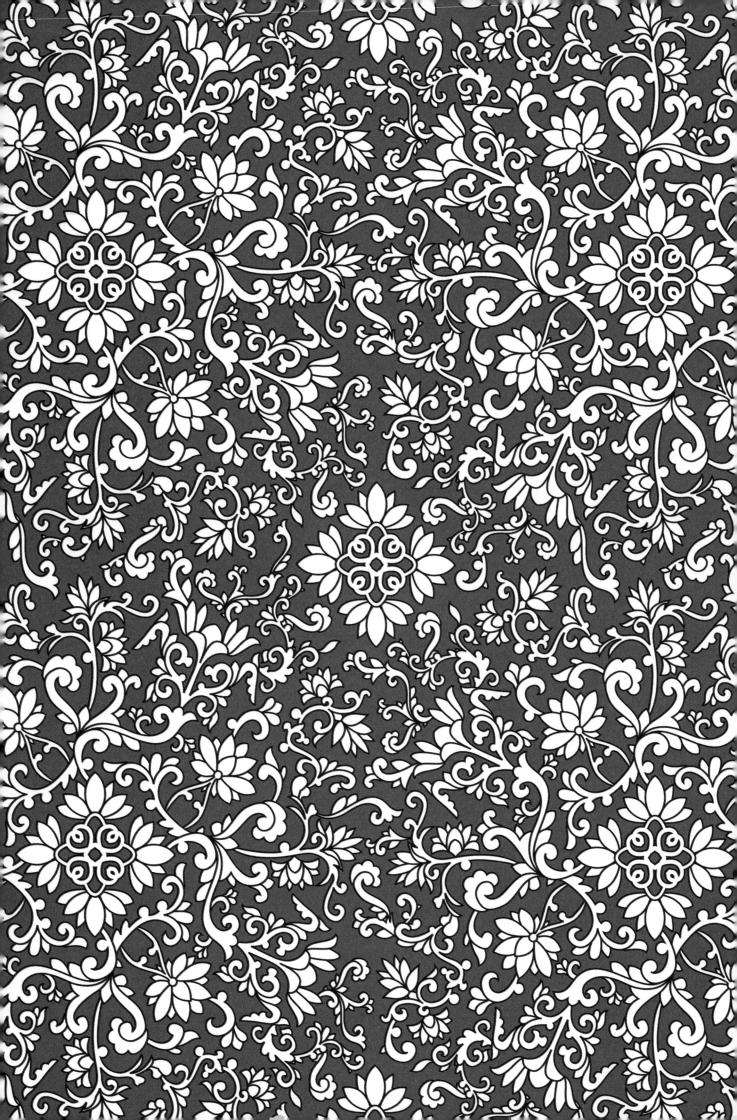

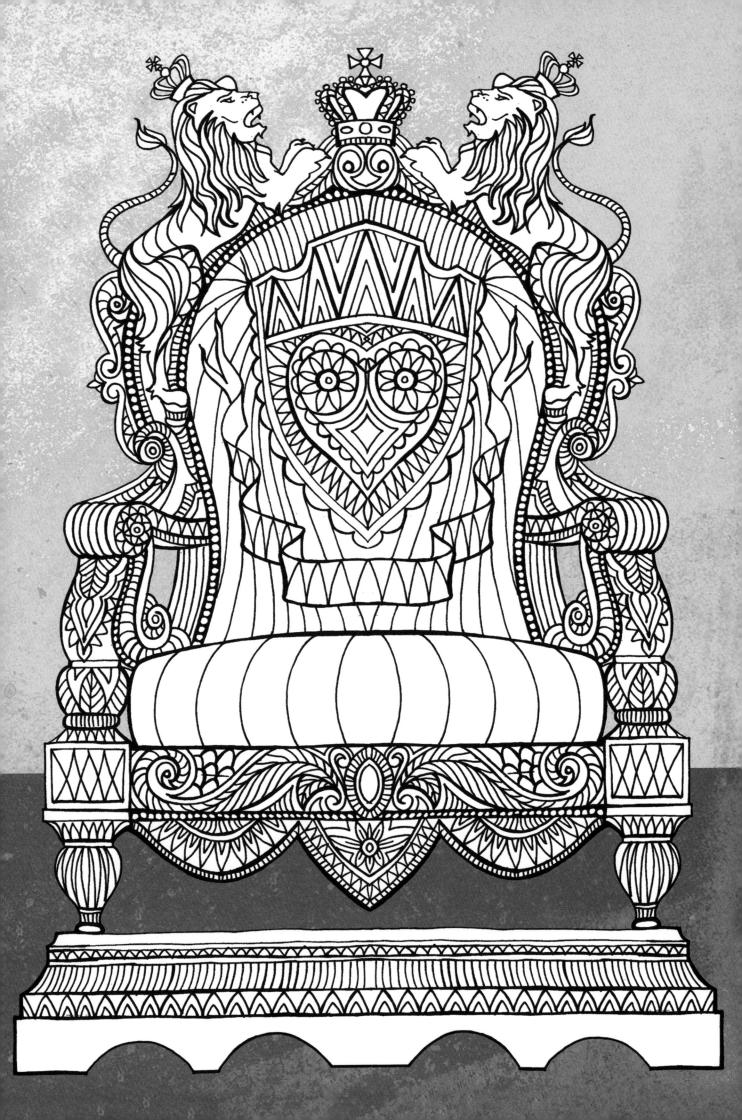

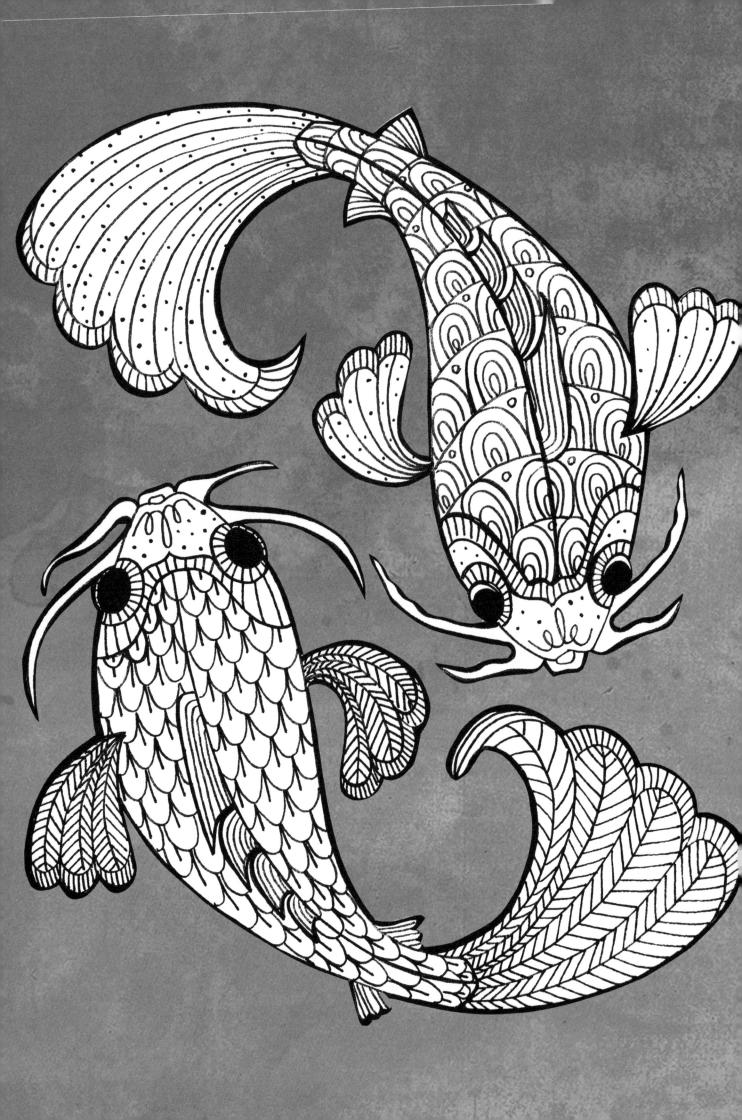

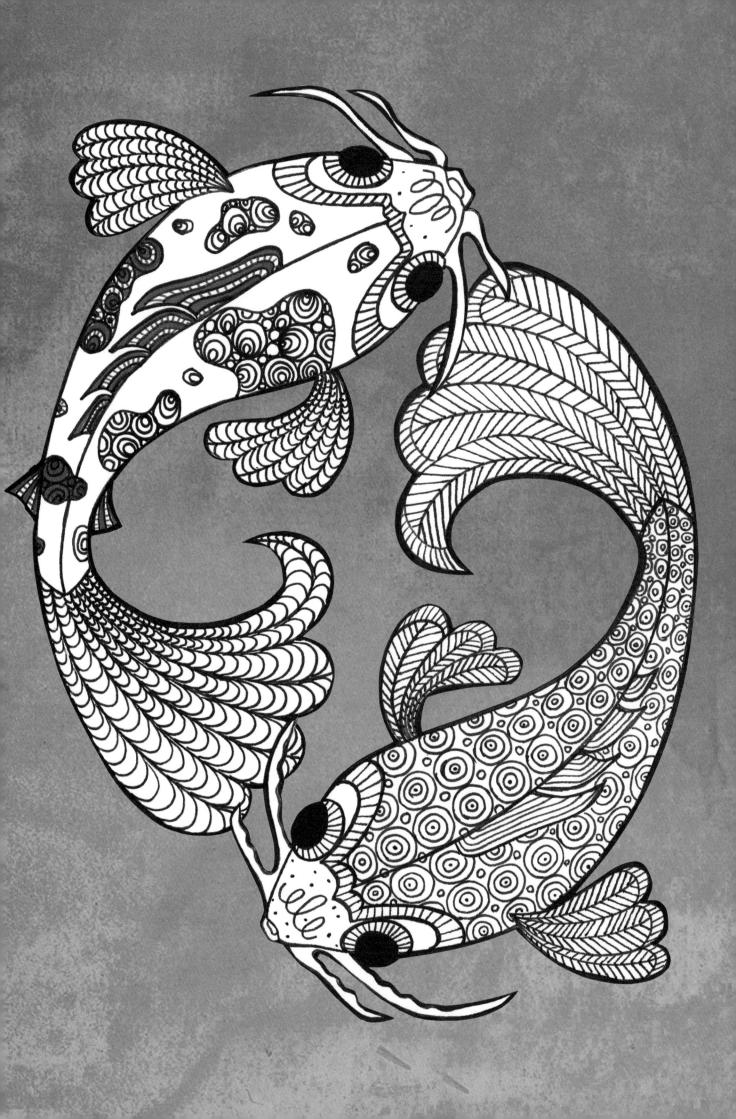

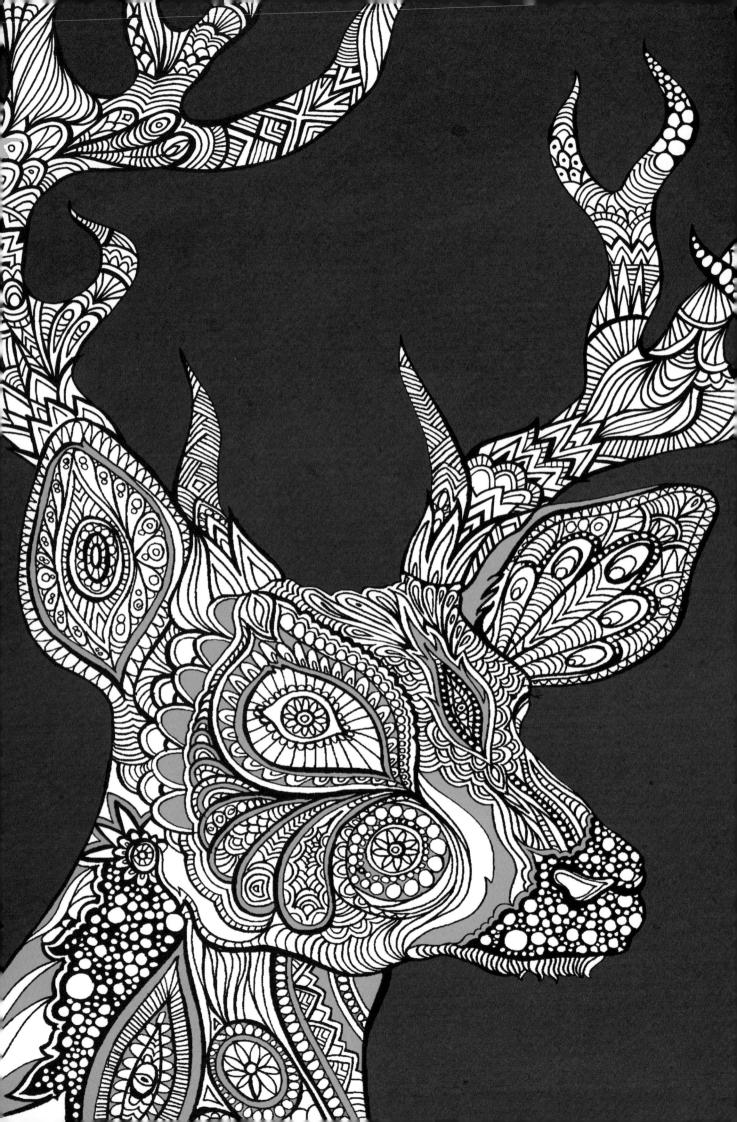

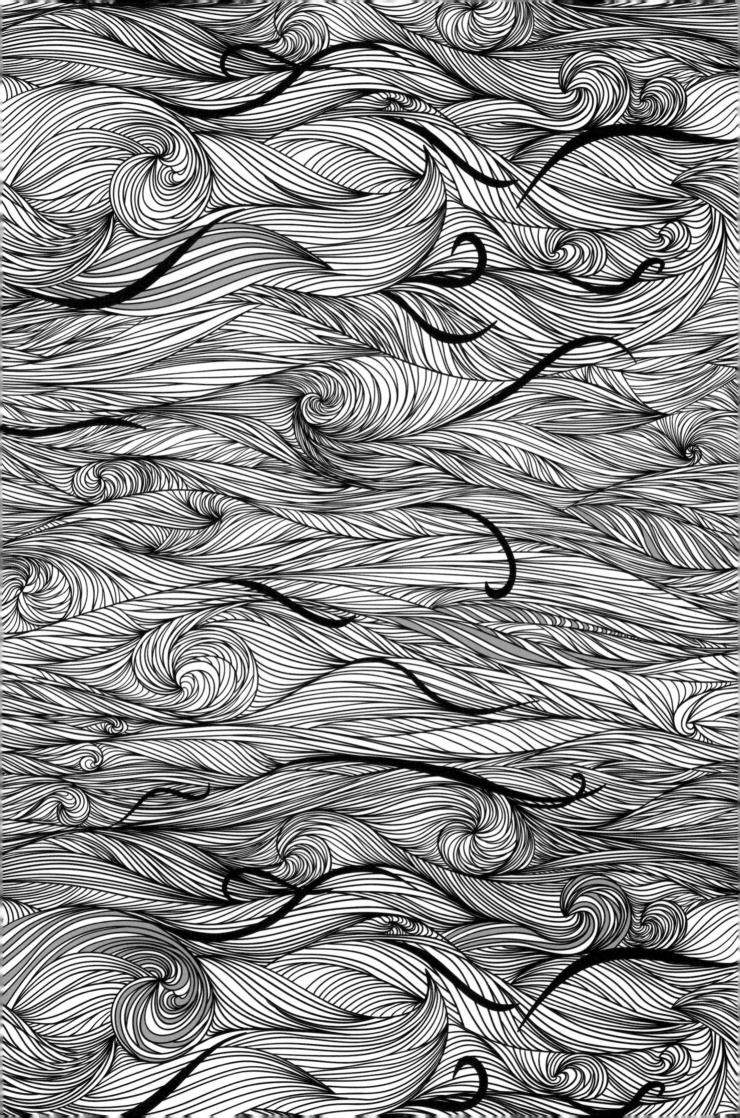

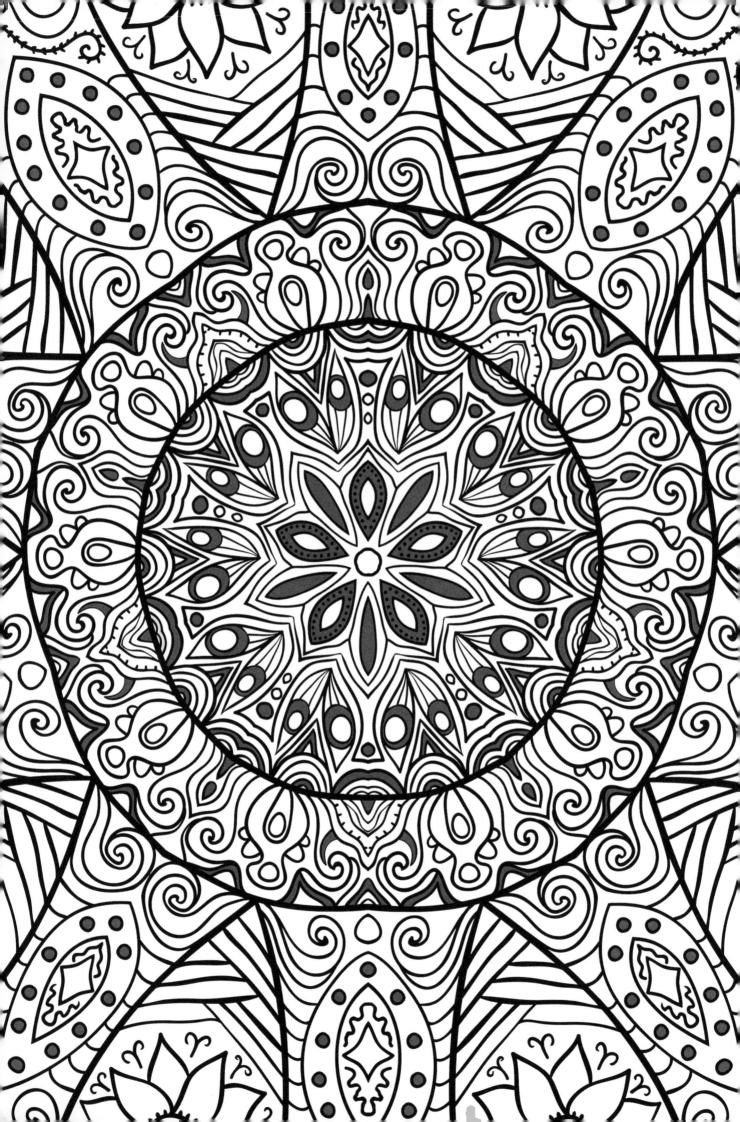

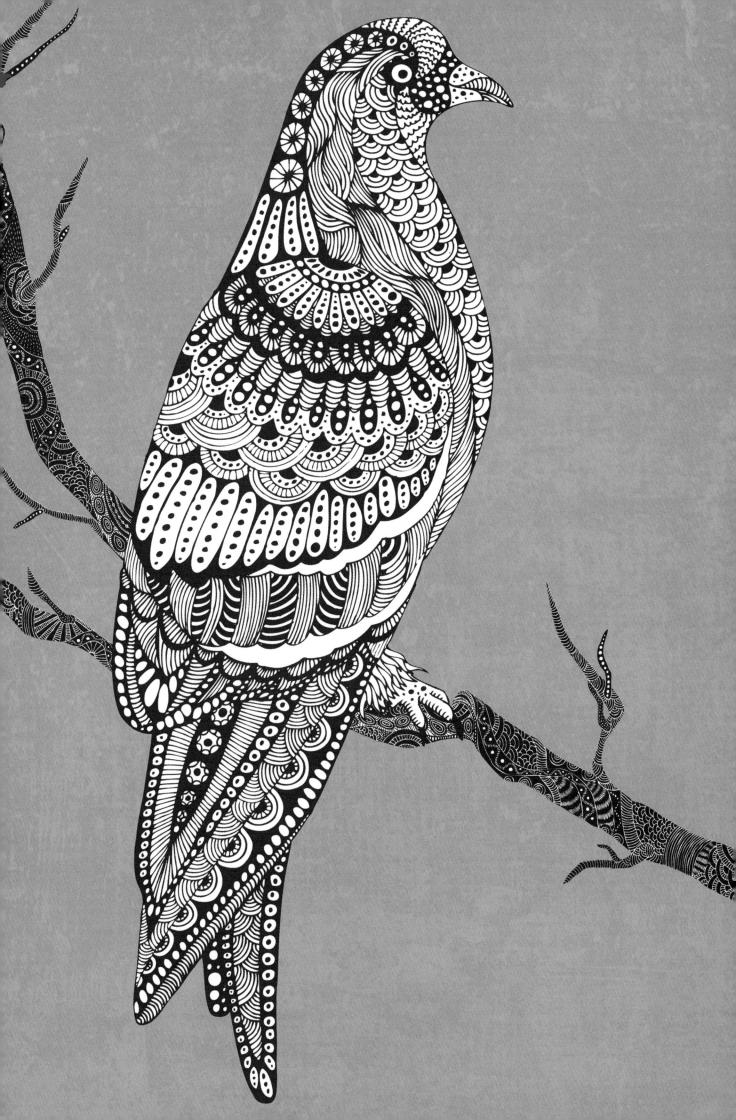

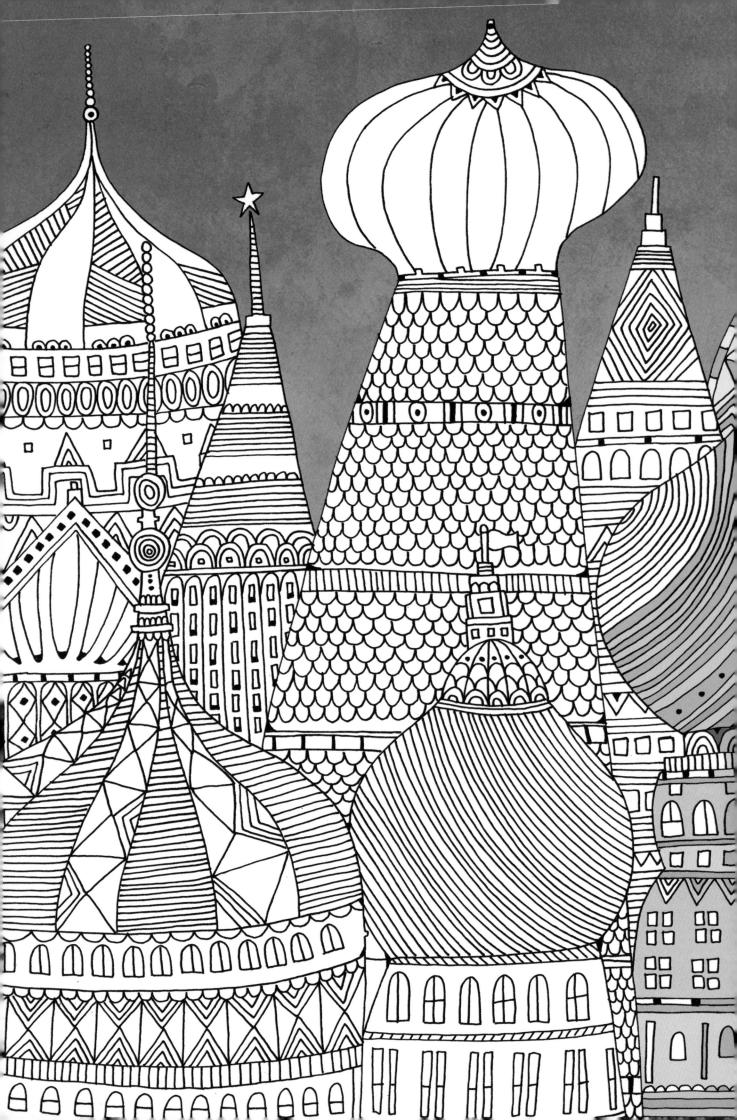

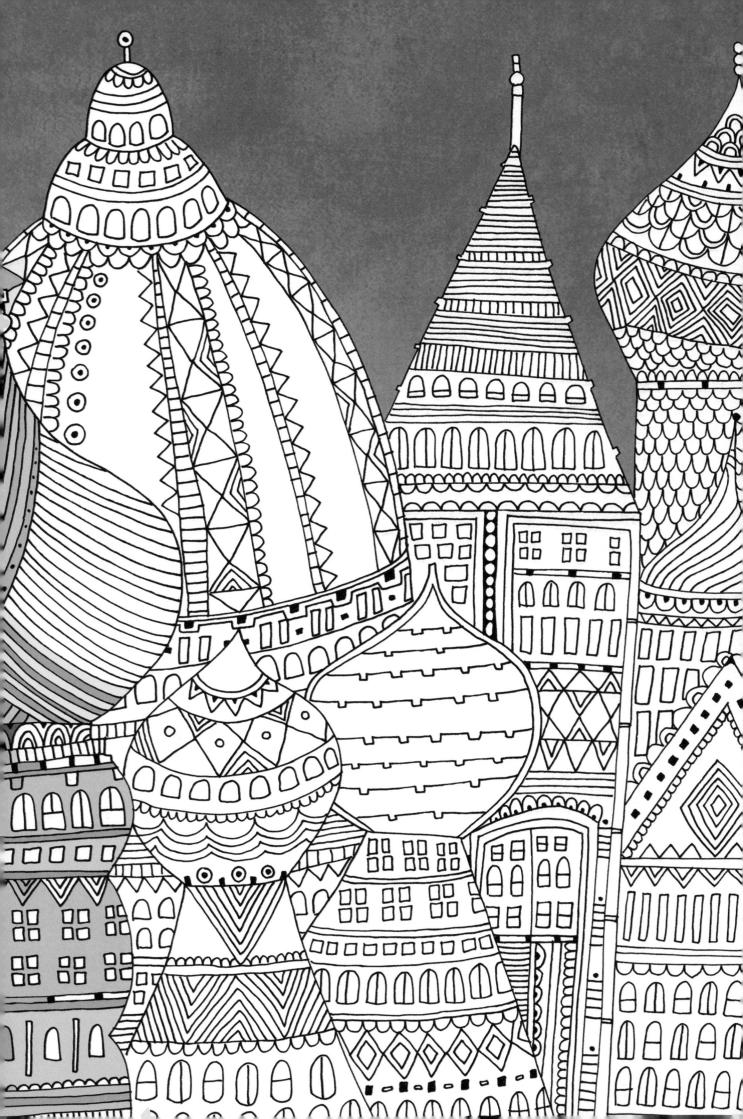

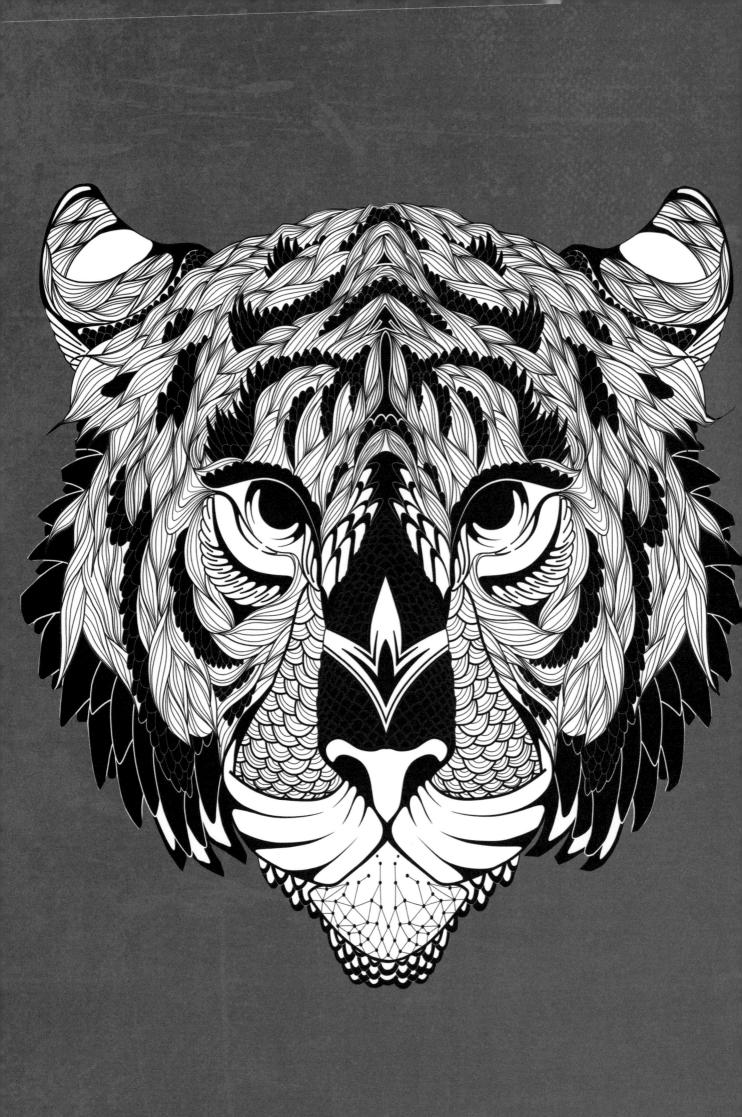

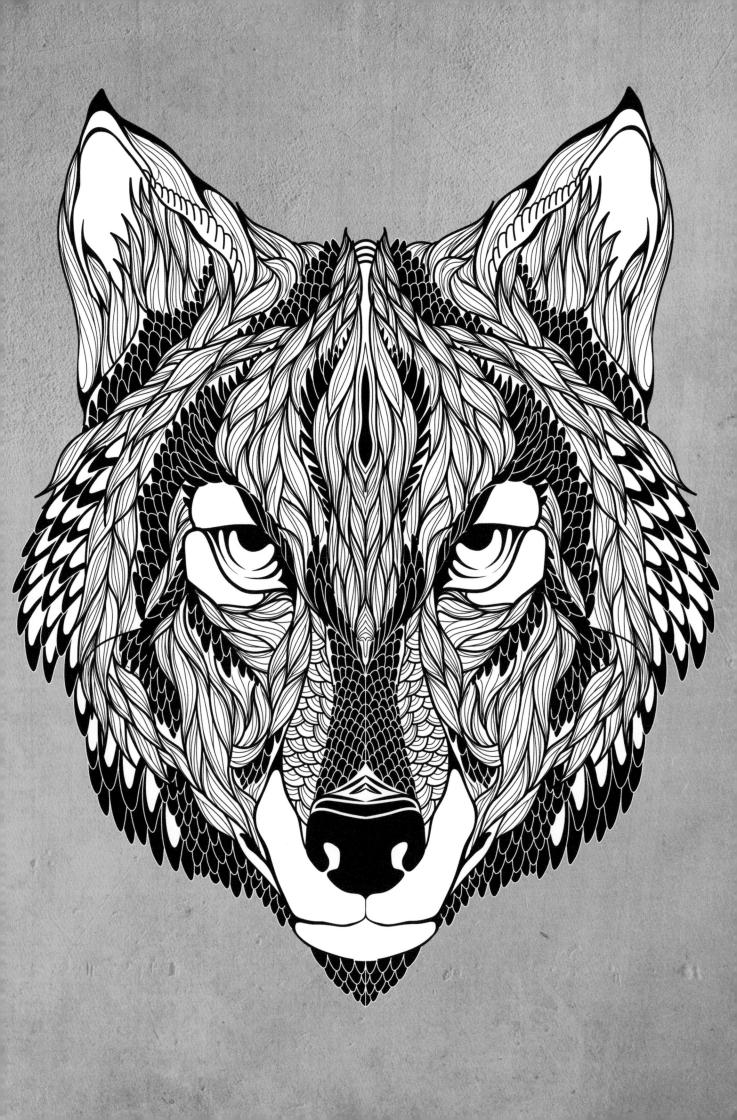

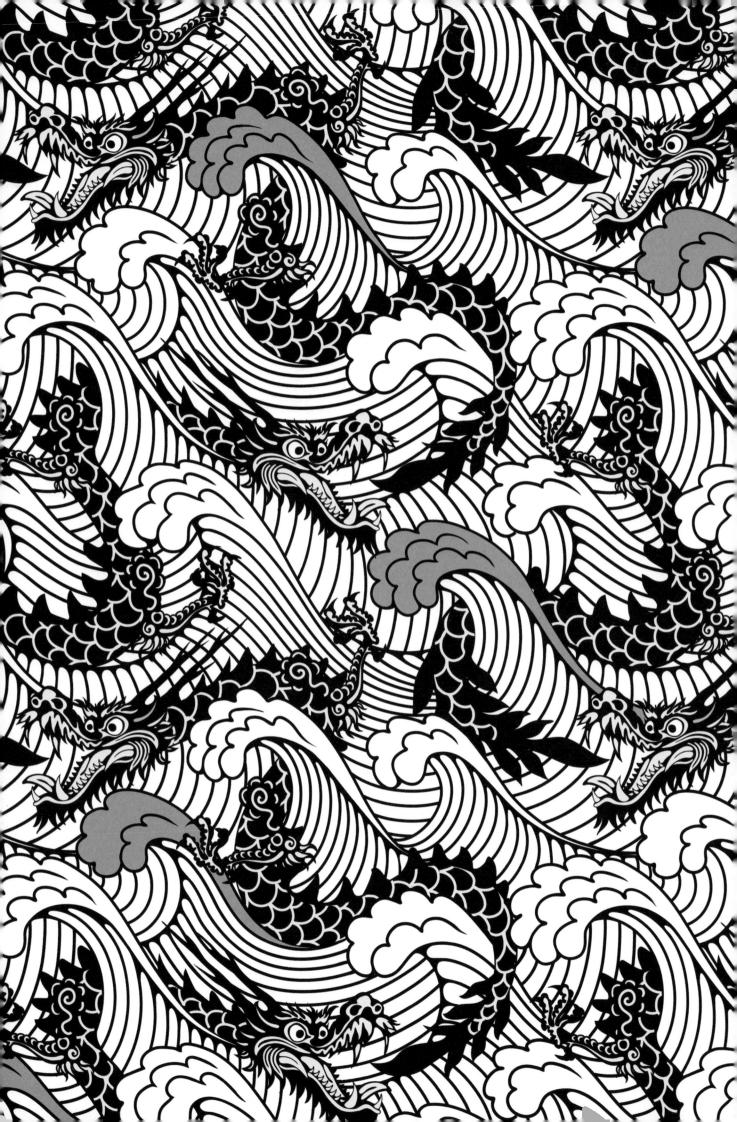

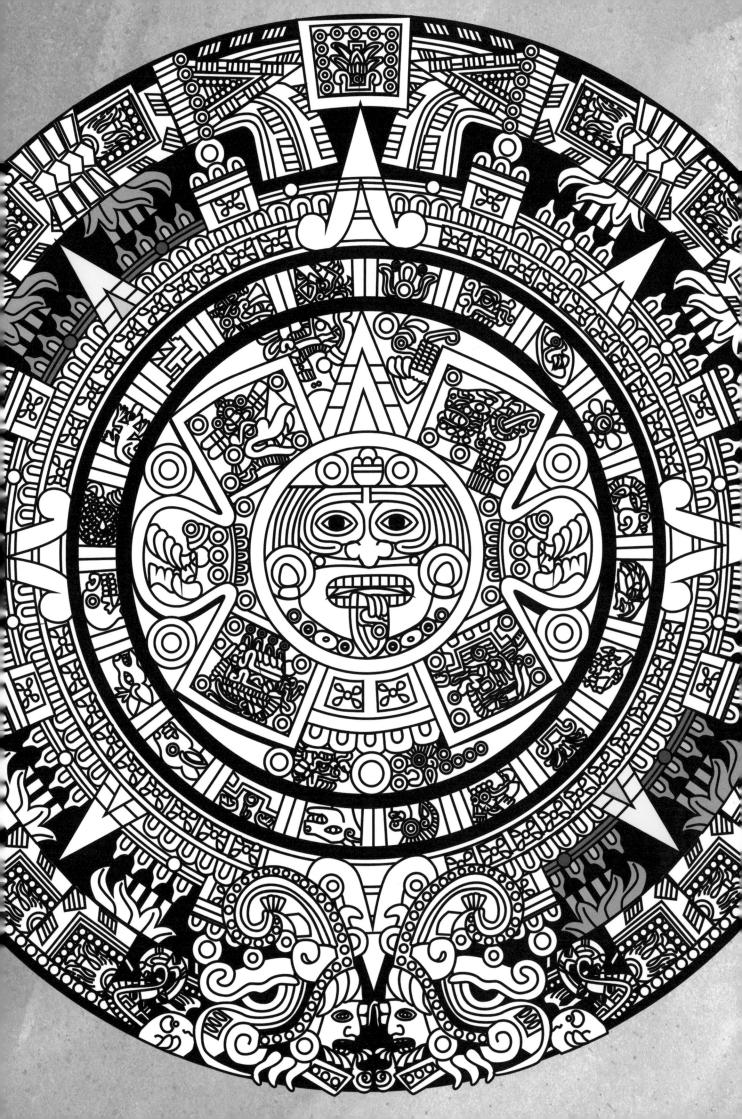

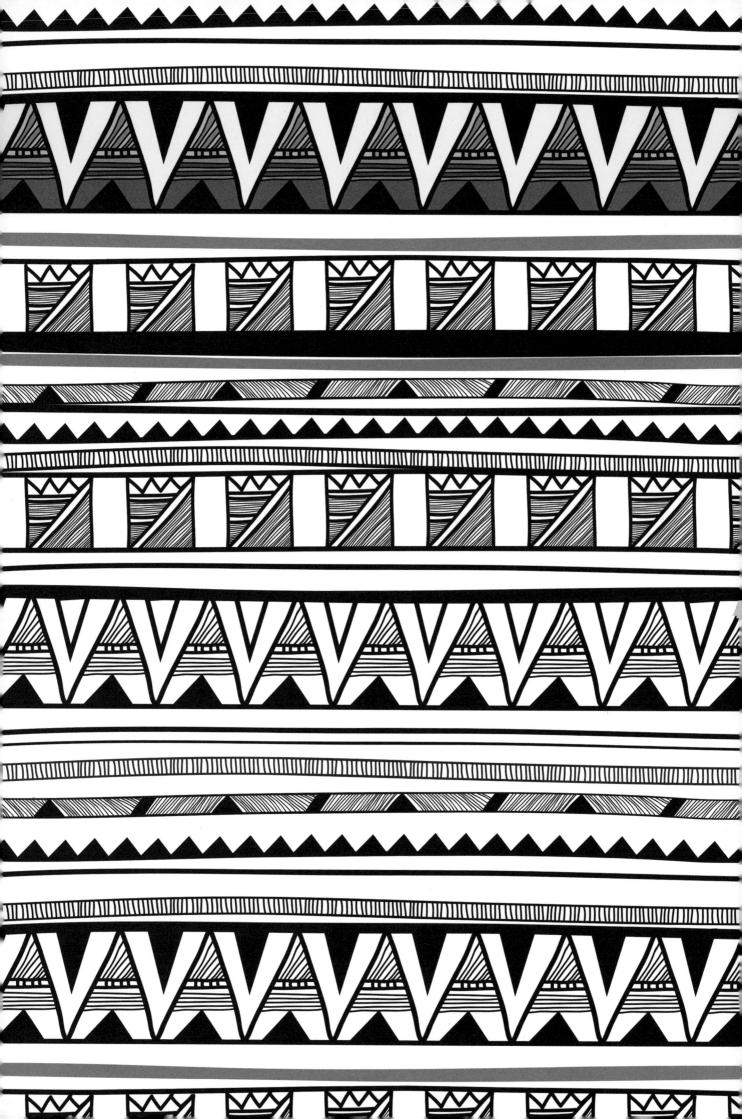

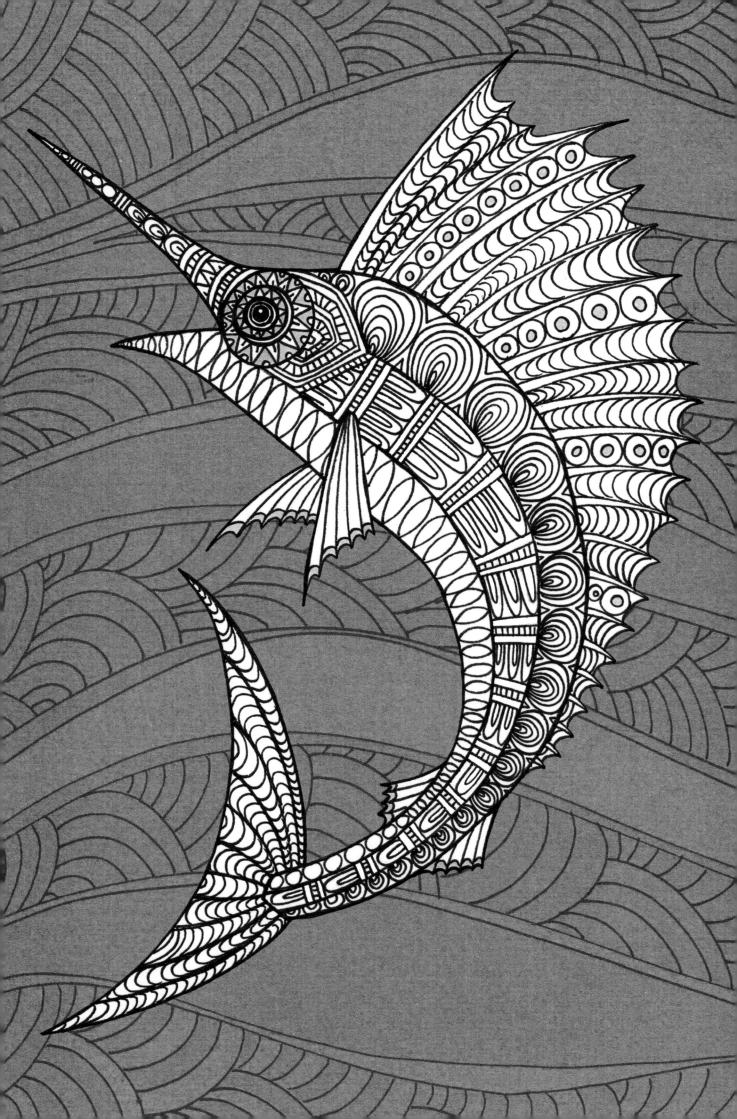

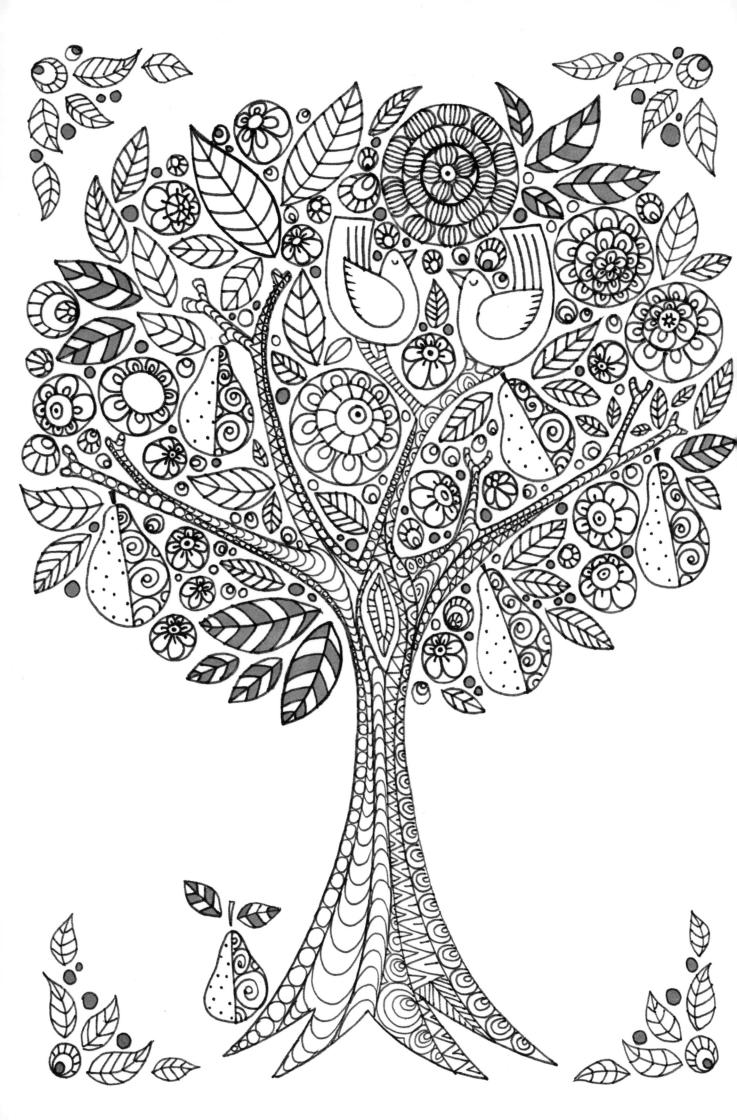

doodling

141

WVV

C

000

0000

0000

00000

Find your colouring pens or pencils and finish off the following pages with lines, squiggles and patterns. How you complete the drawings is entirely up to you — there are no rights or wrongs.

0000

00000

0000

0

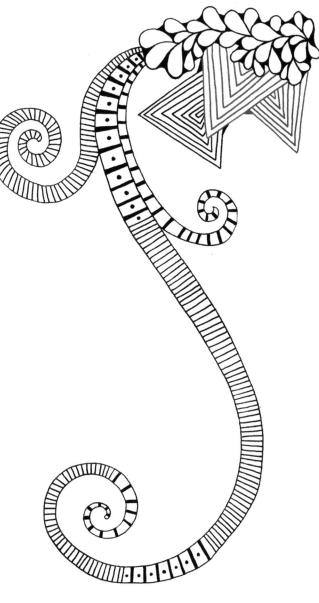

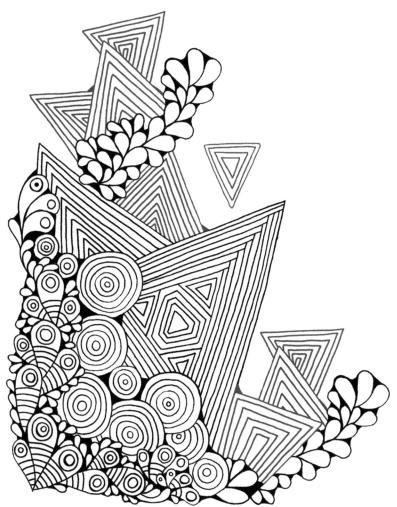

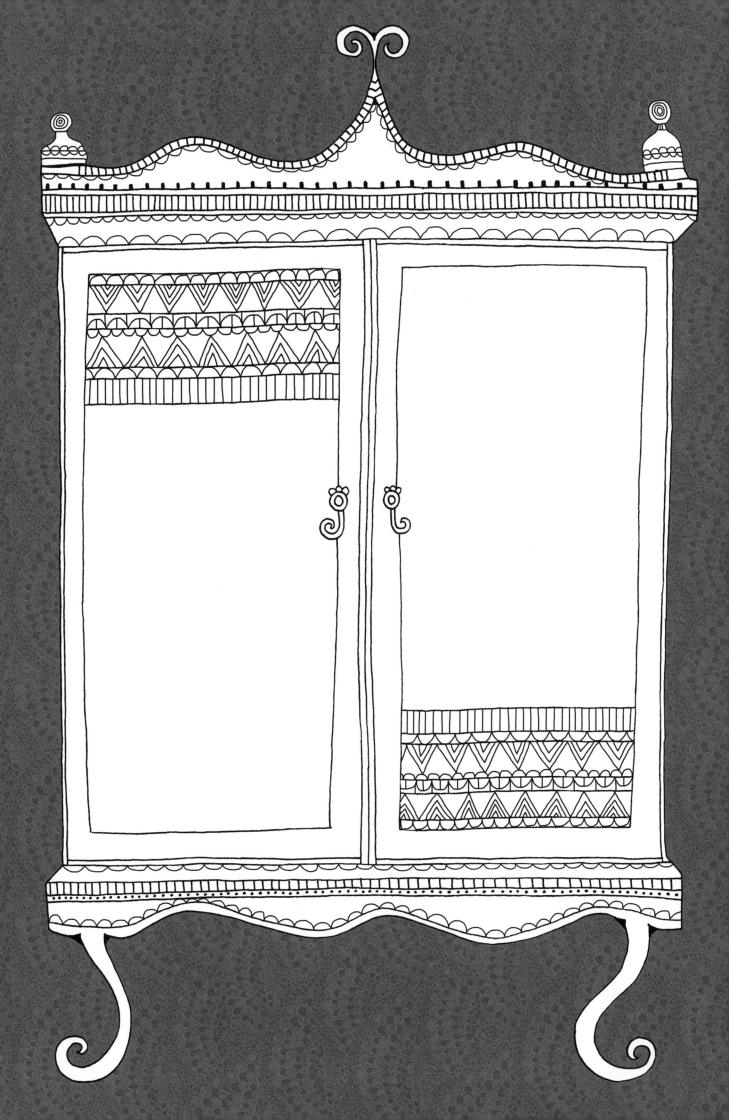

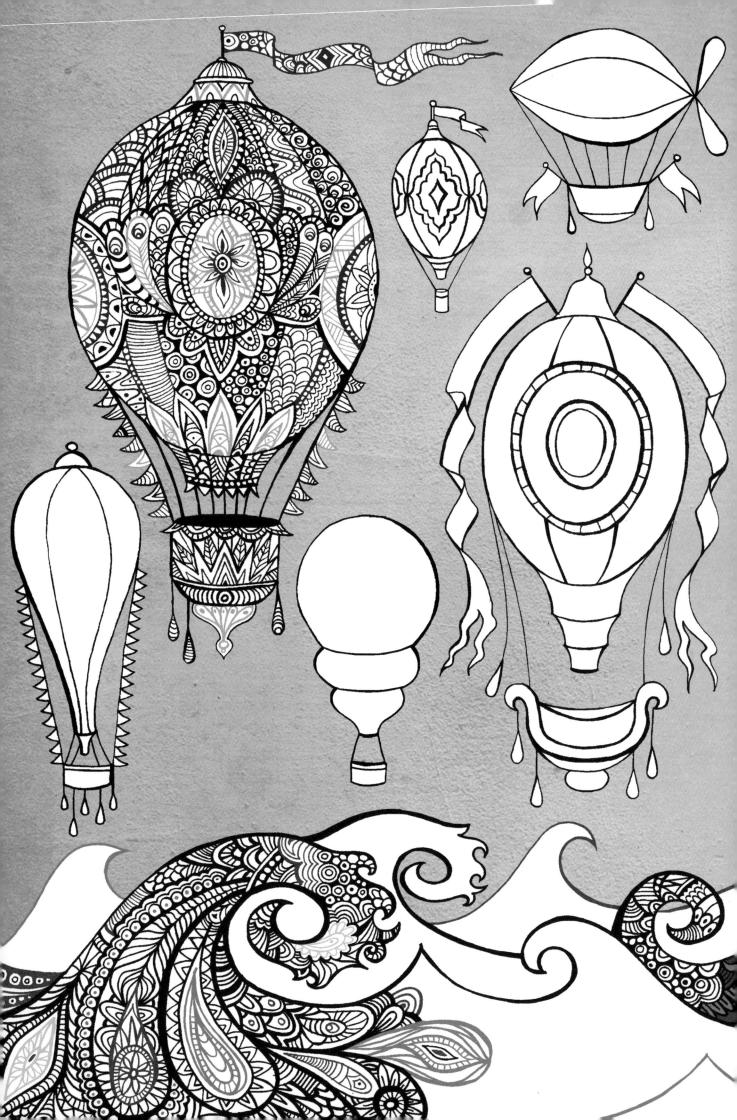

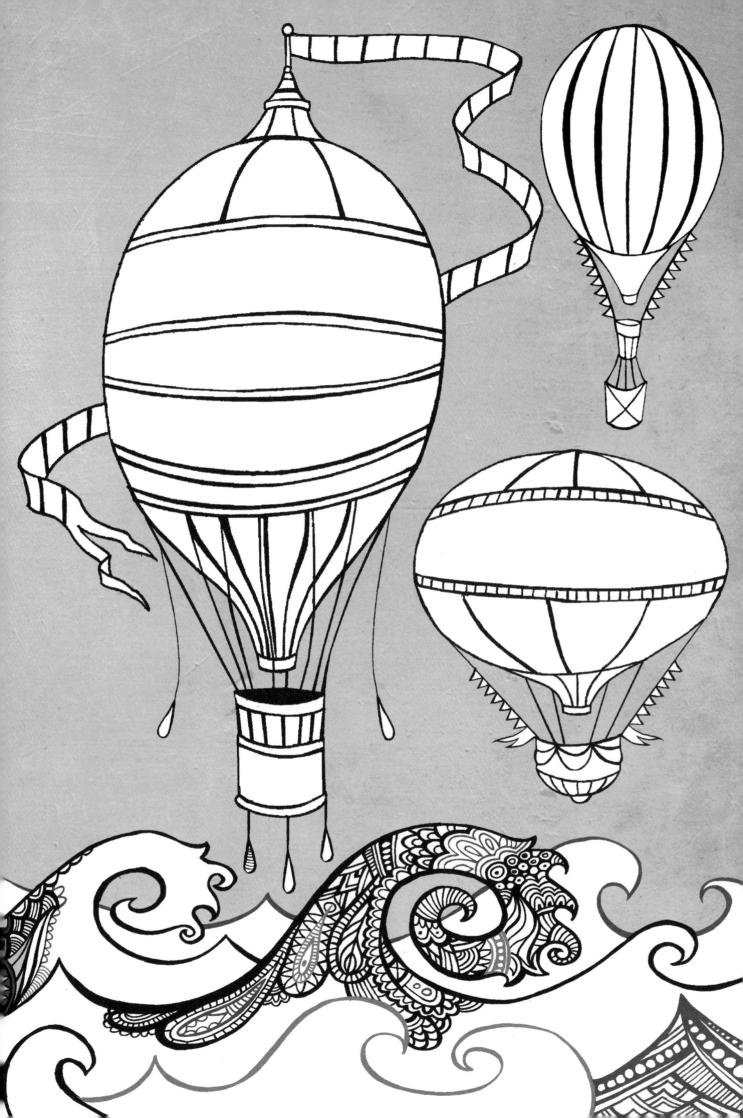

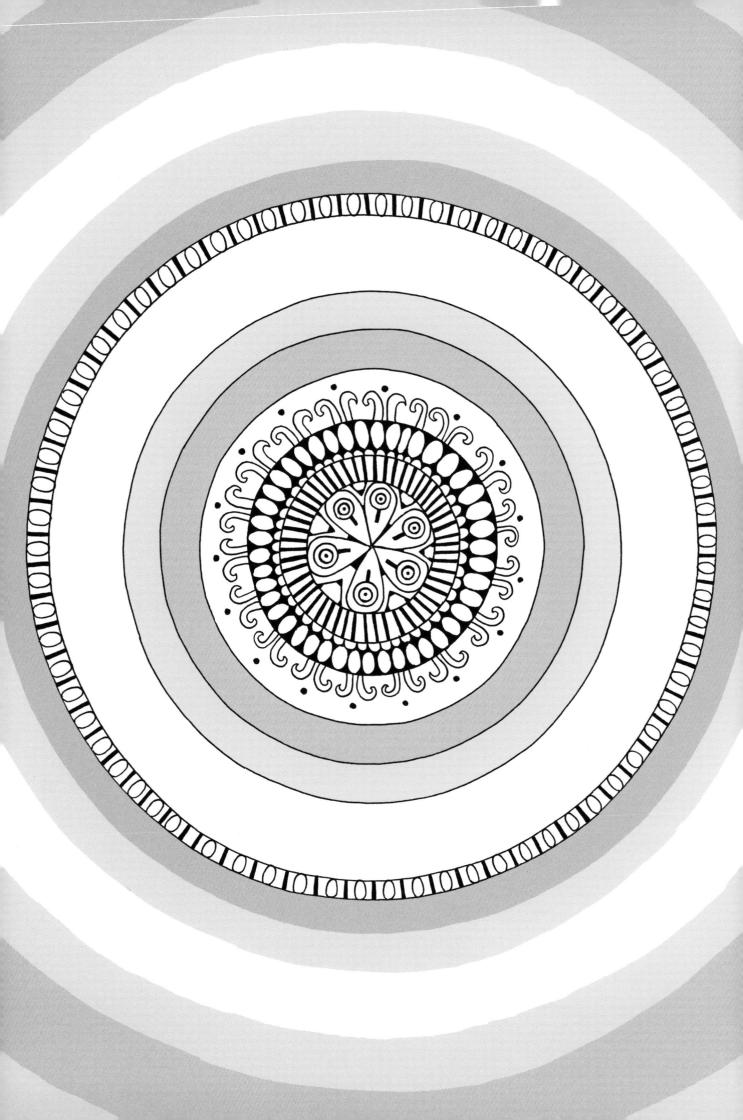

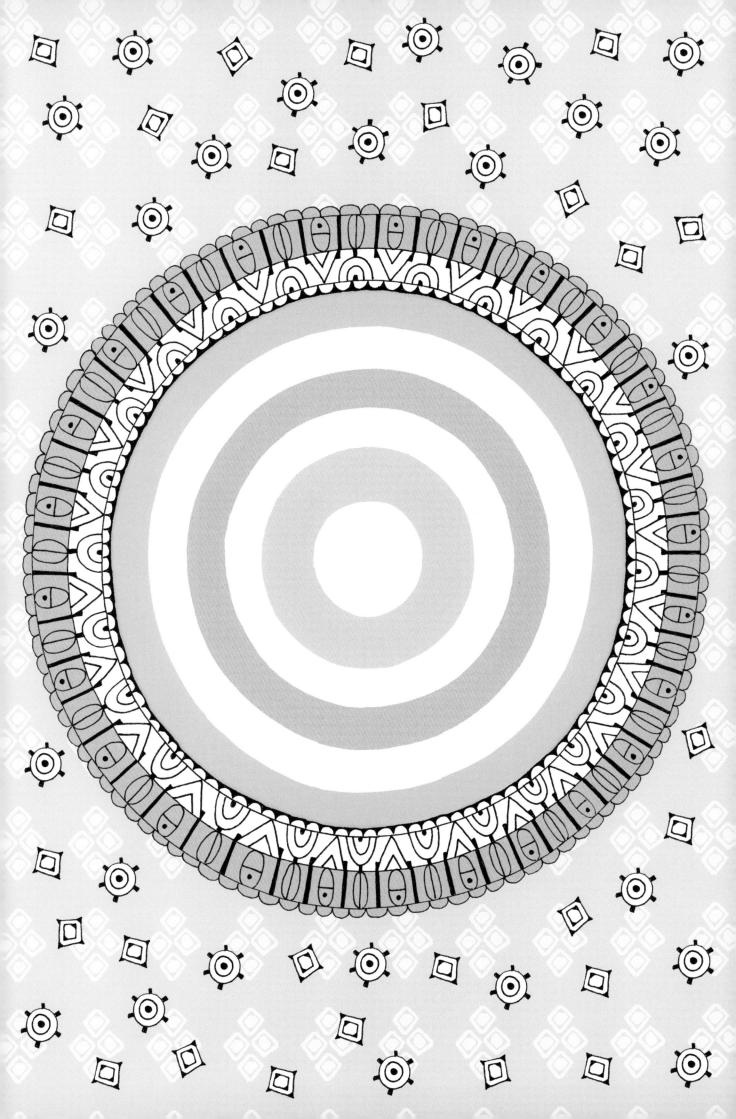

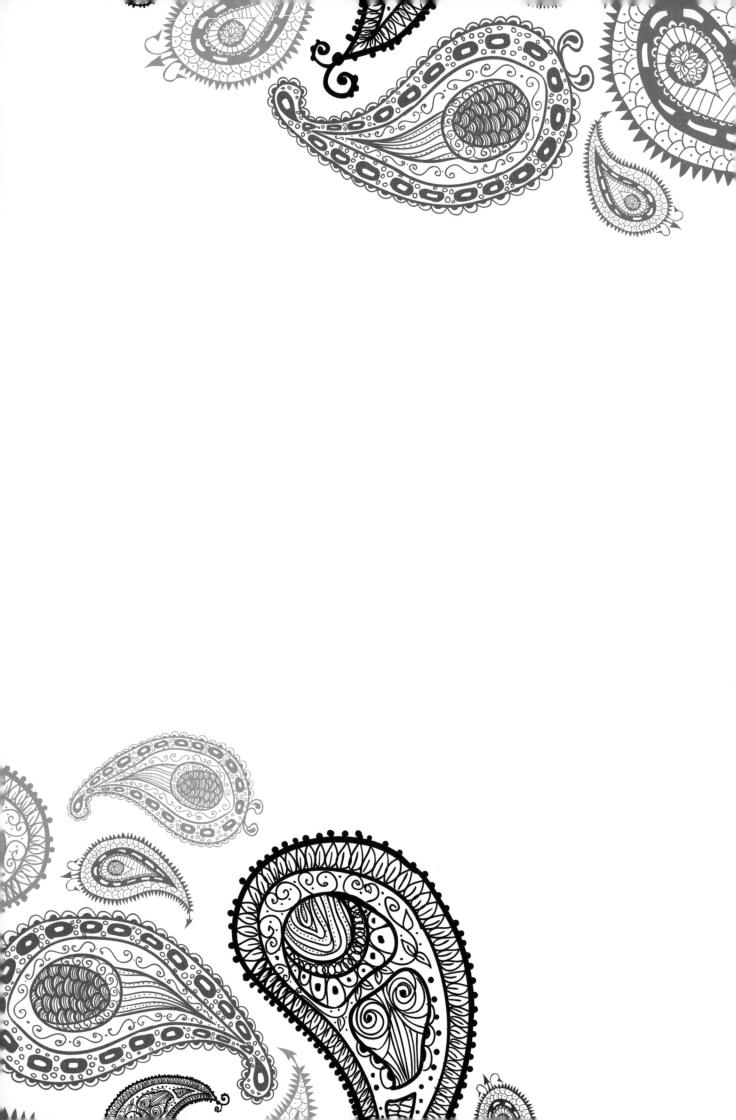

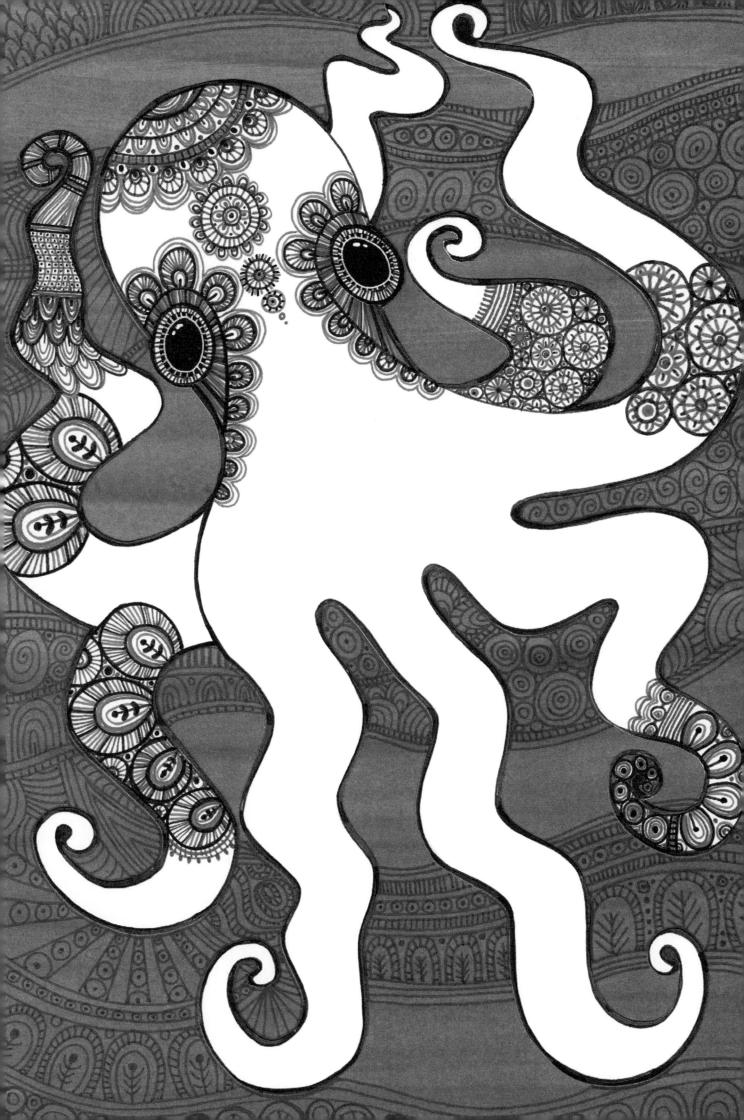

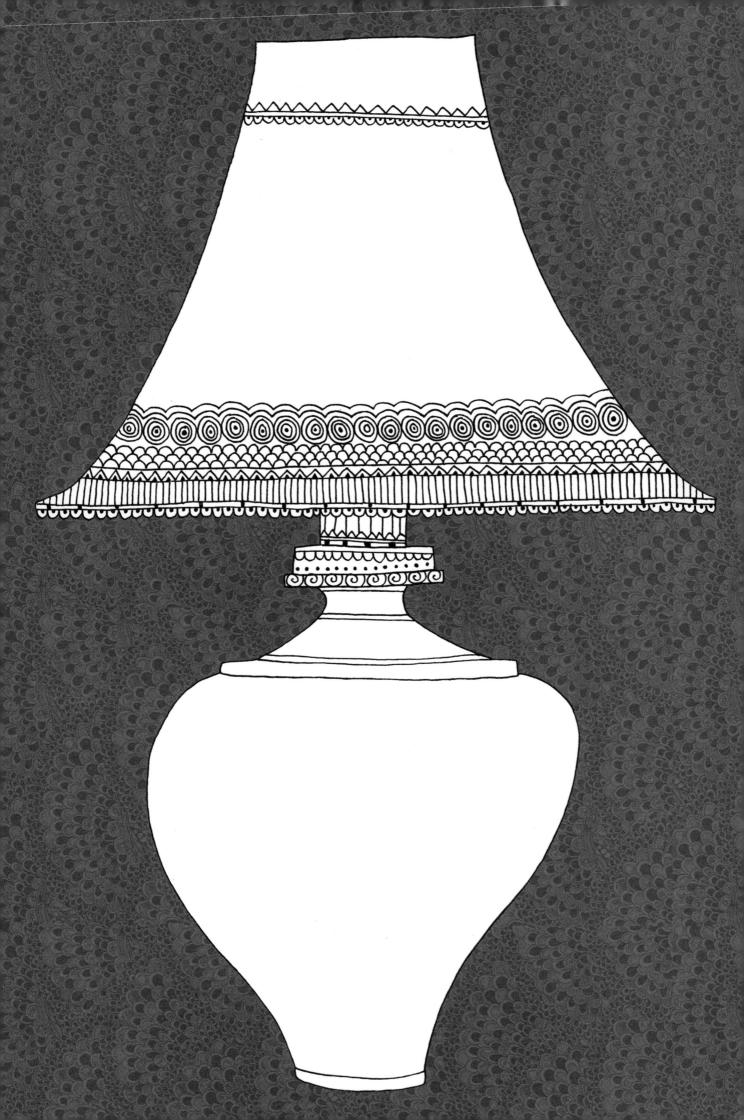

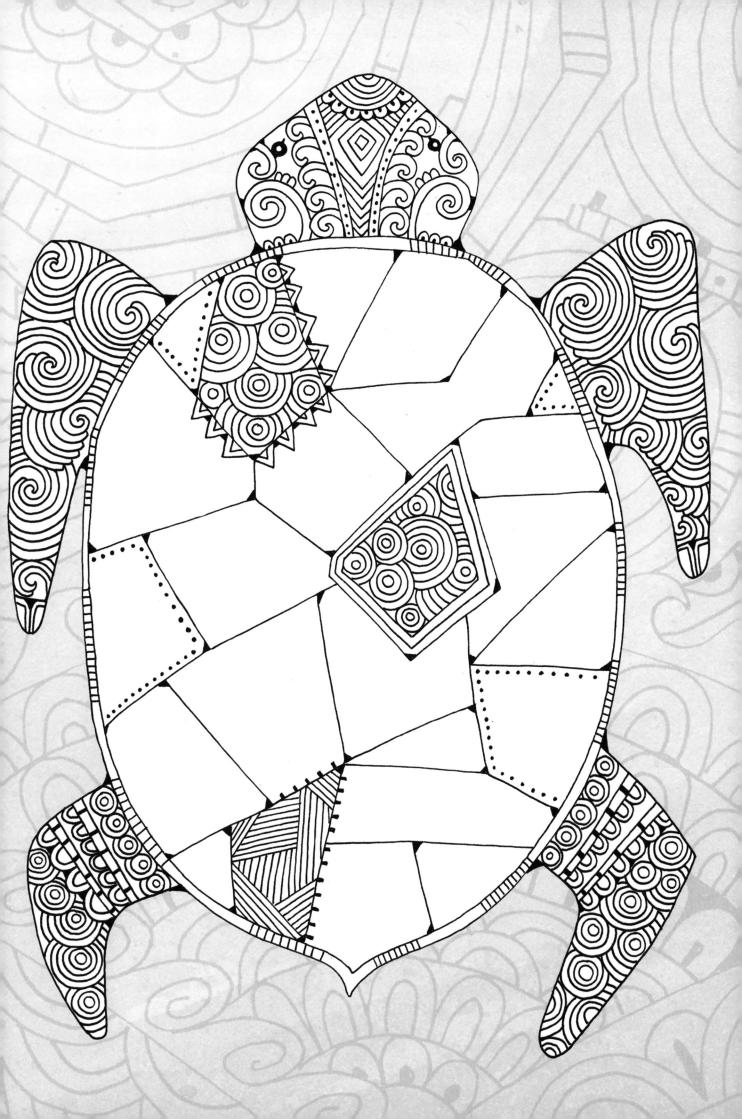

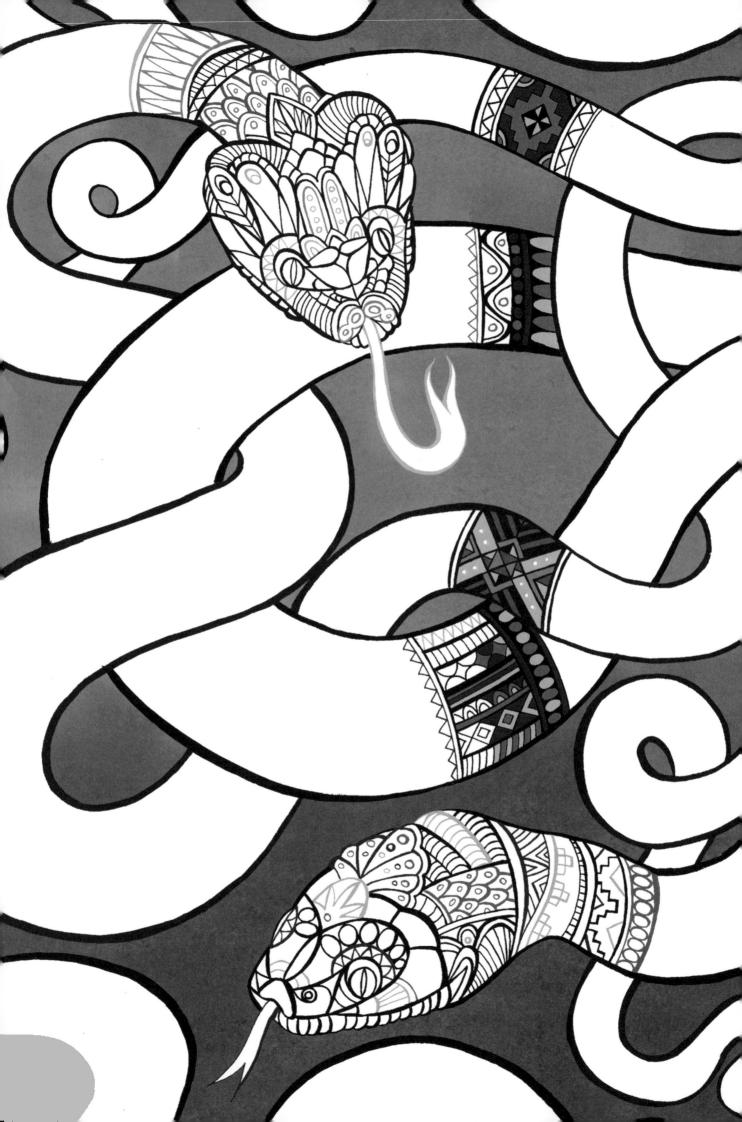

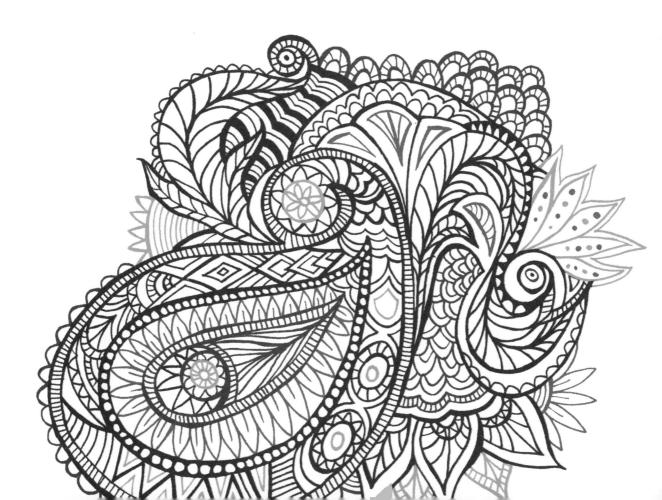

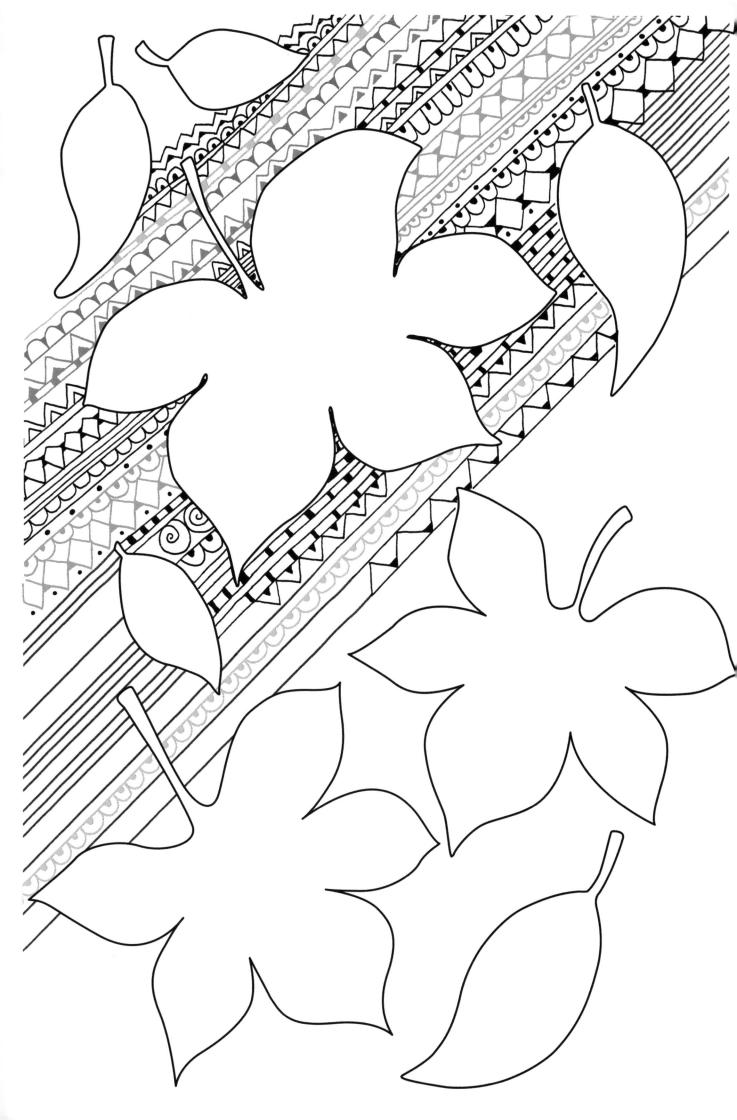

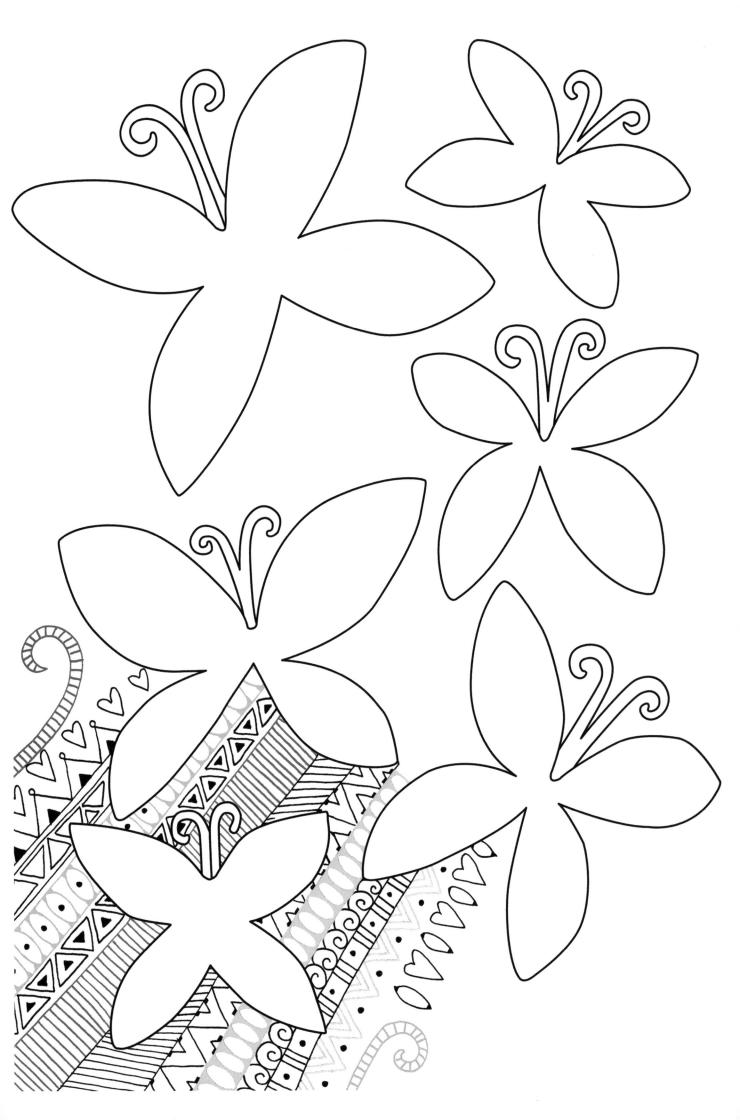

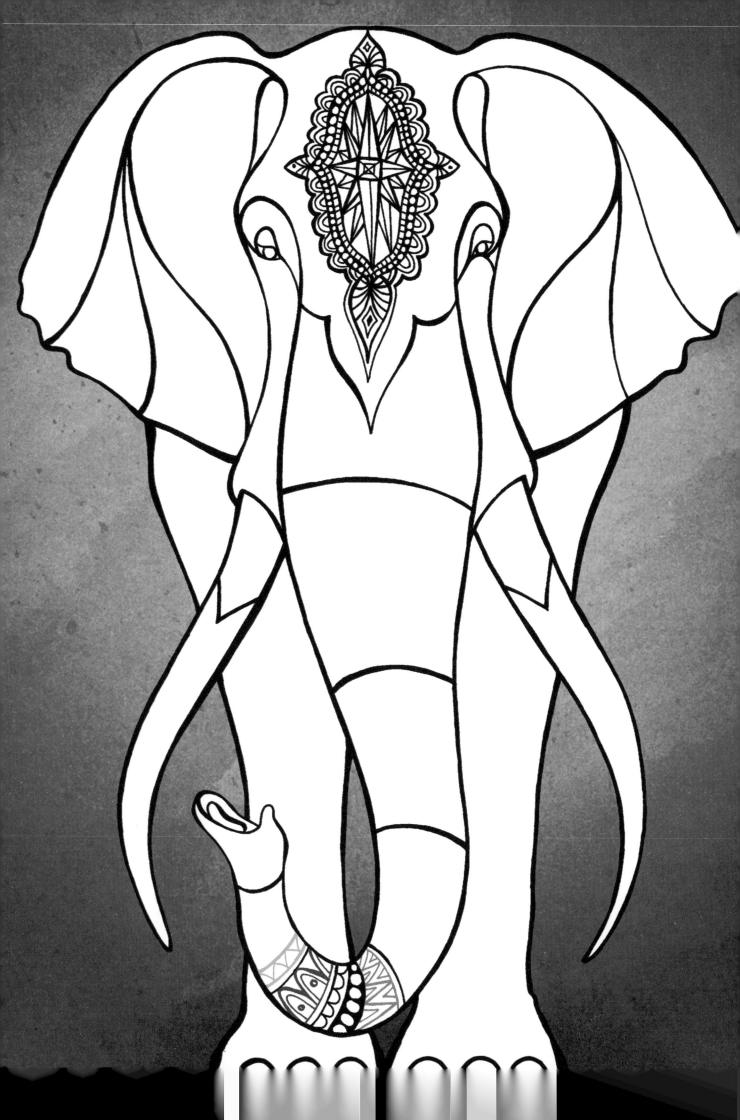

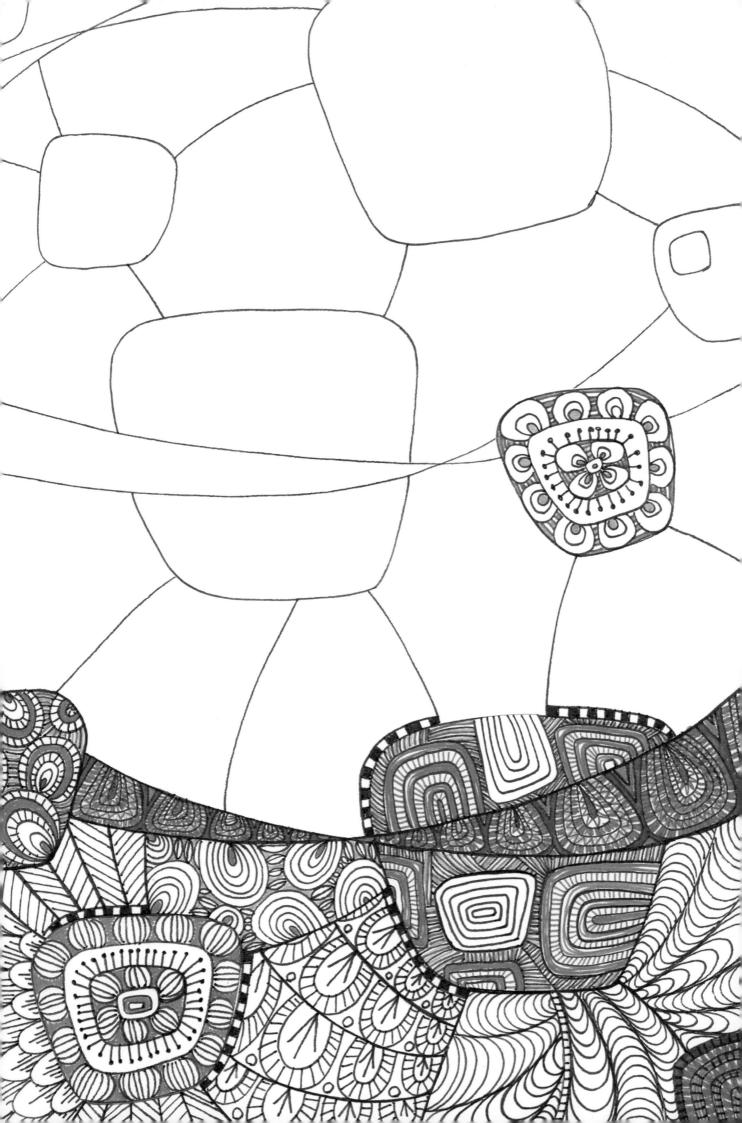

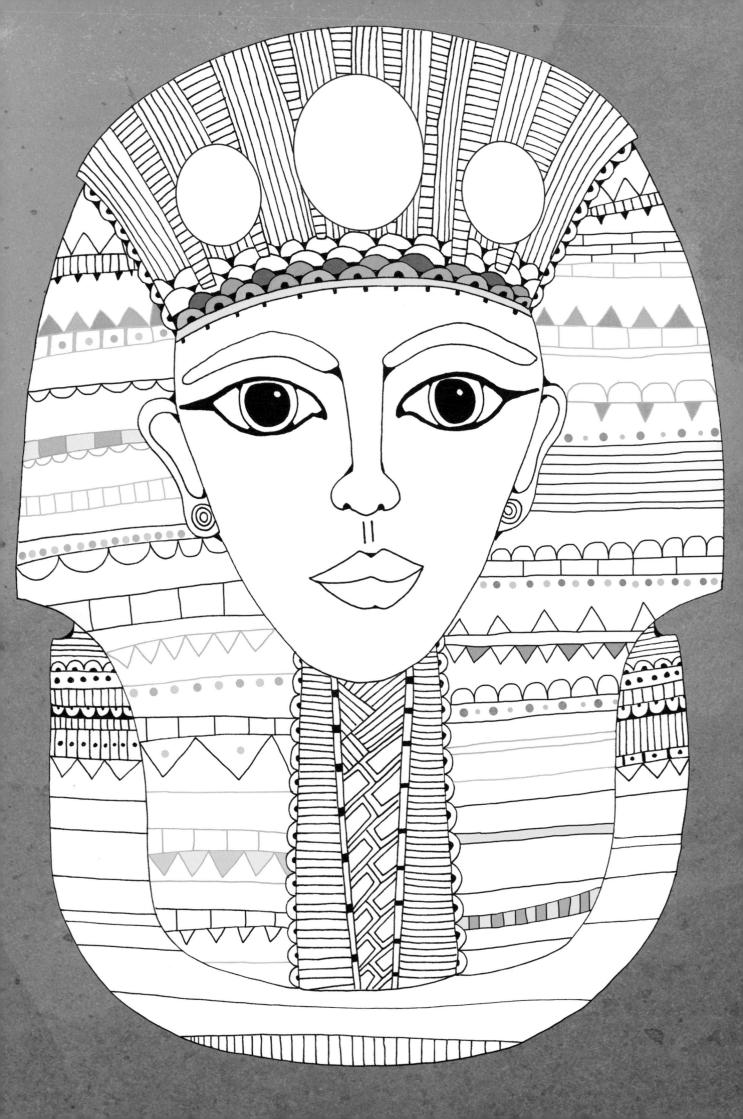

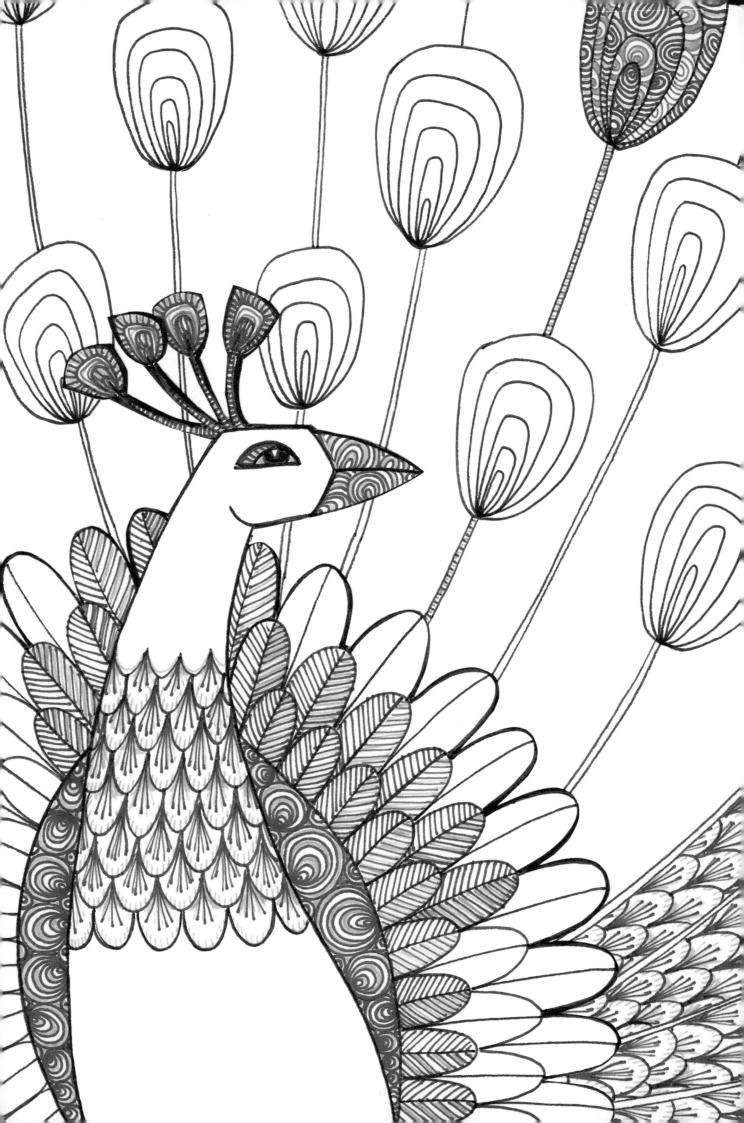

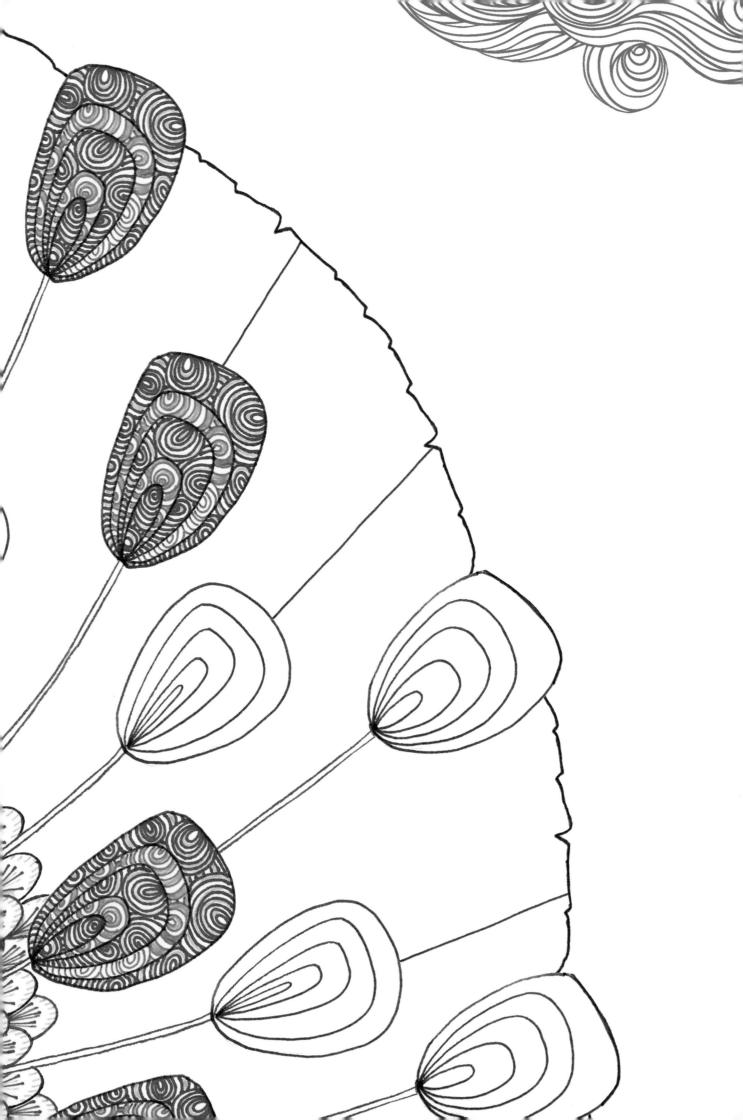

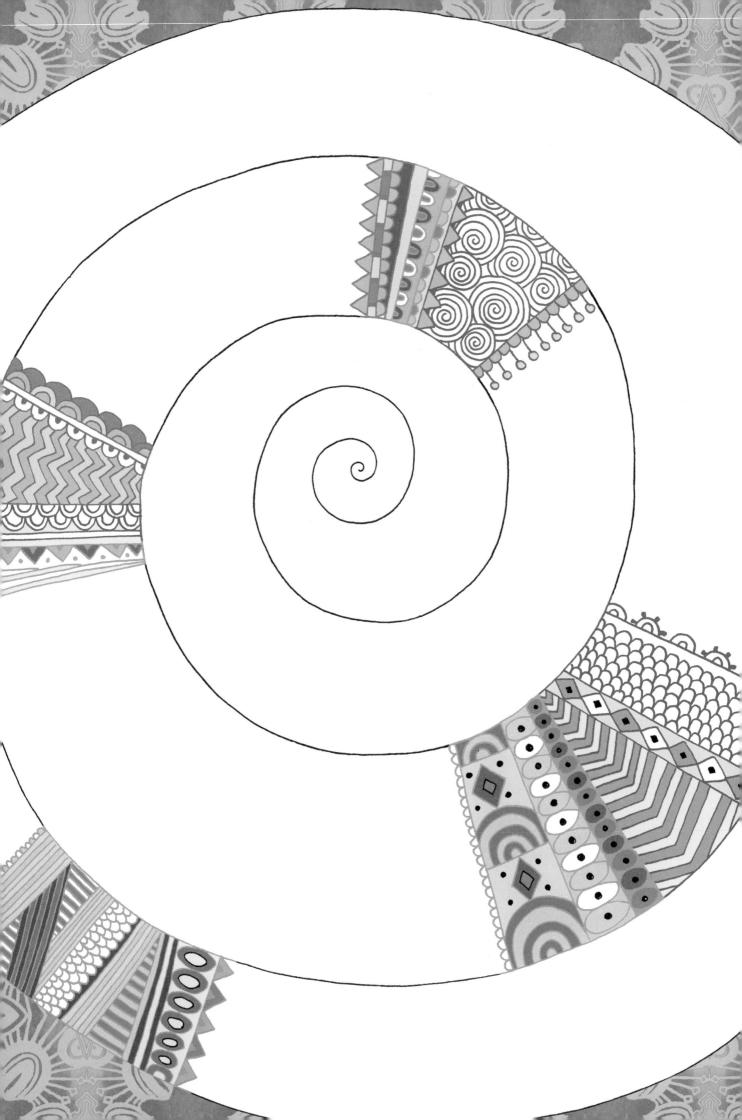

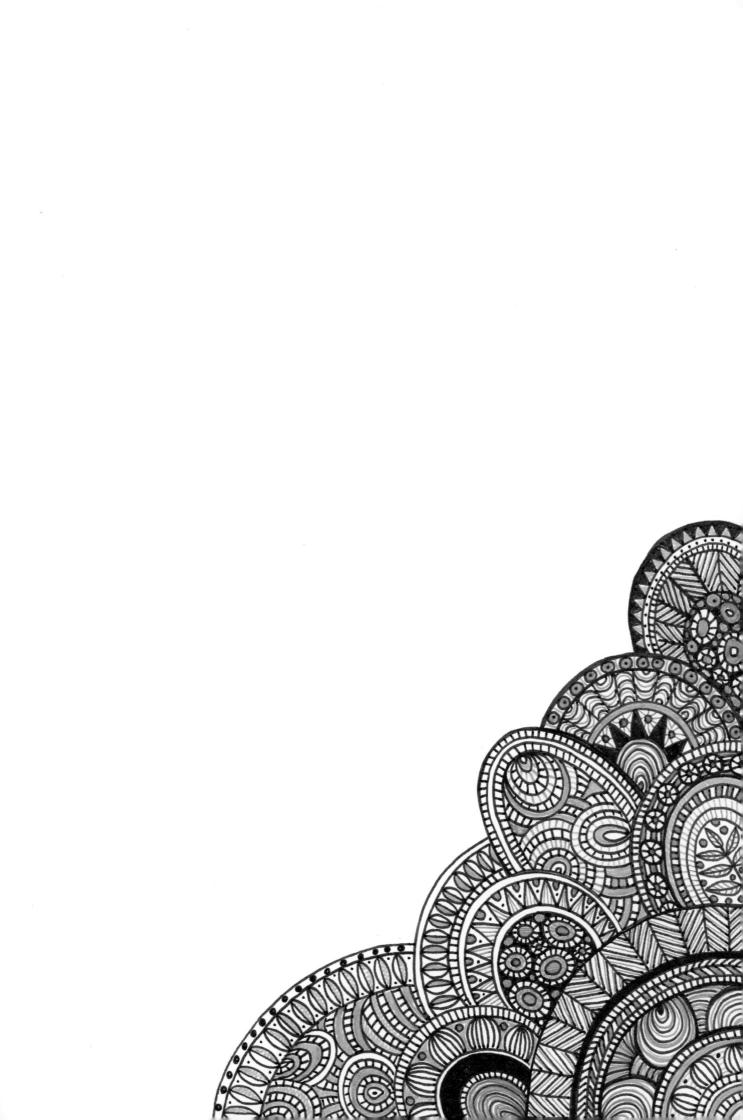

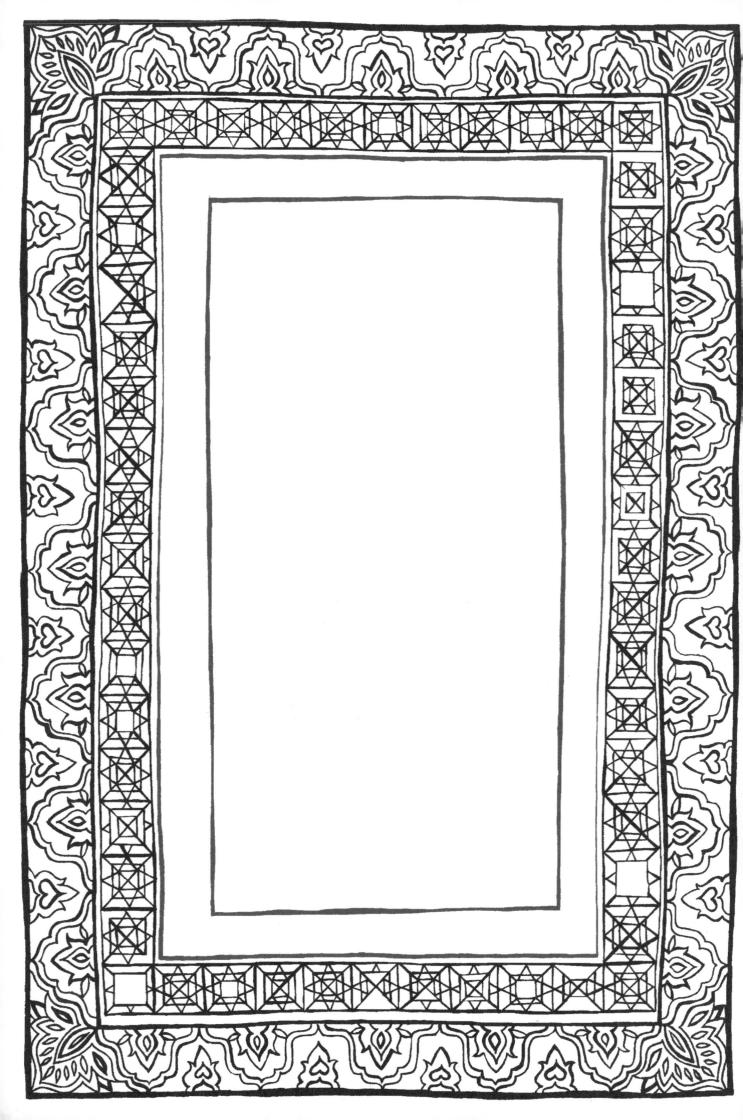

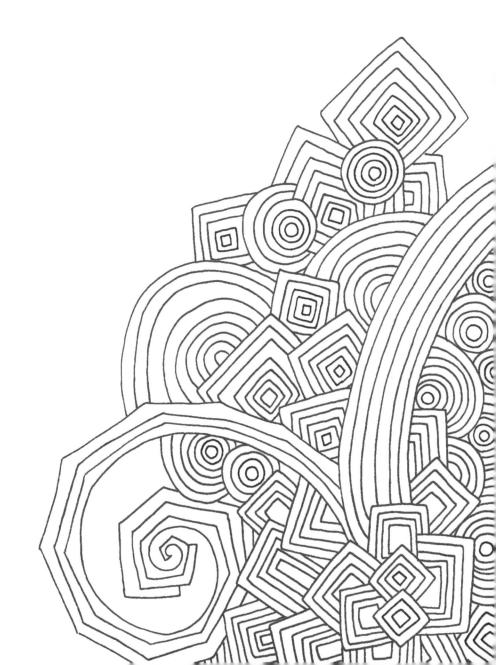

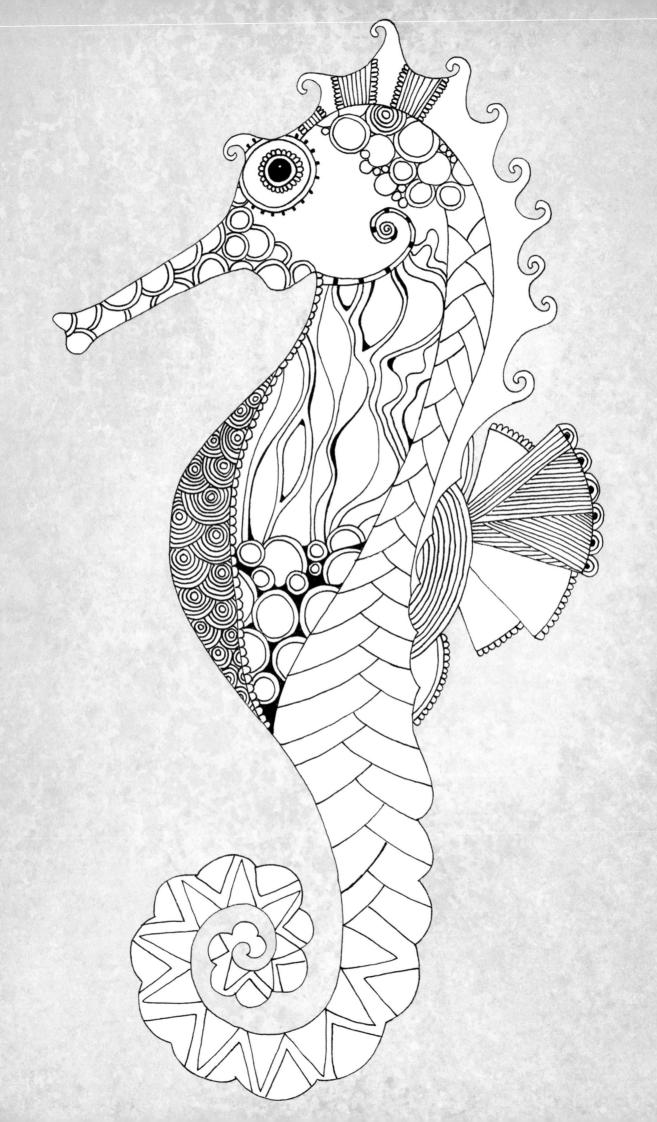

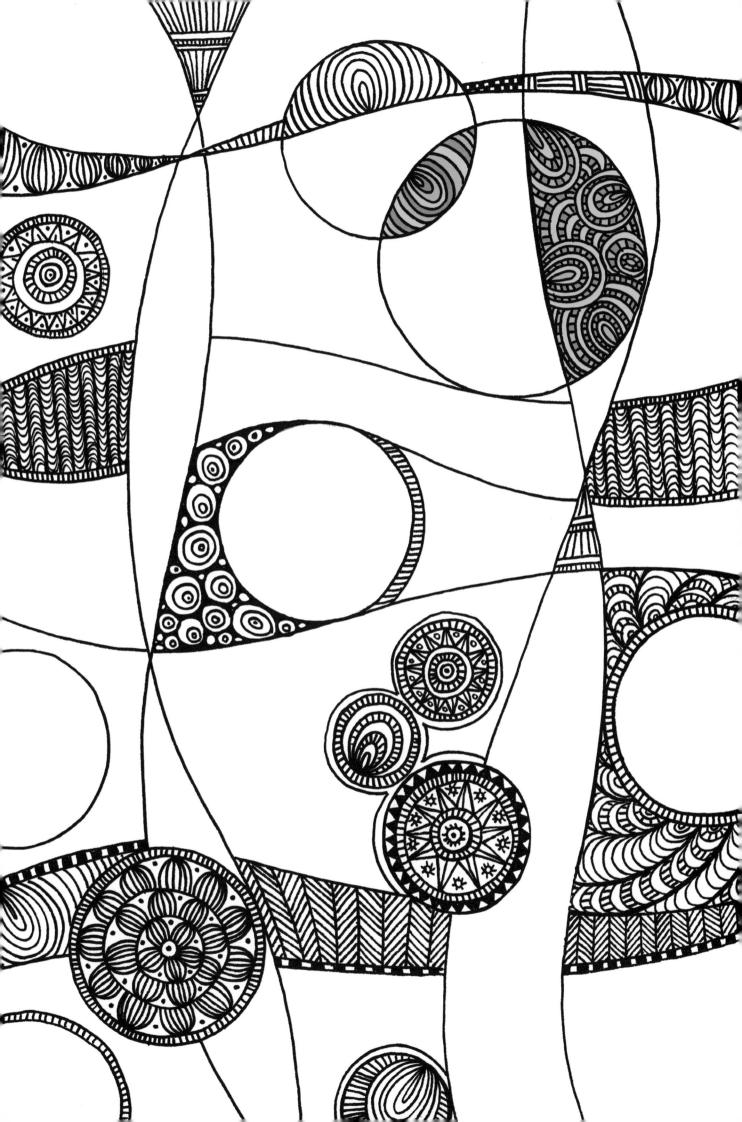

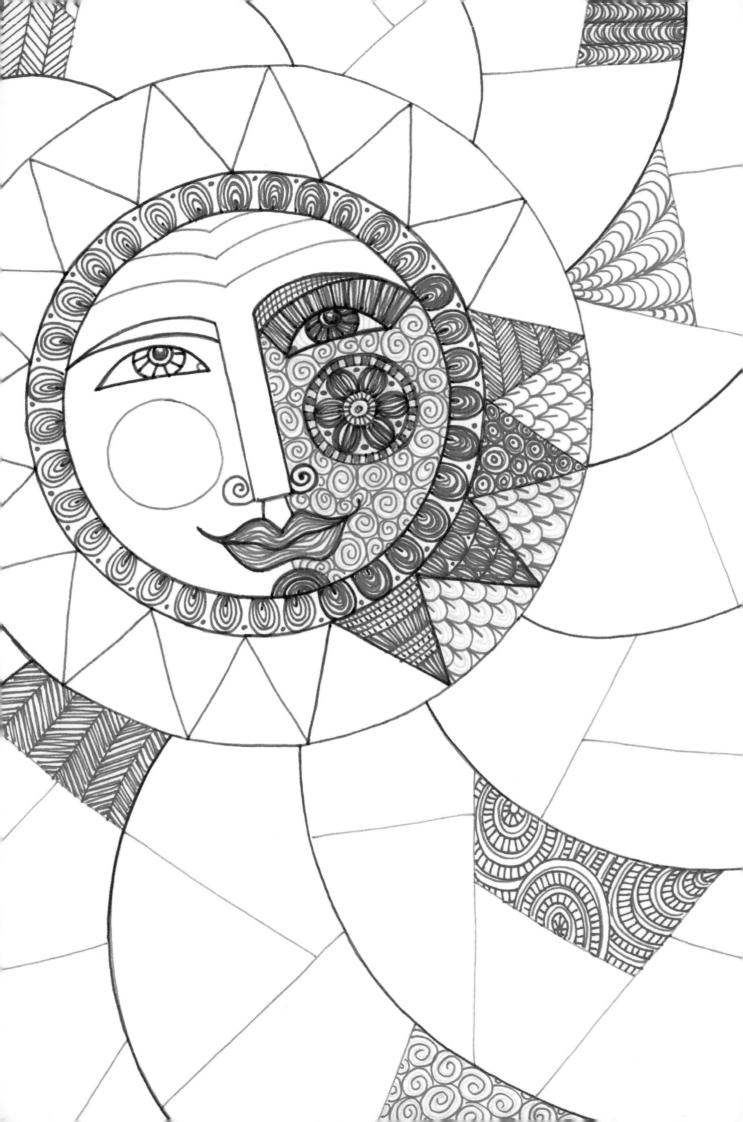

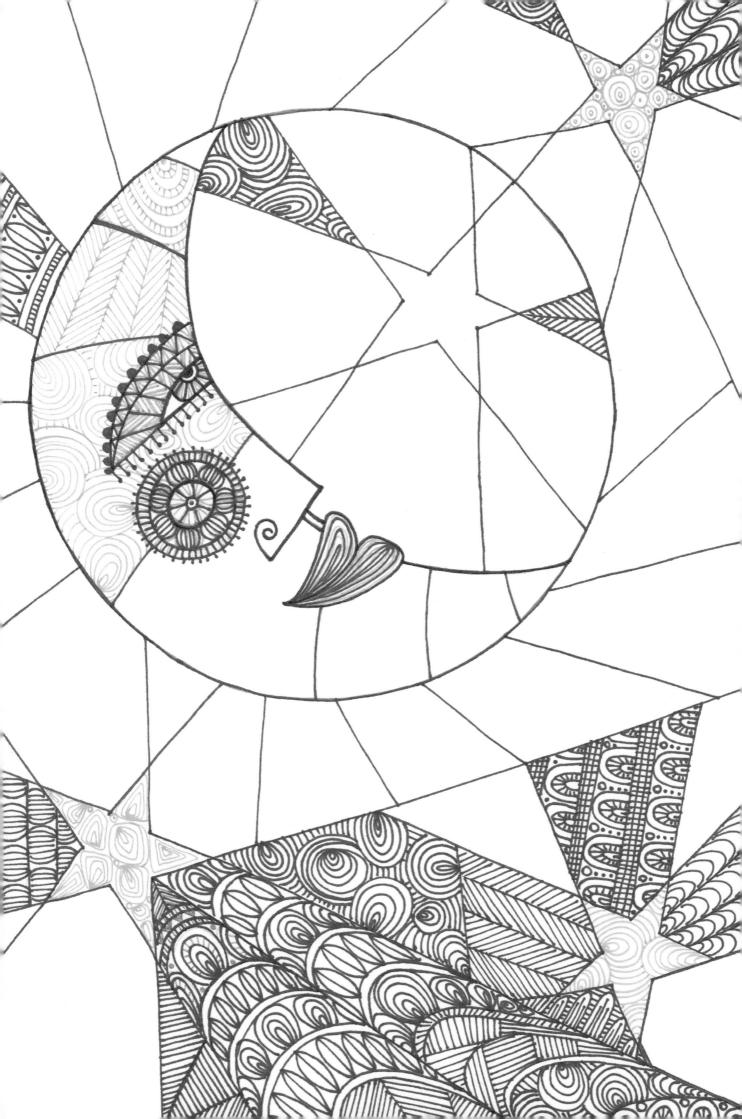

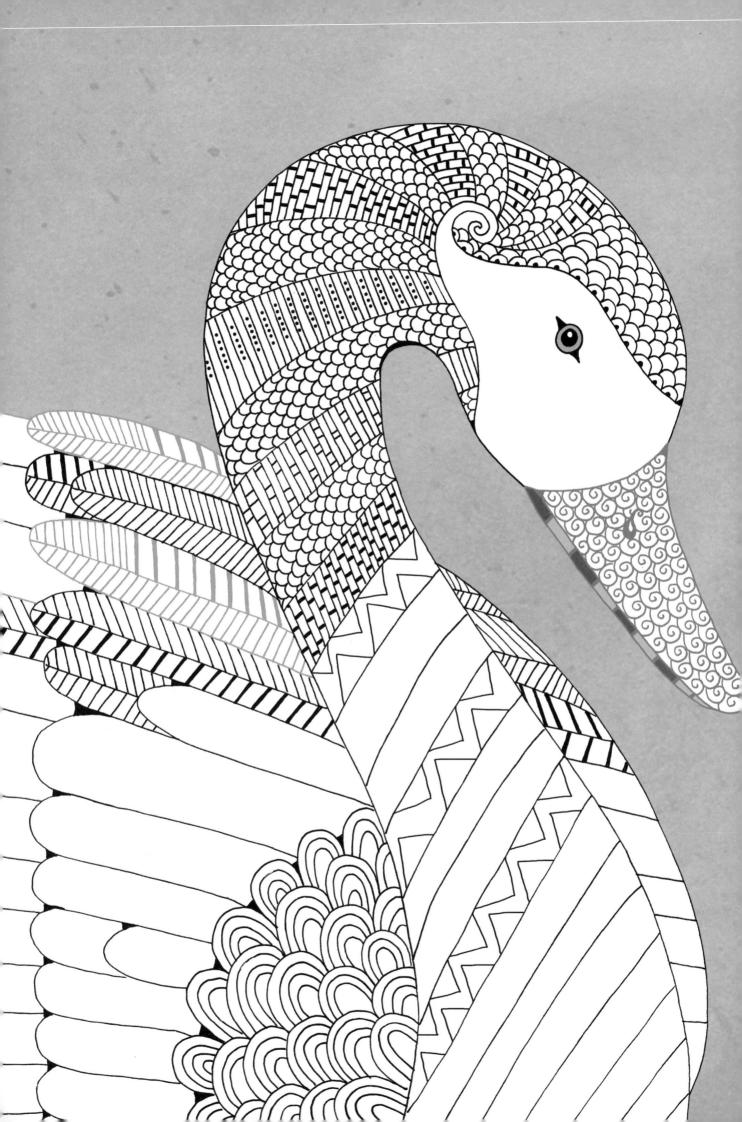

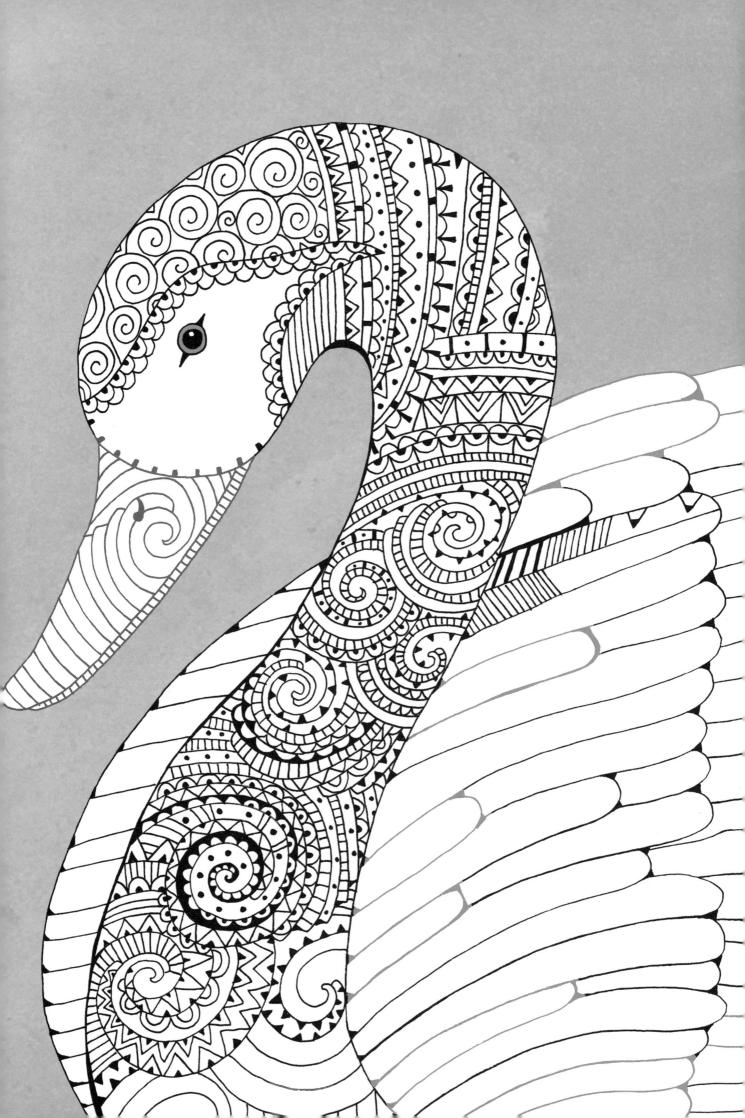

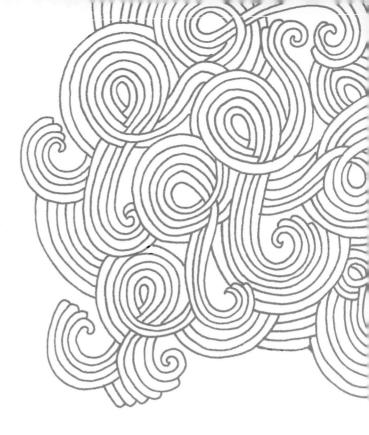

Ô

G

ų

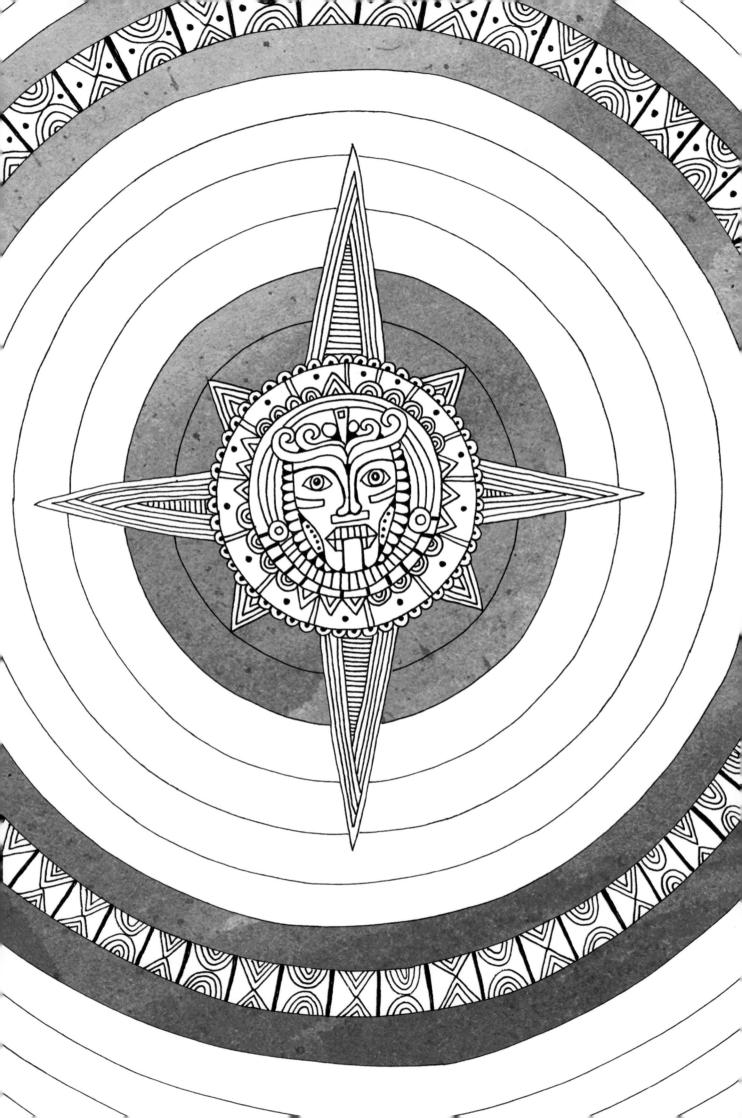

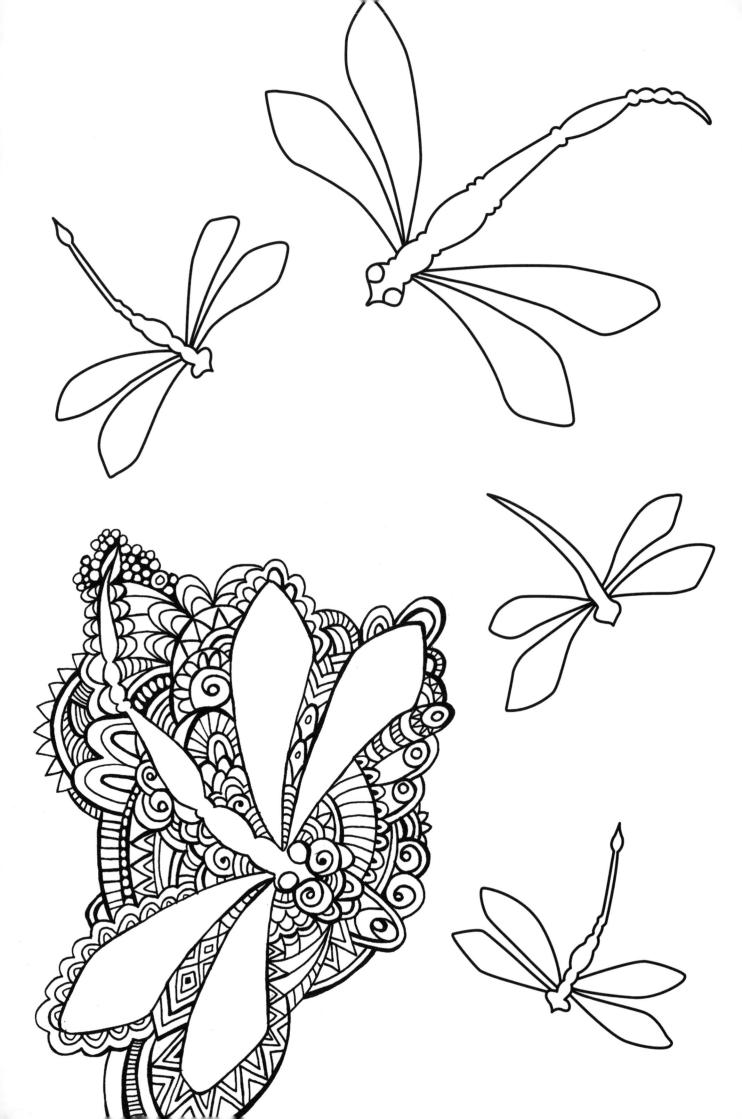

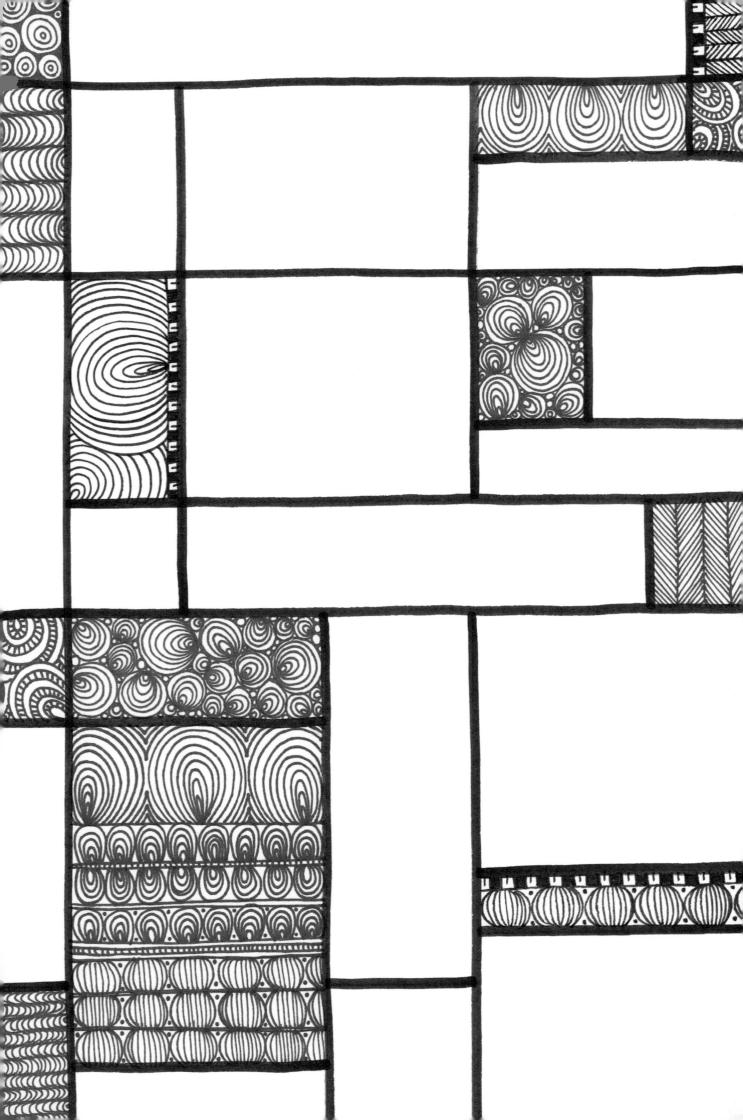

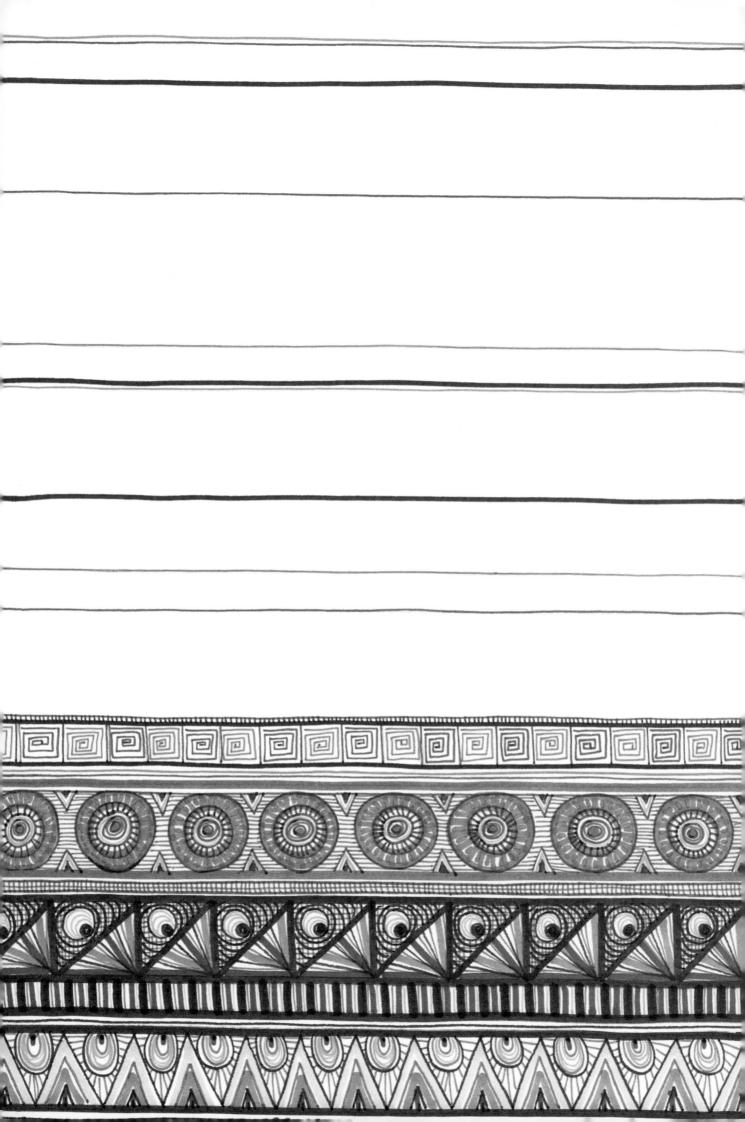

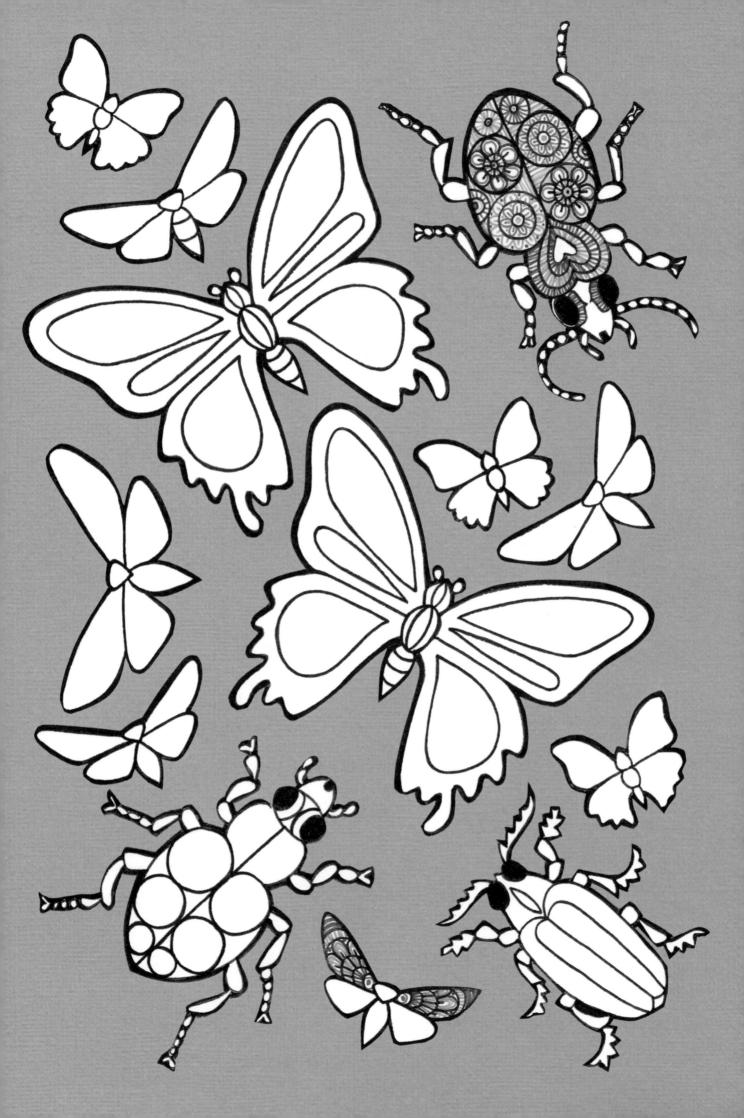

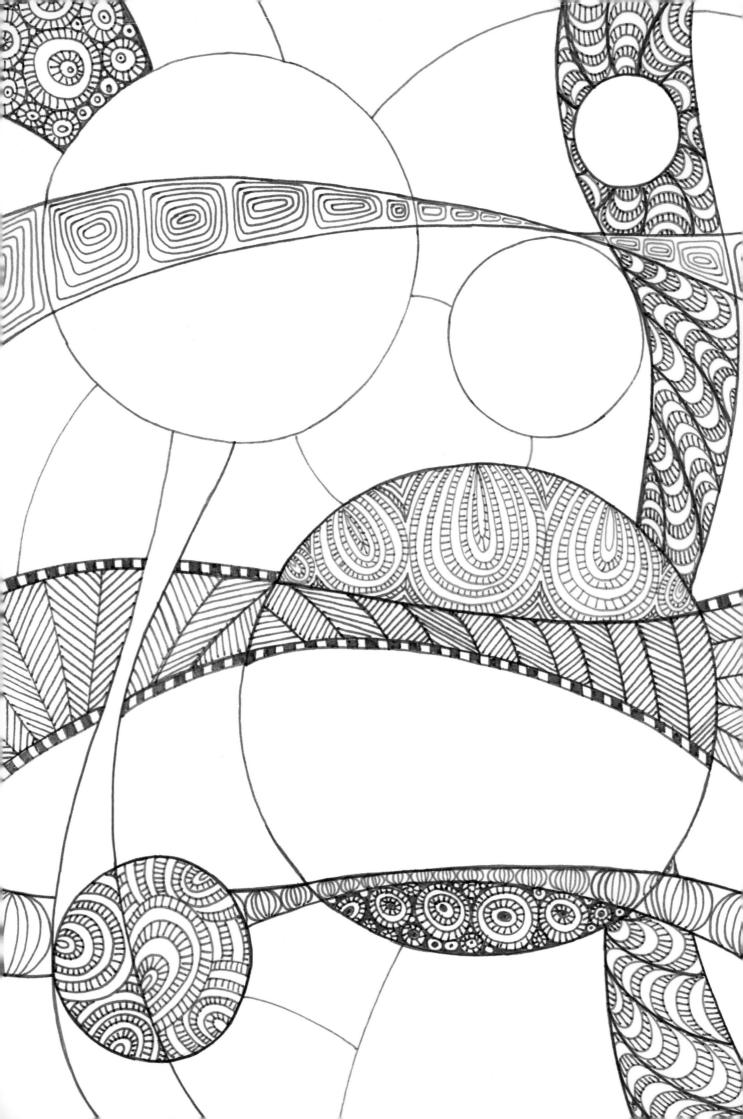

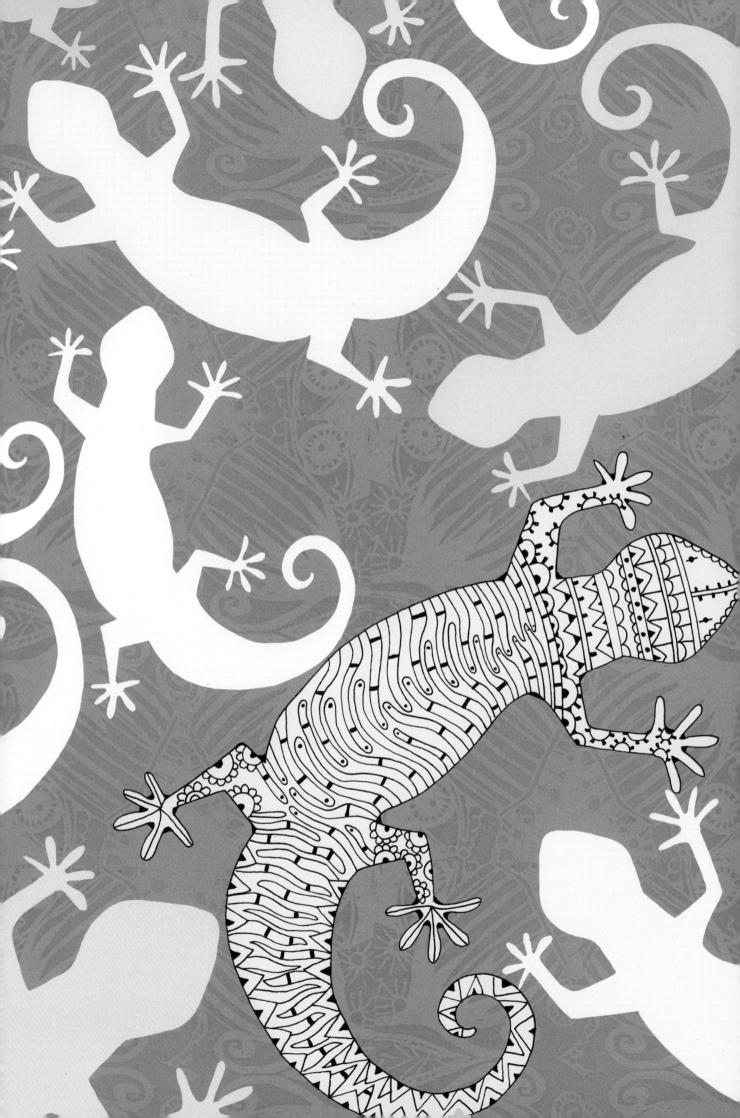

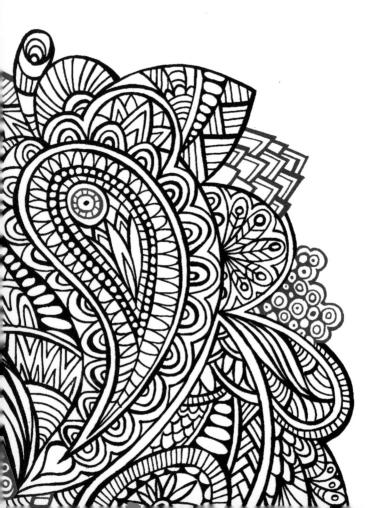

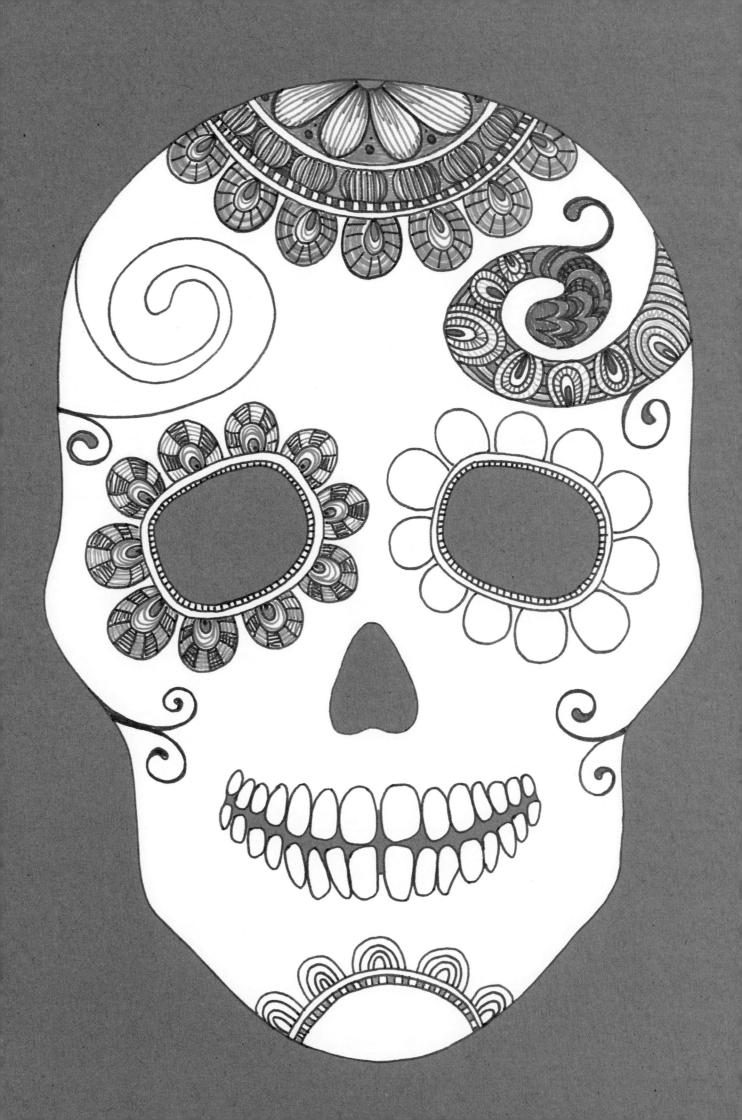

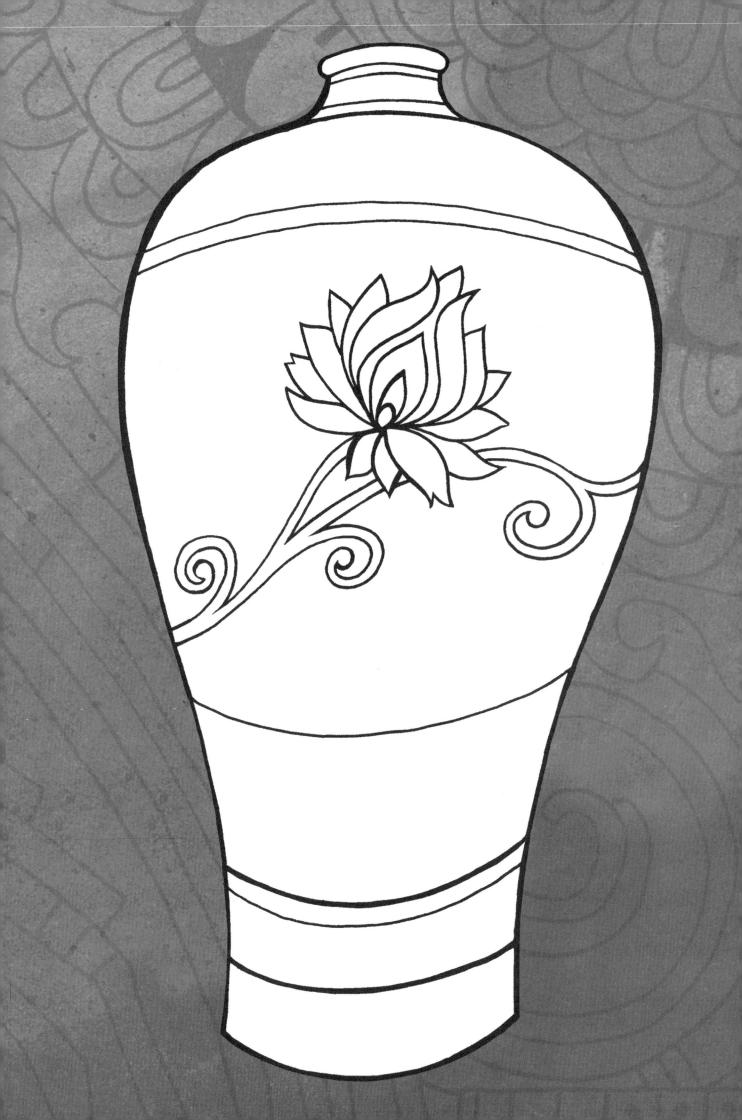

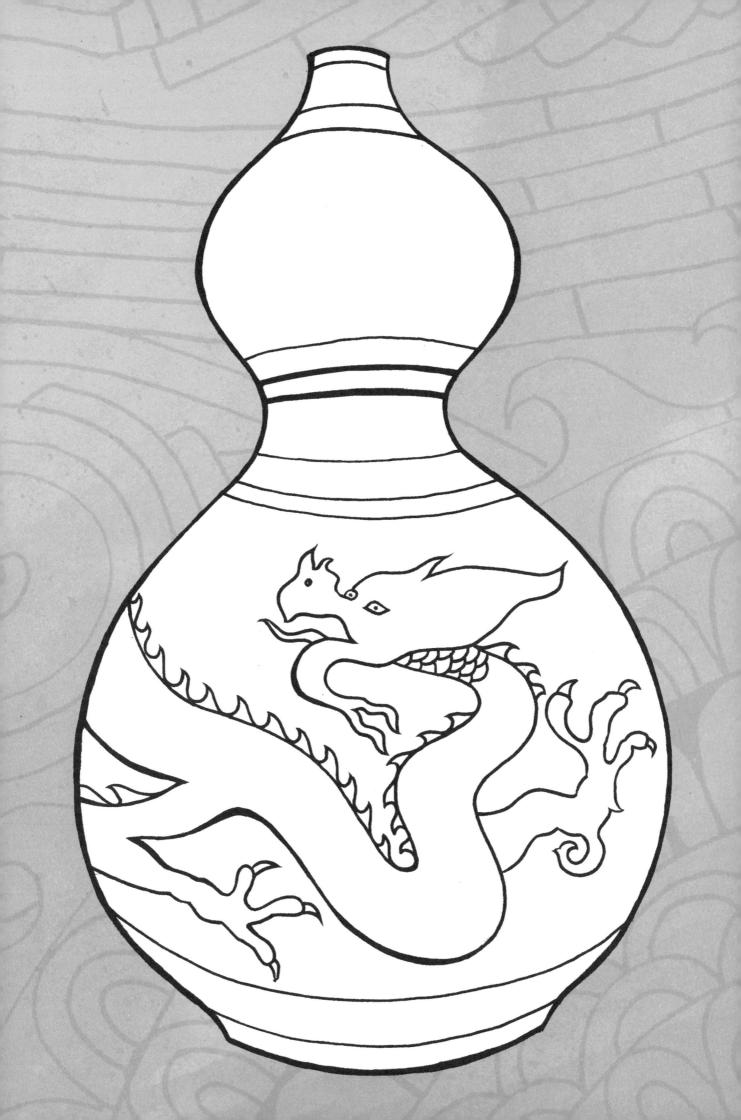

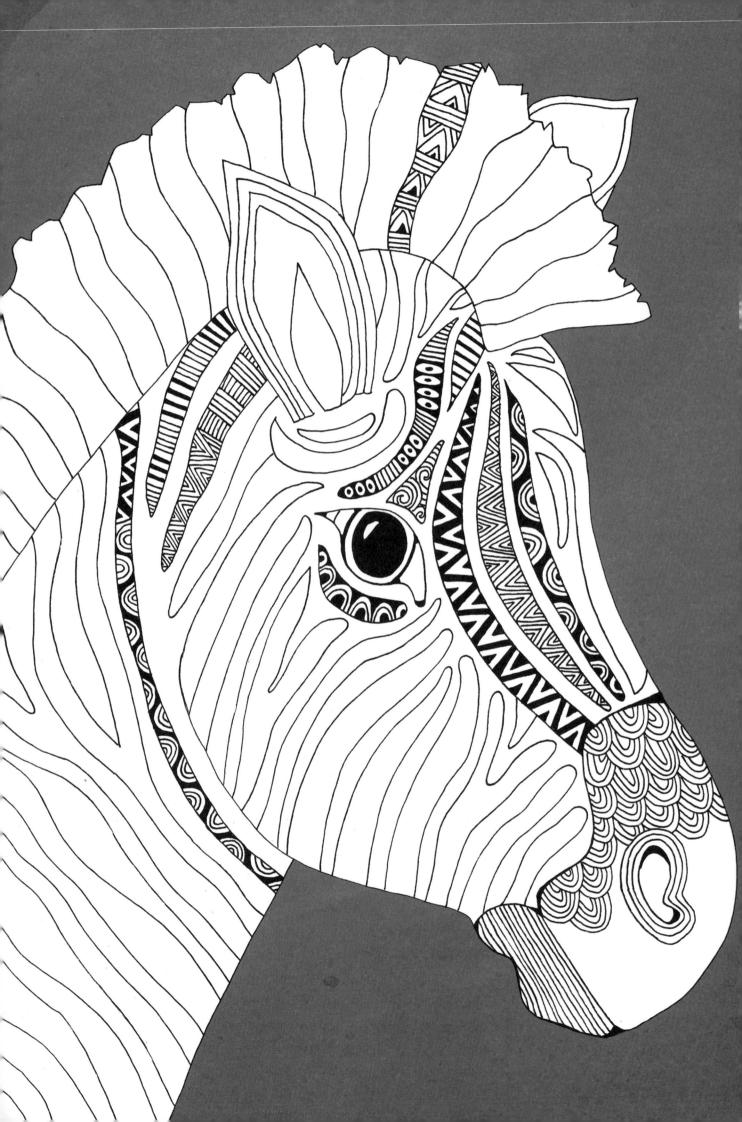